1979

W9-BQJ-832

3 0301 00082911 5

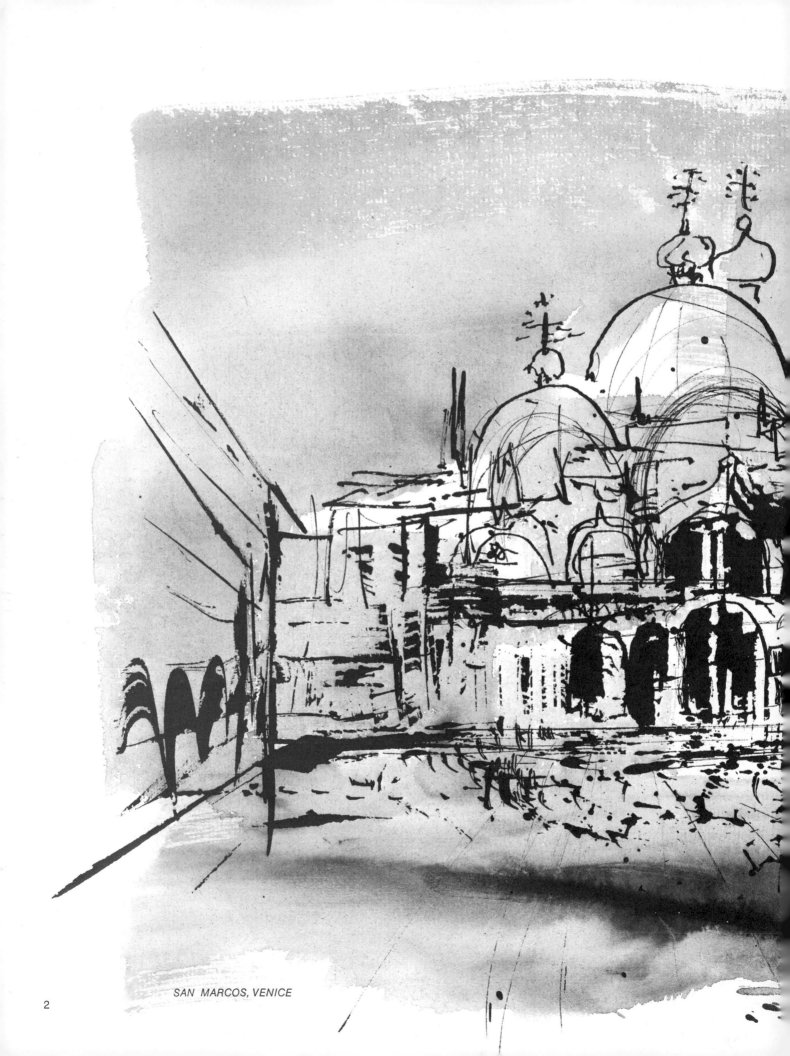

SAN MARCOS, VENICE

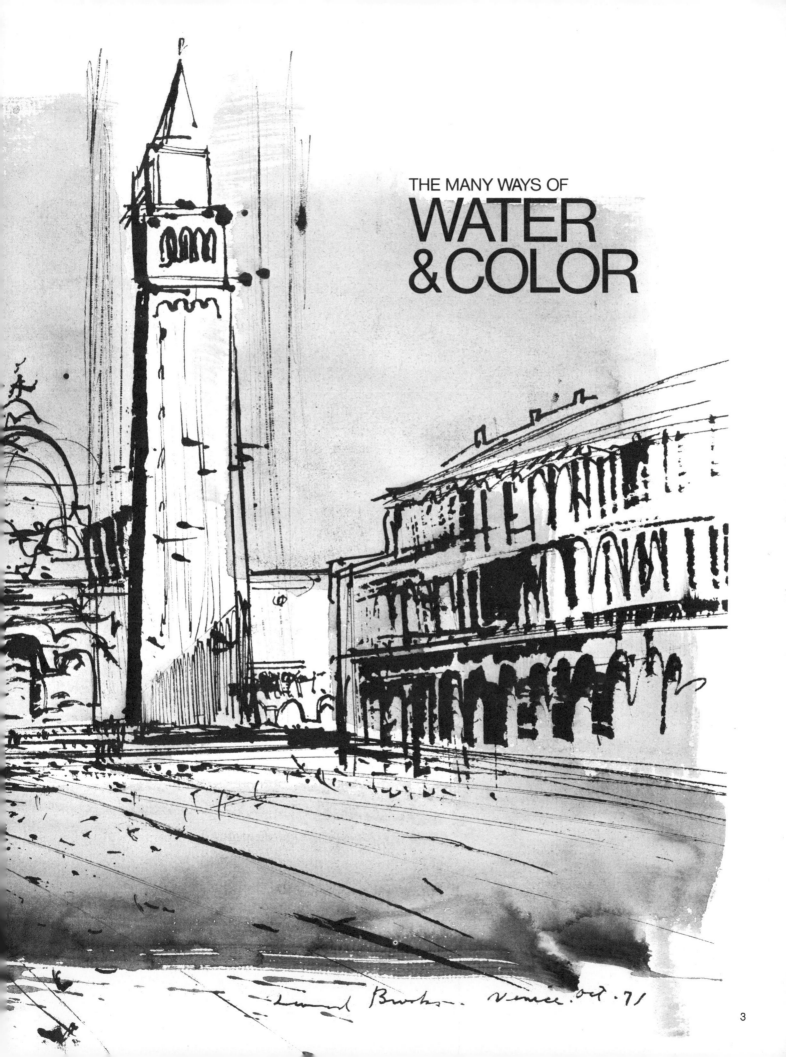

THE MANY WAYS OF
WATER & COLOR

This book is dedicated to the many readers of my first book, *Watercolor: A Challenge.* The author would like to acknowledge his appreciation to those who have helped in the creation of this book, with grateful thanks.

THE MANY WAYS OF
WATER & COLOR

BY LEONARD BROOKS

WATERCOLOR
ACRYLIC
CASEIN
GOUACHE
INKS
MIXED TECHNIQUES

LIBRARY
College of St. Francis
JOLIET, ILL.

NORTH LIGHT PUBLISHERS/WESTPORT, CONN.

Published by NORTH LIGHT PUBLISHERS, a division of
FLETCHER ART SERVICES, INC., 37 Franklin Street,
Westport, Conn. 06880.

Copyright© 1977 by Fletcher Art Services, Inc., all rights
reserved.

No part of this publication may be reproduced or used
in any form or by any means — graphic, electronic,
or mechanical, including photocopying, recording, taping,
or information storage and retrieval systems — without
written permission of the publisher.

Manufactured in U.S.A.
Second Printing 1979

Library of Congress Cataloging in Publication Data

Brooks, Leonard, 1911 —
 The many ways of water & color.

 Bibliography: p.
 Includes index.
 1. Water-color painting — Technique. 2. Artists'
materials. I. Title.
ND2420.B74 751.4'2 77-9319

ISBN 0-89134-010-6

Edited by Walt Reed
Designed by Howard Wilcox
Composed in nine point Helvetica light
by John W. Shields, Inc.
Color printing by Connecticut Printers, Inc.
Printed and bound by The Book Press

Contents

751.422
B865

85269

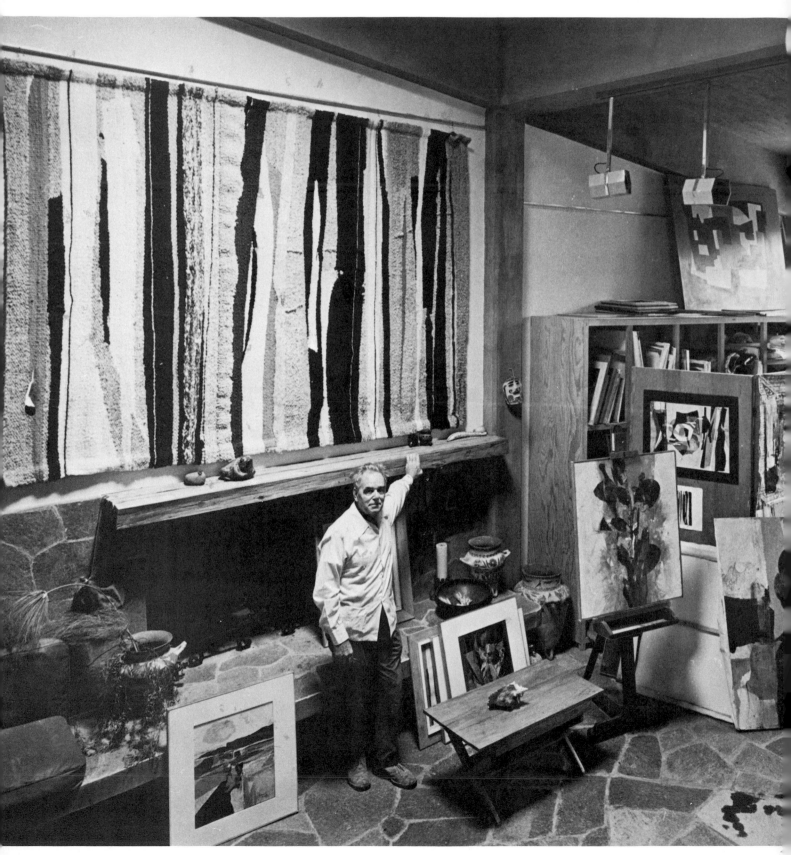

Preface

The artist in his studio.

■ The artist who has the temerity to talk or write about his work with the hope of aiding a beginner is bound to be faced with the problem of what can be taught and what cannot be taught. I know this very well, having tried several times in earlier volumes to select and present material that would be of theoretical as well as practical value to the student. The unique response of one individual at one time to one situation is so vitally important in the creative process that it dwarfs all practical advice, rules, basic principles, and even experience. If this response is strong, fresh, and good, it can (and often does) become expressed in spite of bad drawing, bad composition, bad color, bad brushwork, bad everything else. If you become too practical and methodical, your only possible success will be in gaining an ability to paint pleasant, "correct" pictures that will bore everyone, and much more importantly, bore yourself.

That's the difficulty in writing about art: so much of an artist's work involves feeling, instinct, flashes of excitement, or happy accidents generated when everything clicks into place so that technique becomes automatic, a secondary consideration. What works one day may not work the next. You cannot learn "how to" paint and then go on painting blissfully from habit. There are always new adventures and possibilities, and the beginner can discover them as well as the professional. The best a teacher can do is to start you thinking, feeling as a painter for yourself.

Technique and tools *are* important, but only as a means to expression. Much more important is the training of the artist's eye instead of the humdrum eye. This involves choice of subject, analysis, synthesis, composition, and such related matters as abstraction, literary values, and the rejection of the tyranny of external, humdrum reality of mediocre seeing.

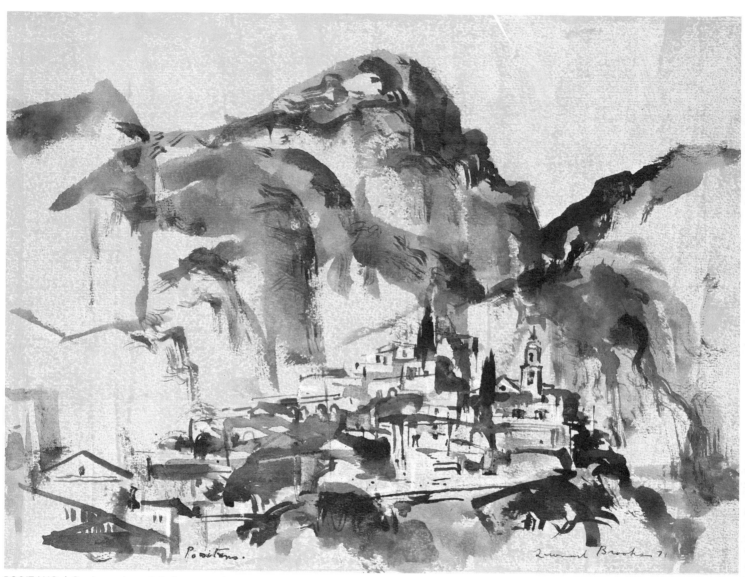

POSITANO / Sepia wash on tinted, prepared paper.

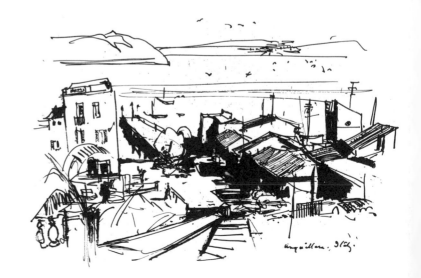

When we give technical information, disciplines and rules, it must be tacitly understood that if you can break some rules and still convey strongly in your picture what you want to express — good luck to you. The chances are you won't be able to express yourself fully until you have discovered and mastered the rules and then broken them. In any case it is often better to ignore regulations and instead make a thousand daubs and then produce something really fresh and interesting than to do everything you're told to do every time and so progress steadily into emptines and boredom.

In this book we are going to explore some of the many ways we use aqueous media, from the traditional water and color techniques to the new plastic emulsion and pigment methods that have revolutionized the painting world in recent years. Understanding the possibilities open to you, from the earliest ways used by ancient artists to the modern acrylics, will allow you to choose the medium most suited to you, whether you wish to paint figuratively or abstractly or somewhere in between. Until we have tried a variety of technical experiments with these diverse materials, we are unlikely to find the particular kind best suited to our own work and expressive desires in paint. Often the discovery of a new medium or the unearthing of an old one will provide an impetus to creativity and new worlds open up to us.

In my own work, over the years, I have utilized the expanding technical additions to the artist's bag of tools and materials and have had the exciting experience of using many of them from their first appearance and availability. It is almost twenty years ago that I discovered how to paint with polymer emulsion and powdered pigments (at that time there were no tubed acrylics on the market all ready prepared for the artist's use). It is only recently too, that I had the opportunity to discover the wonders of water and paint as used by the ancient masters on the walls of Ostia Antiqua and in the newly discovered tombs far below the foundations of the Vatican. What marvels of art have been produced with such simple means! What great things remain to be done with our added technology, our new brilliant colors and binding agents, our mixed techniques and materials! Some of the pleasures and excitements I have found in experimenting with these many ways of using water and color are hopefully, conveyed in the pages of this book.

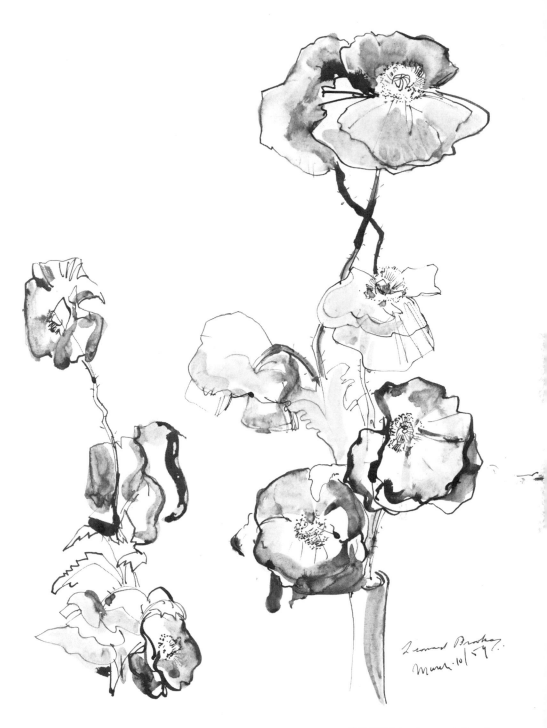

POPPIES by Leonard Brooks

Watercolor ways

It is interesting to make a comparison of the tight, conscientious rendering of the Victorian watercolor techniques with that of the freer, later ways of watercolor handling. The loose, free washes of Turner and Brabazon, the English watercolor school of Brangwyn and his followers, and those of Sargent and Homer of American fame who used the transparent, suggestive and seductive washes of pure color in sparkling impressions taken straight from nature; all these grew out of the neat, technically proficient rendering of the practiced, skillful earlier academic watercolor "drawings," many of them literally architectural exercises, accurate and often quite dull to the modern eye. What part photography took in helping to break away from these renderings and factual paintings is traced by noting the use Degas and other French artists made of early cameras and their prints to influence their compositions and work, both in oil and watercolor. Botanical studies, so beloved by the Victorian painters, produced exquisite small paintings such as the one illustrated here. It is an unfinished watercolor painted by a noted seventy-year-old watercolorist I knew as a boy, and shows the minute observation and love of the subject painted with such trained and careful skill. Modern magic realists please take note! Compare this with a flower painting by the later master Charles Demuth (his *CYCLAMEN* watercolor is a masterpiece), and see how he incorporates the lessons of the cubists and the traditionalists in a fresh, direct interpretation so characteristic of all his work.

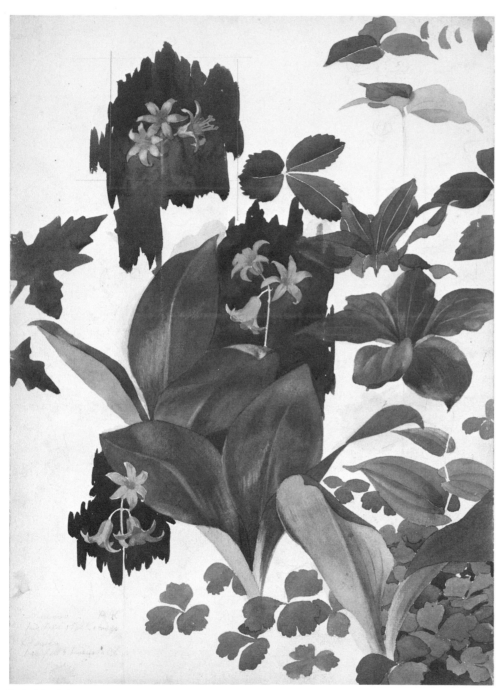

Unfinished flower study in watercolor by Robert Holmes

DEMUTH / *CYCLAMEN*

12

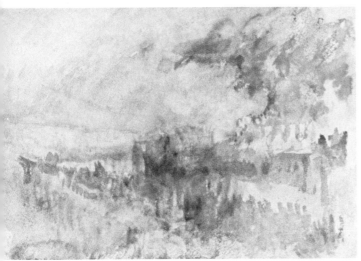

TURNER / *BURNING OF PARLIAMENT*

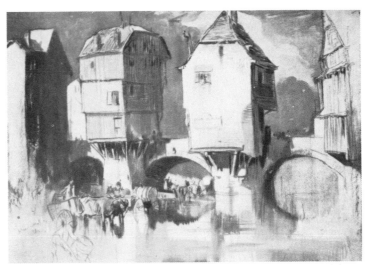

BRANGWYN / *OLD BRIDGE*

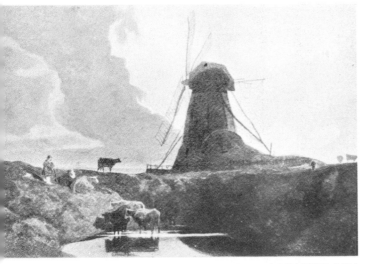

COTMAN / *DRAINING MILL*

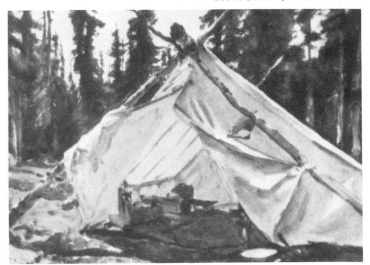

SARGENT / *TENT IN THE ROCKIES*

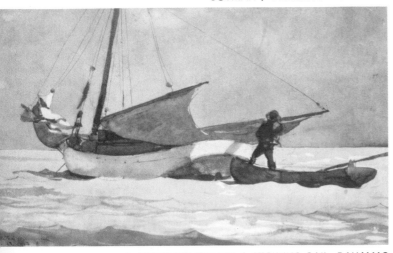

WINSLOW HOMER / *STOWING SAIL, BAHAMAS*

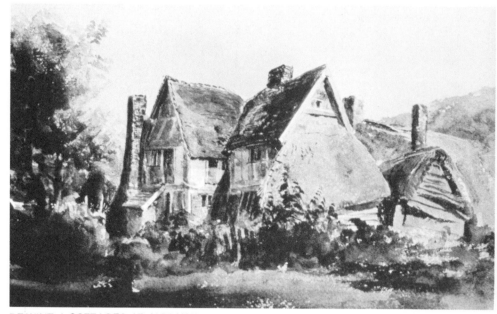

DE WINT / *COTTAGES AT ALDBURY*

PRENDERGAST / *THE EAST RIVER, 1901*

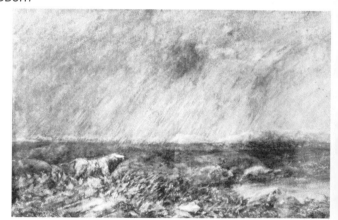

DAVID COX / *A STORM ON THE MOOR*

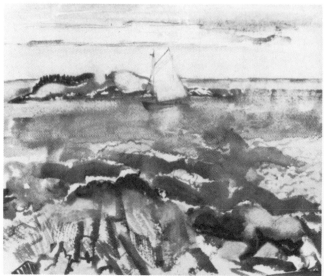

JOHN MARIN / *SEASCAPE*

Yet, in the midst of these rather conservative watercolor paintings, a number of brilliant young painters were producing magnificent watercolors that still remain unexcelled in quality, perception and skill that outlast changing styles and move us as much today as when they were painted. Who can look at a fine Peter De Wint, David Cox or John Cotman — see his *DRAINING MILL, LINCOLNSHIRE,* 1810 — without feeling the mastery of the medium, or the strange, mystical works of Samuel Palmer whose influence on landscape painting has been inestimable. Or Whistler, Prendergast, Marin and others who brought watercolor out of the 19th Century into the 20th with enthusiastic verve and discernment of a high order. You will find an excellent volume devoted to these historical figures in *A Concise History of Watercolors* published by Harry N. Abrams, Inc. Understanding the background of watercolor will help you to realize its versatility, how it has adapted itself over the centuries from the earliest use of sumi (soot used for black-and-white paintings) and caligraphic paintings of the Chinese centuries ago, through the countless changes of style and influences of endless schools of painting until today it has emerged once more, in a new form, as a significant language and medium for our times. Today its limitations are few. It can be used, thanks to acrylic, in the most abstract or figurative ways.

From the gesture splashes of Sam Francis to the tightest of huge surfaces, the expanded technical potentiality has broken down the gulf between what once was considered the "serious" painting of the oil painter and that of the restricted and lesser watercolorist. Today a painter can, if he wishes, for it is quite practical, paint his acrylic washes across a twenty-foot canvas surface staining immense color fields exactly the way turpentine and oil underpaintings and stainings are made. He can also use the acrylic as a fresco painter on the wall without the complex, difficult processes of wet plaster technique, imitating the fresco perfectly. The barriers are down and the artist is able to concentrate more than ever before on the more important matters of significant expression with techniques simplified for his usage.

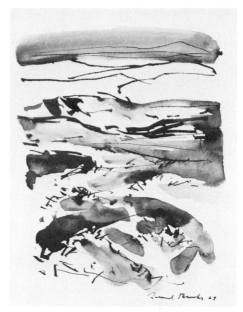

Lamp-black watercolor note.

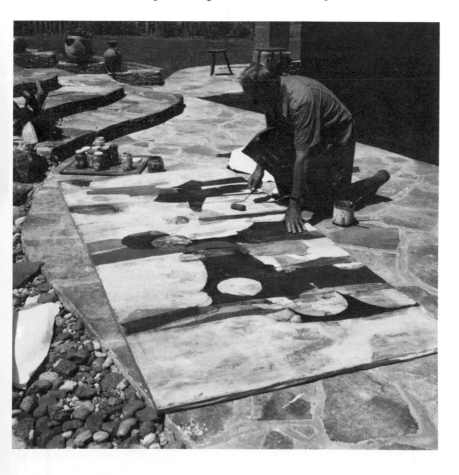

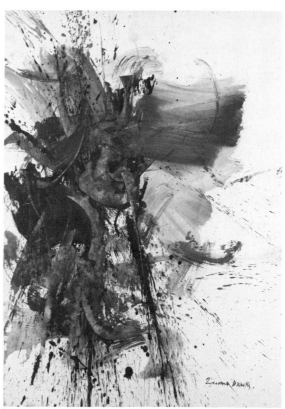

BROOKS

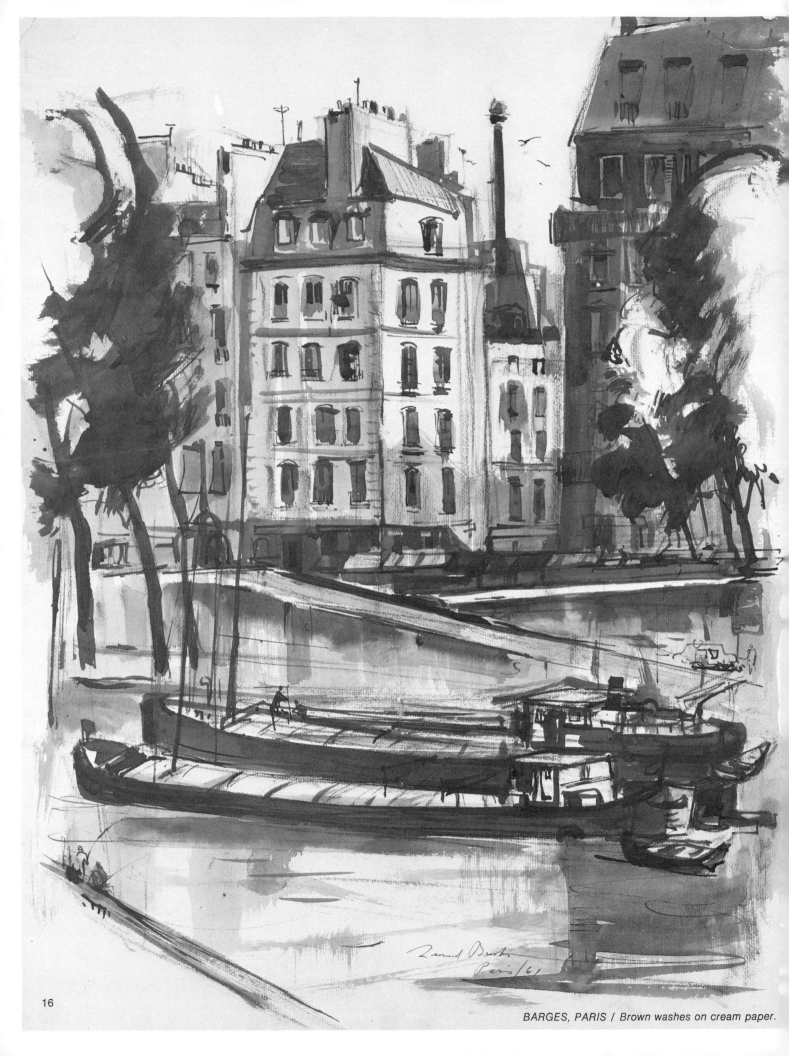

16

BARGES, PARIS / *Brown washes on cream paper.*

Traditional techniques

WASH: If you are a newcomer to watercolor, here is a basic method that will start you off with some sense of control and direction instead of floundering helplessly in a sea of daubed pigments and water. Such techniques do not take too long to learn and will not inhibit your self-expression.

EXPERIMENTAL WASH TECHNIQUES

1. Squeeze out a generous portion of lampblack or ivory black watercolor on your paint tray or box. Use a No. 12 pointed sable or other good quality brush. Load the brush with water and pick up plenty of pigment in the hairs. Swirl the brush about in the tray until it is evenly saturated. Make a good, firm, dark stroke of even gray using a semirough watercolor paper. Now try the same stroke *quickly.* Notice how the brush hairs will "break" as you press down and the "drybrush" effect happens.

2. Scrub out the pigment on a piece of paper and make dry-on-dry strokes.

3. Vary these as shown.

4. Make lighter-toned grays, adding more water. Make a number of gray strokes.

5. Paint out an area of gray. Paint another darker stroke of pigment into it while it is still wet.

6. Scratch out lines while paint is wet with a razor blade or the pointed end of the paintbrush.

7. Wash the paper with water. Stroke a fine line of dark pigment into it and watch its dispersal and action.

8. Lift off wet pigment with a sponge or a piece of Kleenex — fine for soft edges and cloud modeling.

9. Use a wax crayon or piece of candle to make marks. Wash over this and observe the rejection of water to make a broken texture.

10. Paint strokes of rubber cement and wash over them. Erase the cement when dry.

After you spend some time experimenting with these suggestions you wil be ready for the first watercolor adventure — the three steps of brush control — and the three minute painting.

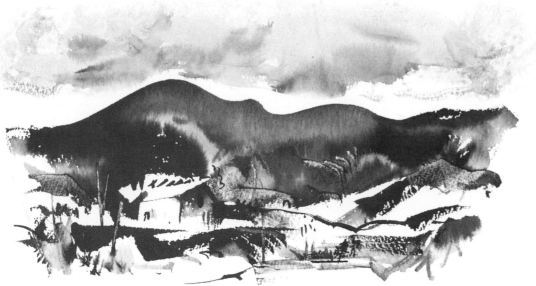

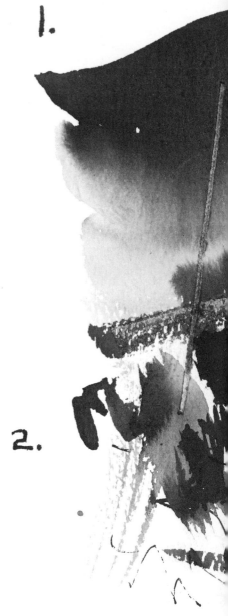

3 MINUTE BRUSH EXERCISE

Three Steps in Brush Control

A Three-Minute Exercise. Use a black watercolor paint. Use a 16″ x 20″ paper or pad. Work directly without pencil outlines, inventing shapes with the brush. Choose a simple theme — a hill, a house, a field, a cloud.

Figure at right shows the three steps in this rapid exercise. The time element is important for it will force you to work without fussing, helping you to make a direct, fresh wash.

1. The one-stroke dark hill first; add water to pigment for modeling.

2. Slow-quick strokes in black to give textures to foreground. White paper is left dry and clean. Some dry-on-dry brushwork adds details.

3. A smaller brush to add final accents and linear touches of drawing. A few scratches with razor blade into the wet paint for definition. Try this again and again. Take five minutes to do it this time. Soon you will discover some of the secrets of control of the brush to give variety and sparkle to the many ways of manipulating pigment and water on dry and wet surfaces.

As you experiment with brush control you will soon note the difference that the quality and texture of your papers make. Figure below shows three papers; a cold-pressed, or smooth, paper; a medium-grain paper; and a rough-textured paper. Observe how the brush slips smoothly across the surface or skips across the rough indentations, leaving some paper untouched. Notice how this changes the edges of the stroke giving even, hard edges in the smooth paper, and rough, broken edges on the rough-textured paper. Control of these edges will become an important part of your watercolor technique later.

1.

2.

3.

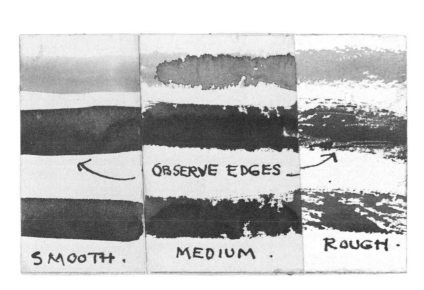

OBSERVE EDGES

SMOOTH. MEDIUM. ROUGH.

Smooth, medium and rough papers determine the texture and quality of the brush stroke.

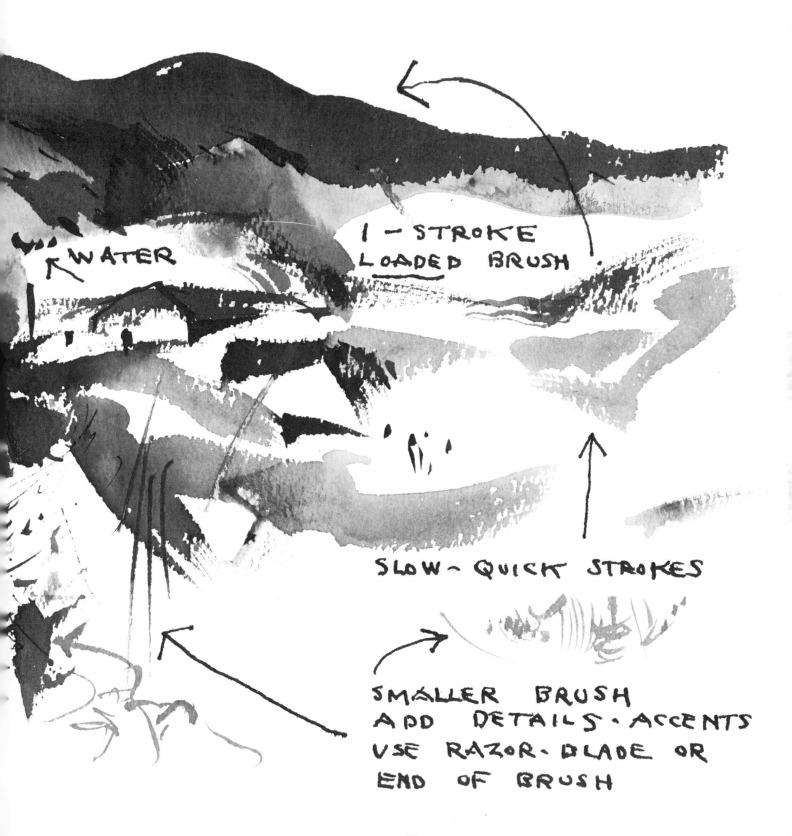

WATER

1 - STROKE
LOADED BRUSH

SLOW - QUICK STROKES

SMALLER BRUSH
ADD DETAILS · ACCENTS
USE RAZOR · BLADE OR
END OF BRUSH

Try Everything!

After the disciplines of learning some brush controls the time will come when you will feel like letting loose and having fun splashing watercolor on the paper. Shown at right are a number of ways you can explore further useful brushwork by making the accidental markings of blobs, spatters and other manipulations of the pigment work for you. Automatic lines that drip and run when the paper is held vertically, paint running into wet paper, patterns and spottings made by flicking the brush to make dots — all of these are legitimate ways of using watercolor. Make the accidents work for you!

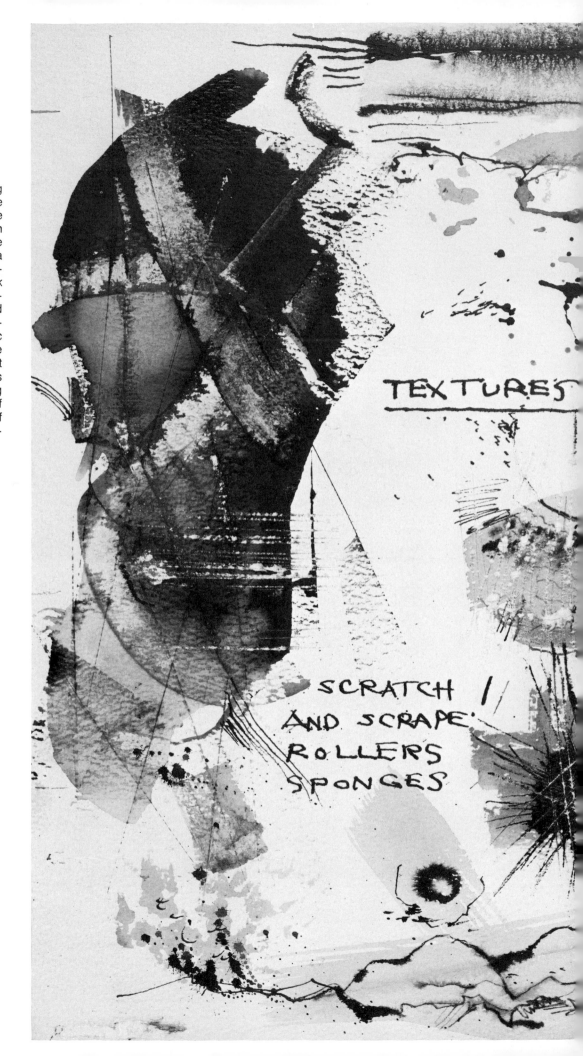

TEXTURES

SCRATCH
AND SCRAPE
ROLLERS
SPONGES

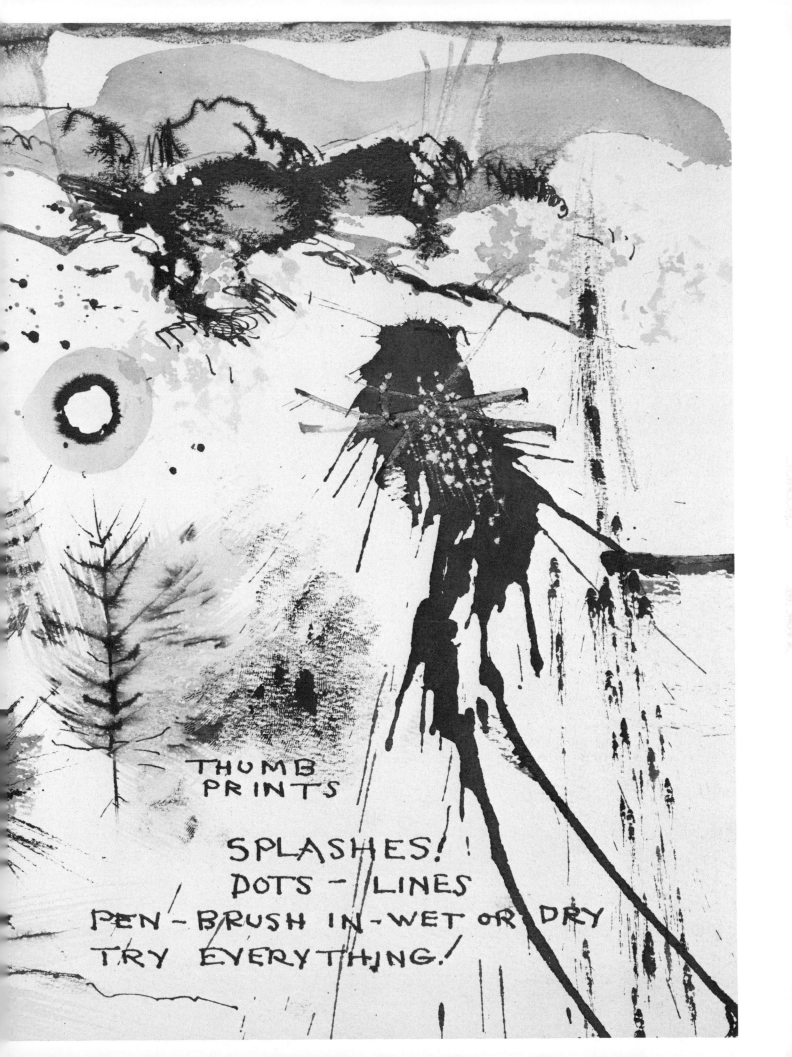

THUMB
PRINTS

SPLASHES!
DOTS — LINES
PEN — BRUSH IN — WET OR DRY
TRY EVERYTHING!

Equipment

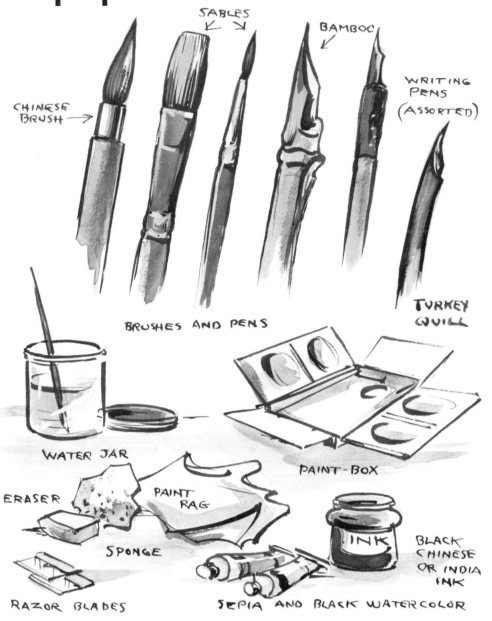

CHINESE BRUSH →

SABLES

BAMBOO

WRITING PENS (ASSORTED)

BRUSHES AND PENS

TURKEY QUILL

WATER JAR

PAINT-BOX

ERASER

PAINT RAG

SPONGE

INK

BLACK CHINESE OR INDIA INK

RAZOR BLADES

SEPIA AND BLACK WATERCOLOR

■ The basic equipment needed to make the exercises in wash and water color is shown at left. Add to this later a few special tools — rollers of plastic or rubber, steel "brush pens" and colored watercolors in tubes for full range watercolor painting.

Watercolor washes set differently on varied papers. Some papers are prepared with sizes and do not absorb the pigment deeply so the color remains on the surface. Smooth papers and soft surfaces such as most Japanese papers blot and absorb the pigment with a nonhard edge. Experiment with the many varieties of smooth, rough and medium textured papers to find out how your brushes and colors react.

Techniques, methods, knowledge and experience; the papers you use will add, with experiment, something to each of them.

Textures of Foliage

Painting foliage, brushing in the suggestion of thousands of leaves of various shapes and sizes will give you practice in brush control. Use pointed and squared brushes to obtain large masses and detailed touches.

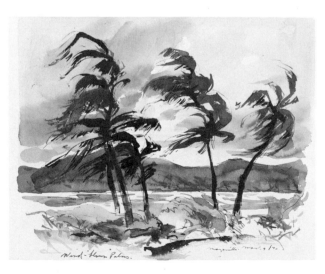

PALMS IN WIND / The fast active brush stroke suggests the movement of palm fronds blowing in the wind.

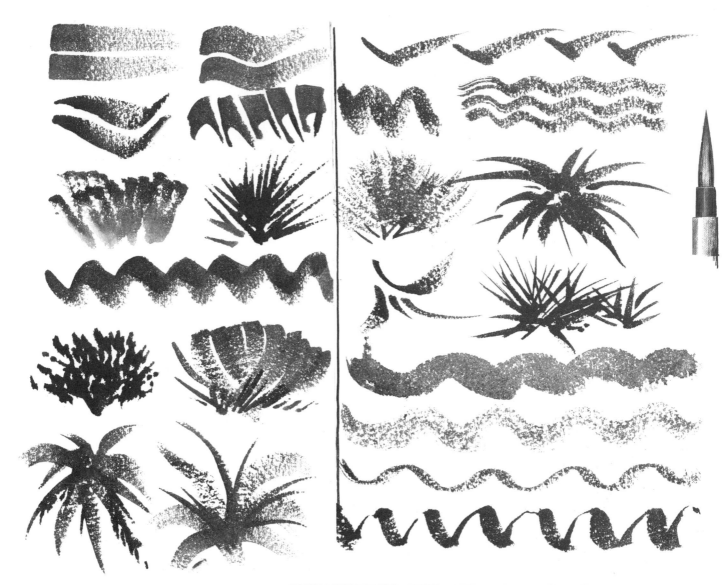

*Pointed brush and flat sable brush
provide contrasting strokes for
foliage texture-making.*

A detailed wash drawing in sepia on tinted Fabriano paper. This paper can be bought in light and heavy weights and many shades and colors. Touched with a few discreet and selected crayon accents in light tones, it was a favorite sketching technique for many of the great landscape sketching travelers of the 19th century who took the ''Grand Tour'' of Europe to gather material for their paintings. Study the work of Lear, Turner, Ruskin and earlier classical masters for examples of skillful work.

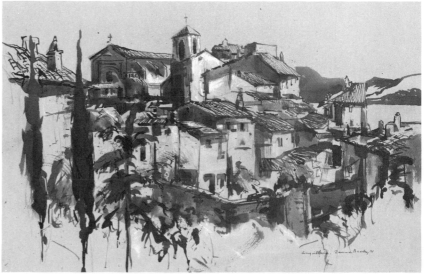

Wet-in-wet

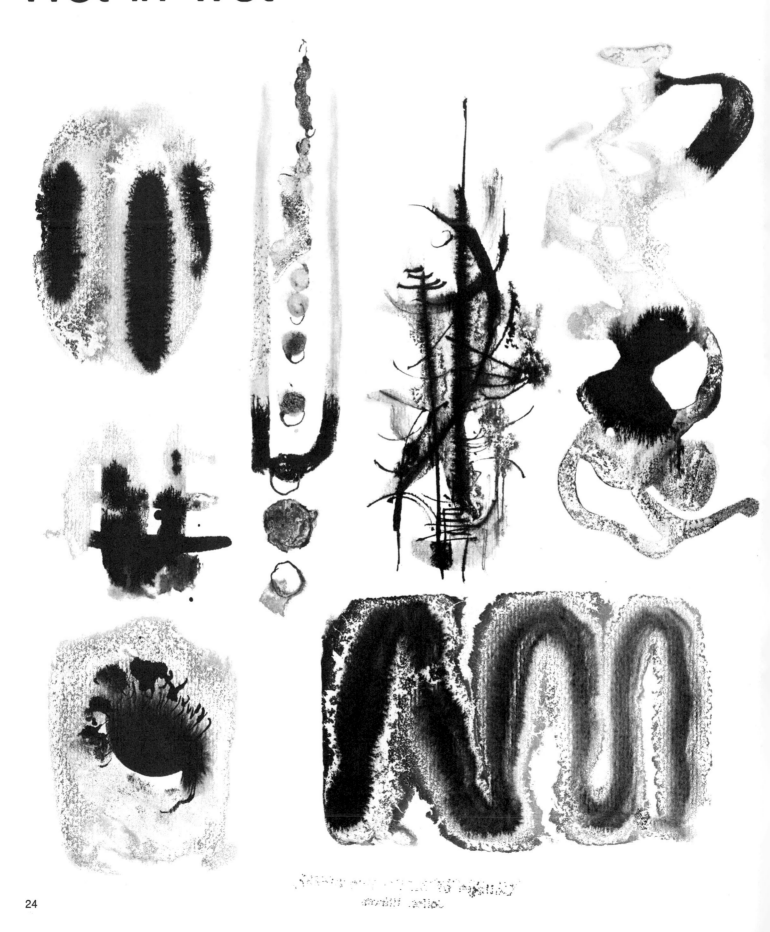

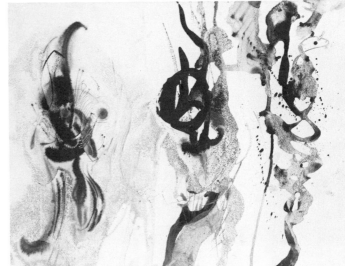

Free forms made with water and ink or color dispersal. Wet paper provides the ground to drop the pigment or ink into. Try it with brush or pen line. Accents may be controlled with practice and experience. The controlled accident is a useful technique.

■ Use black or deep brown watercolor or either Chinese or India ink. Drop the pigment or ink on to the water-washed surface of the paper and watch the dispersal granulate and texture the surface, changing as it dries. Experiment with different brushes and pens to learn how to control these varieties of surface, rough, medium and smooth.

When you feel you have mastered some of the brush controls, you are ready for the next step.

Choose a simple subject from nature making a rough note of it in your sketchbook as shown on Page 52 (Thumbnail sketches.) Use it as a basis for a watercolor to be painted in one color...a black or deep brown pigment. Work inside with some comfort — there will be time enough for the struggle of sketching on the spot later on. Think of your subject in a tonal scheme of several grays, a white and a black, and leave plenty of white paper. Time yourself to fifteen minutes for this effort, working on a 10" x 12" pad of your favorite-textured paper. Keep to the same brushes you used in the earlier exercises. Don't feel that you have to end up by making a fine painting. You are doing your scales and learning the possibilities of your medium. These bouts of work will pay dividends to you when you really set out to express yourself and to interpret seriously whatever subject you choose.

85269

College of St. Francis Library
Joliet, Illinois

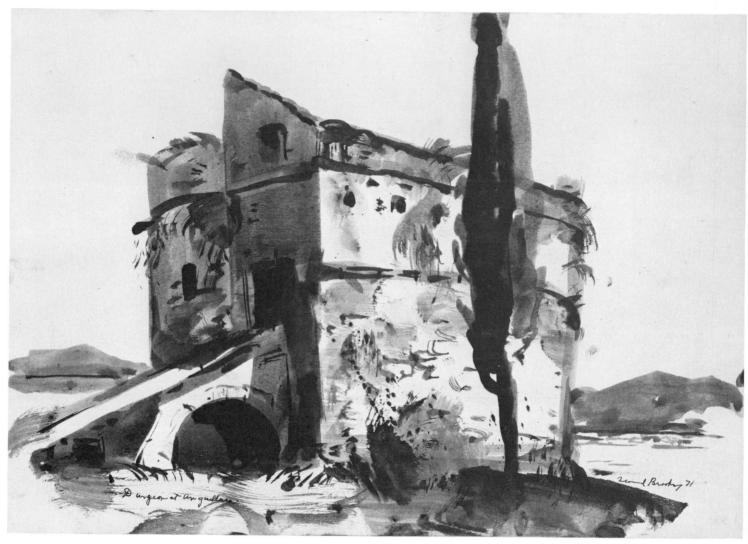

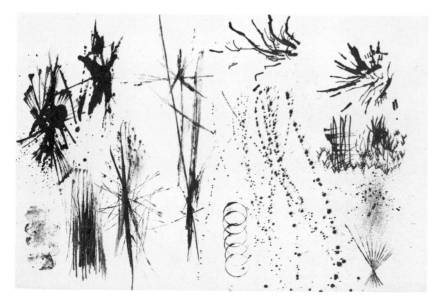

Dots, dry-brushings, splatters. The variation of texture-making is used in a quick note made from an Italian dungeon. Strong contrasts, direct painting, no blocking-out or drawing with pencil first. Sum up large areas of light and medium tone first, working toward the darkest accents and detail at the end.

A large (20″ x 24″) wash drawing at right painted rapidly on the spot to make a suggestion of the brilliant light of Venetian sky and water. Chinese Sumi ink, squeezed from the tube, was used with a few touches of bamboo pen strokes to provide needed details. Working with black and white will soon teach you the value of preserving areas of white paper to suggest light. The controlled, exact brushings of a precise technique reject the accidental qualities of the free gesture and uses a tight and decorative handling of the water and color.

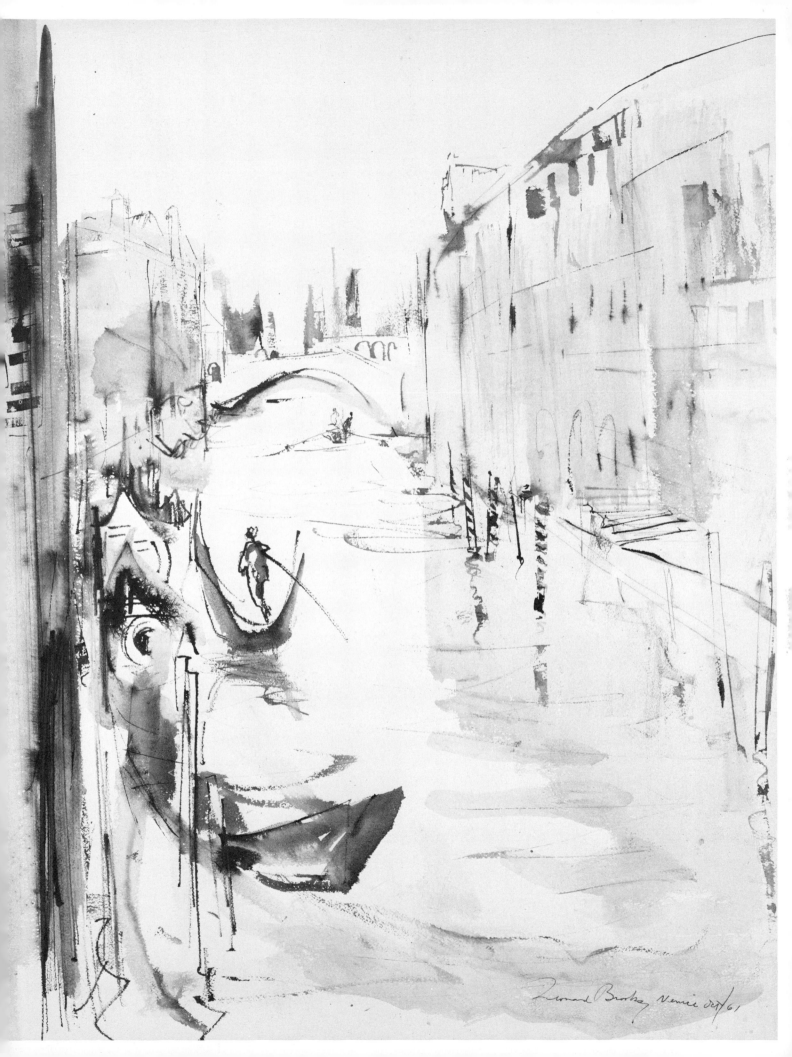

Leonard Baskin Venice Oct/61

Light

White paper—your key to making watercolors sing brilliantly. The experienced watercolor painter knows how to preserve the clean sparkle of a good watercolor paper, leaving it untouched or washing a pale float of ochre or a warm colored tone to enhance its suggestion of sunniness and light. He may surround white areas with dark shadows to force the high contrast of high-keyed light and rich transparent dark shadow, or he may let the light filter into the shadowed areas of his picture with translucent washes that enhance the whites to a surprisingly intense quality of luminosity. Careful planning of your black and white tones and special attention given to the placing of small, dark accents will help augment the pristine white of watercolor light passages.

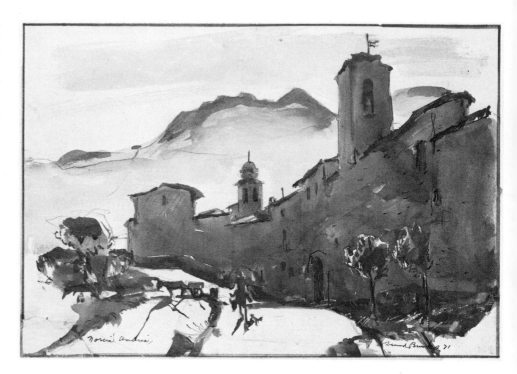

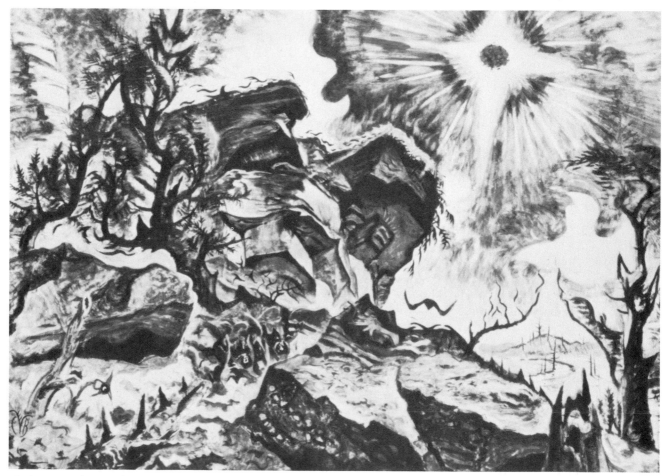

BURCHFIELD / *SUN AND ROCKS*

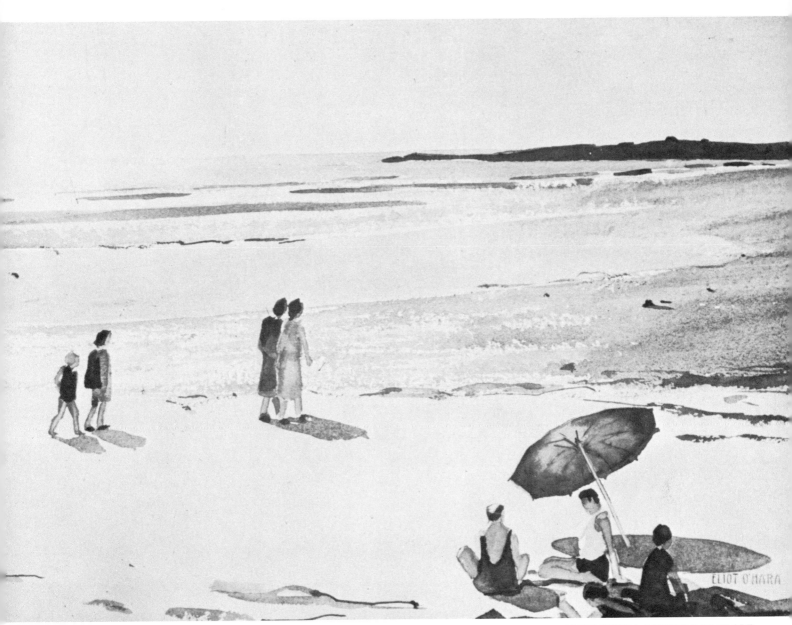

ELIOT O'HARA / *NOON-DAY GLARE*

Japanese paper

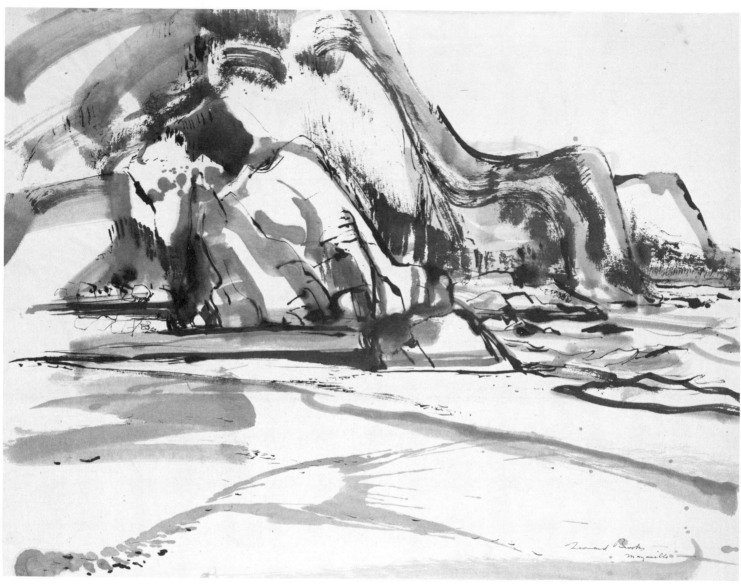

The soft edge of a brush stroke in Sumi ink on Japanese paper leds a certain style and quality to brush paintings. The rock and shore study was done on rice paper, an absorbent line that cannot be changed or washed out but must be put down directly and left. Precise, direct, one-go attack is demanded with no corrections later — a good discipline for timid workers.

■ Japanese paper — there are many varieties of rice, mulberry and other exotic white papers used for Sumi ink painting and available in most large art stores — provides a discipline in direct notation. Its surface is delicate and cannot be scratched or rubbed and washed out without damage. The absorbent quality makes a line or brushstroke with its own peculiar character. The watercolor shown here was made with pale yellow and brown watercolor and fine brush line.

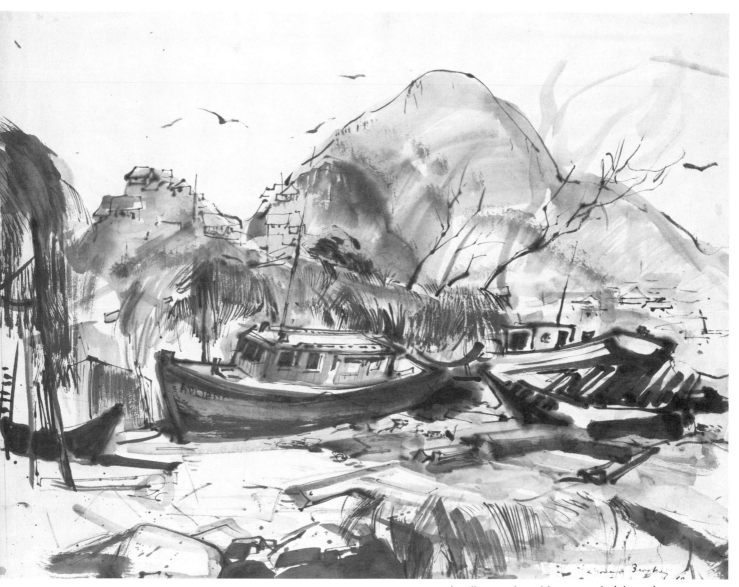

A yellow wash and brown sepia ink on Japanese paper.

Tinted gesso grounds

■ Rolled out tinted acrylic gesso surface made with plastic roller and pale ochre, thinned-out color. Or make a printed off-set surface by coating a lino block with acrylic and press the paper on to it, peeling off the offset print. A beautifully mottled, textured ground can be made that serves as a starting point for over-painting watercolor washes. Here are two on-the-spot sketches made on such a prepared paper with brush and pen, watercolor and inks.

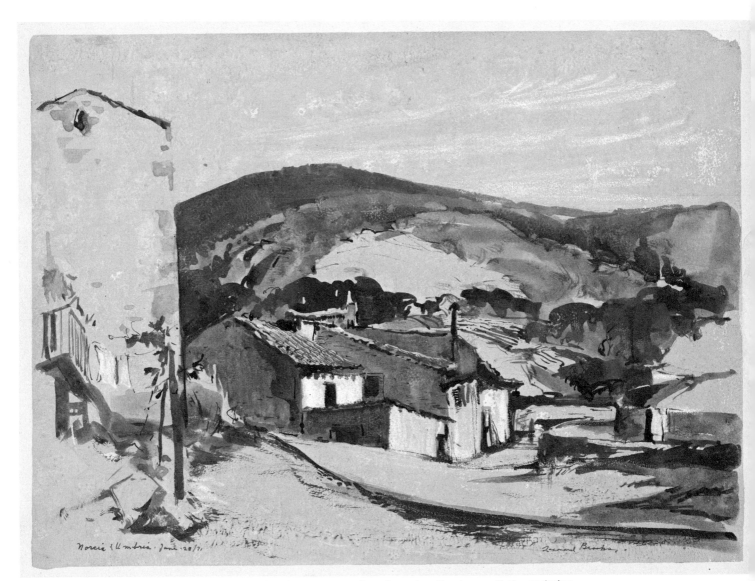

UMBRIAN FARM / A tight, careful rendering on tinted gesso ground made on location in a realistic rendering.

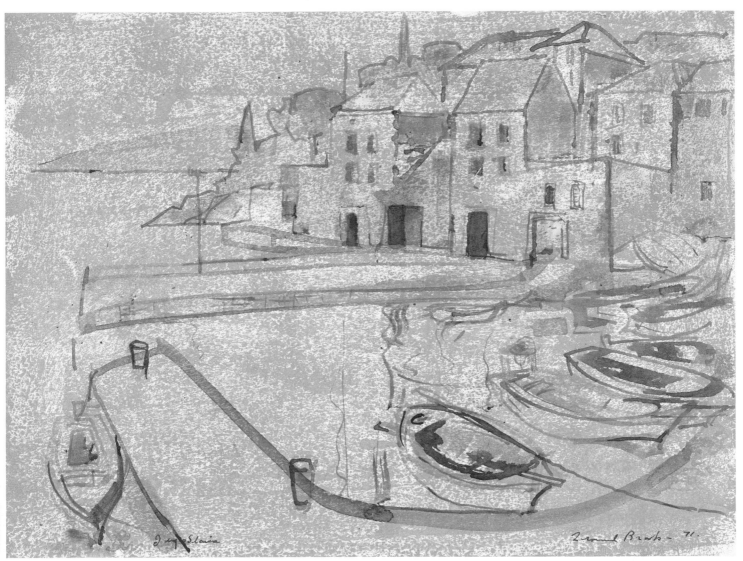

Wash painting on gessoed paper. A mottled background of light, tinted color was rolled out on a cream paper using thin acrylic paint. A number of papers pre-prepared in this manner are useful for a sketching trip. Select one for your subject and use brown inks or sepia washes over it. Such sketches will have an "Old Master" look about them for the limited means of this kind of sketch was beloved by them. Claude Lorrain loved bistre, brown and sepia on blue and pink tinted papers.

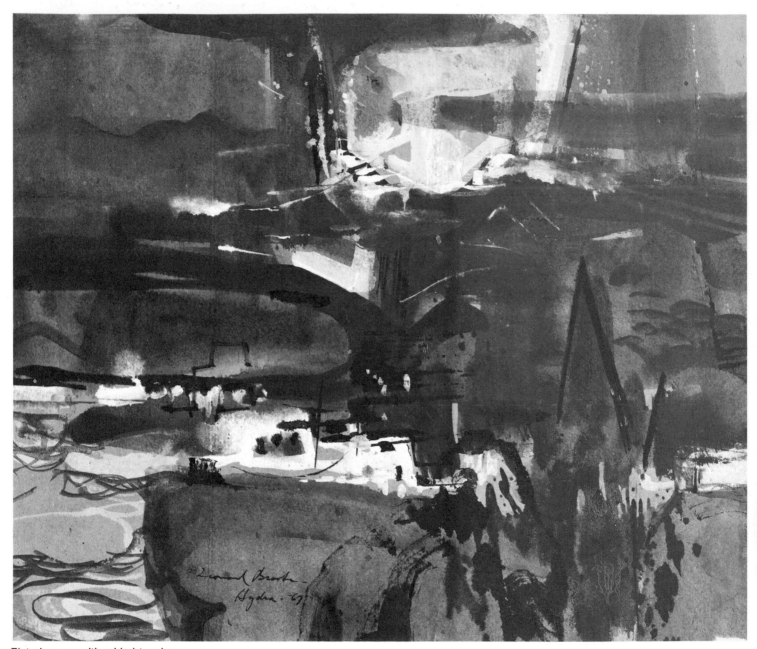

Tinted paper with added touches of opaque white watercolor.

Amalfi Coast *(at right)*

Early morning. The drive along the steep, curving roads of the Amalfi mountains in Italy unveils panoramas our sketchbook cannot resist. Somehow we find a safe parking place off the road and look over the vast drop to the sea. "Ten minutes," our companions say, for they are anxious to move along to breakfast time in Portofino. "Fifteen," we say, and get to work. Black ink washes on gray paper, a touch of white and Venetian red acrylic. The simplest of broad washes are put in first, over this the suggestion of hundreds of villas perched on the mountainside, the trees and rocks plunging downward. A direct transcription *suggesting* our subject; a fast rendering of this type of sketch will sometimes catch qualities we are after better than those we overwork. I made this one in twelve minutes of concentrated work.

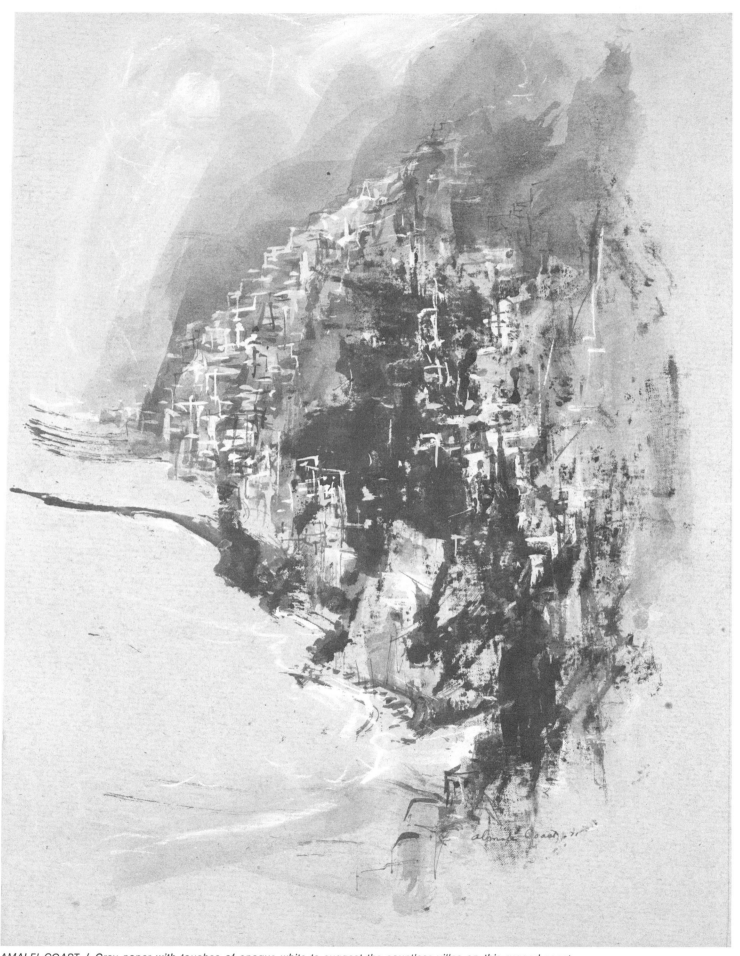

AMALFI COAST / Gray paper with touches of opaque white to suggest the countless villas on this rugged coast.

Abstraction

Explore the free gesture of watercolor brushwork in caligraphic exercises. These are much more difficult to do then they appear.

■ These look easy to do until you try them. Space, line, form — a few tones on a light, warm-tinted paper. With these we will try to make an expressive statement, free of figuration of a realistic motif or objective forms.

Rhythm and sequence, repetitions, spottings of light and dark areas, contrast of heavy and light forms, thin and thick pen and brush strokes — all of these can be used to build up an organic unity from the first to the last touch. One calligraphic line calls forth another. Try this exercise in abstraction.

Begin somewhere and let it grow. Think of major and minor keys; light and dancing, heavy and pensive, automatic or controlled touches, free or tight. Such studies call for understanding of the abstract idiom of "pure" painting that does not depend on illustrative subject matter for its message.

BEACH FORMS / Painted on rough white Arches paper.

The Automatic Watercolor

The liveliness of a line or stroke made with the free gesture, sometimes called "automatism," which releases vitality and energy across the page is easier to describe than to do. Try it! The beginning stroke should call forth the next, generating its own design, form and unity, a growth as organic as that of a tree branching into *its* own predetermined form. Work for variety, sequence with unity which makes the smallest part integrate with the whole all-over conception, so that no part can be taken away without destroying the completeness. You may find a warming-up session with brush and ink on old newspapers will prepare you for a try at a free, serious session of gesture painting. Curved forms, vertical and horizontal contrasts, combinations of both, the placing on the paper, the space suggested by overlapping of forms, edges soft and hard, textures, repetitions — these are some of the elements that will determine if your work holds together when it finishes itself, for this is what such a painting does. It will tell you when to stop.

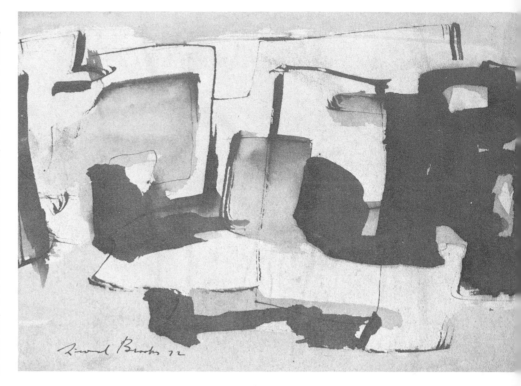

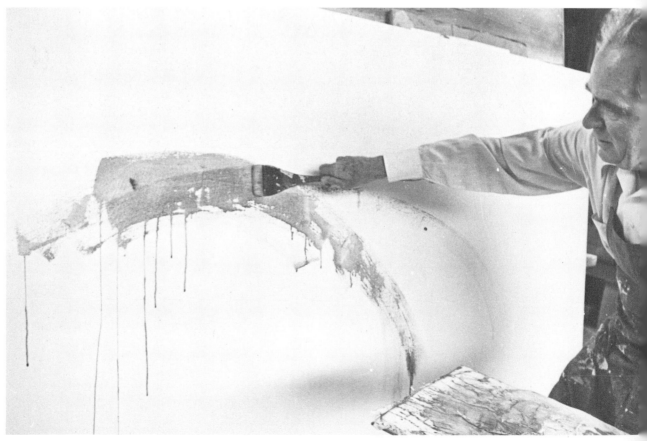

Photo of author painting.

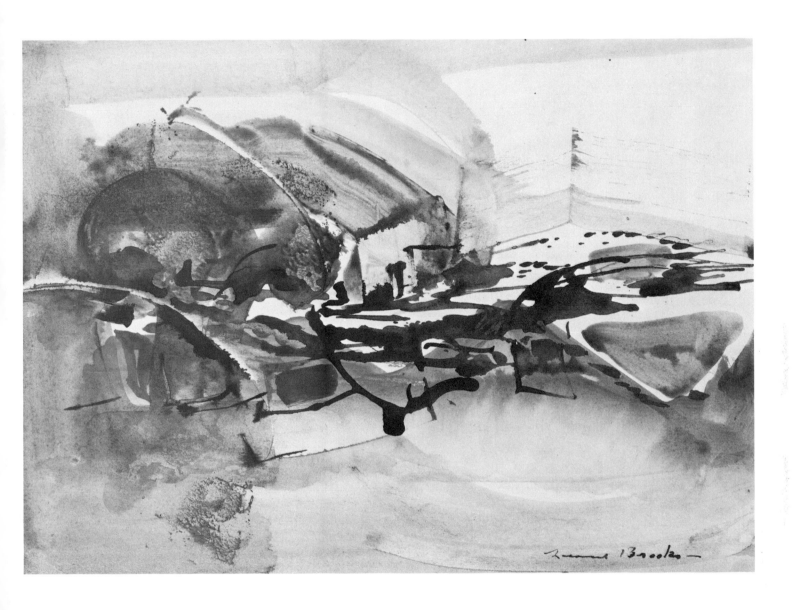

Brush and pen

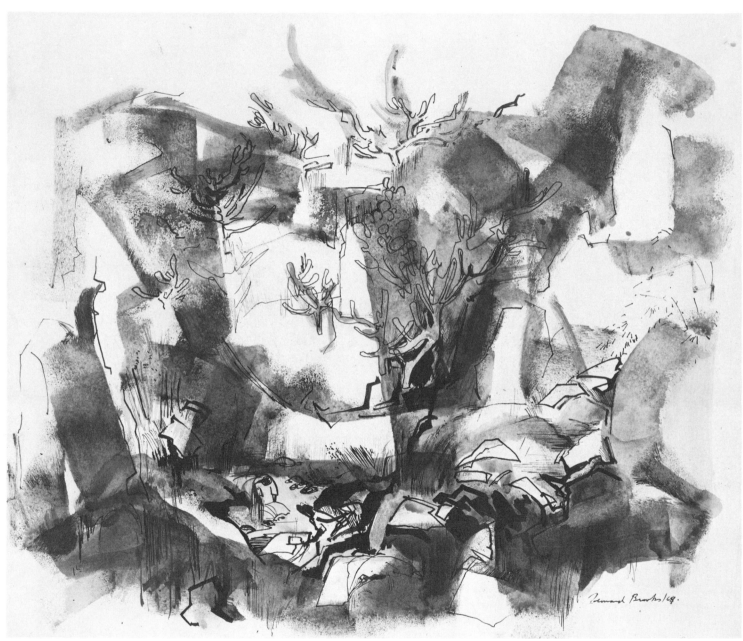

CACTUS GORGE

TOOLS

Here is a list of a series of unorthodox tools, some of them known, some unusual, with which you can experiment. It is important not to just use them as "tricks" or formulate them into a style of work that is dependent on their use alone. They will not suddenly improve your work or become shortcuts to standard techniques, but they can suggest new ways of working or be used in a combined technique to give variety to the media you are using.

I list them here and illustrate some examples from sketches I have done where they have proven valuable for my work. A morning or two of experimenting with them, using different textured papers, inks, watercolors and acrylics will show you their possibilities, and whether or not they can be of value to you.

SPATULAS — steel scrapers or rubber on sticks. An ordinary kitchen plate cleaner is used here.

FLEXIBLE STEEL KNIFE — professional painting knives of varied shapes.

SPONGES, TISSUES AND RAGS — useful for swabbing out washes, dabbing on textures, etc.

PIPE CLEANERS — make an interesting, broken line, good for dry-brush effects.

BAMBOO STICKS or end of brush (pointed and trimmed with a knife) — scratchings and drawings of a loose kind.

ROLLERS — Small and large, plastic rollers, soft and hard varieties can be most valuable in working with acrylics. (Be sure to wash them immediately after use.)

TURKEY QUILLS — Cut and trimmed for a classic "old master" type of line and wash drawing.

THE STEEL BRUSH — A new tool useful to the sketcher is the steel brush made by the Speedball Company. It consists of different widths of flexible steel pen-nibs which can be used to make thin or heavy strokes of ink or wash. Some practice is needed to realize its possibilities, but it can be a useful addition to the painter's tools.

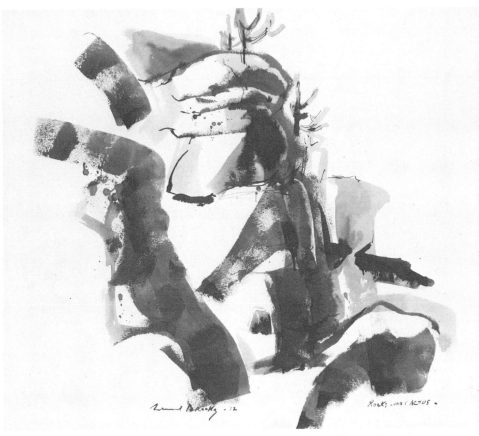

ROCK AND CACTUS / A plastic sponge roller was used to paint the broad textured strokes. Over this, on soft Japanese Sumi paper, direct notations from landscape subjects were made with a pointed brush and diluted black ink. No erasures or scrapings can be made on this delicate surface and the brush strokes must be put down in a direct, crisp manner with a freedom of execution and transparency. Preserve the white paper where possible and put down only the selection of a few gray and clean lively black accents to suggest the subject. A morning's sketching should produce four or five papers, after scrapping several that didn't come off, and saving the best results.

The Brush Pen. A steel pen nib is available from Speedball Pens and adds another useful tool to your equipment. With it, it is possible to make a fine or broad line or dry-brush effects, most useful for sketching. Use it in combination with watercolors or acrylics.

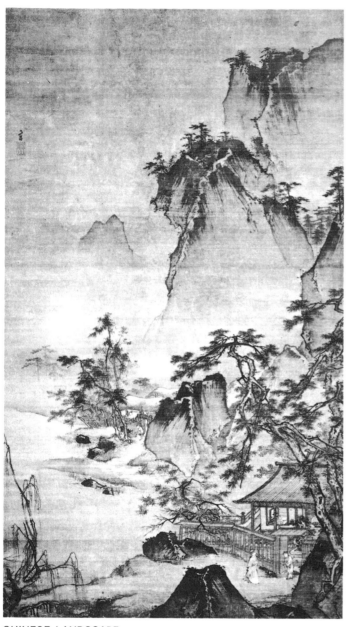

CHINESE LANDSCAPE

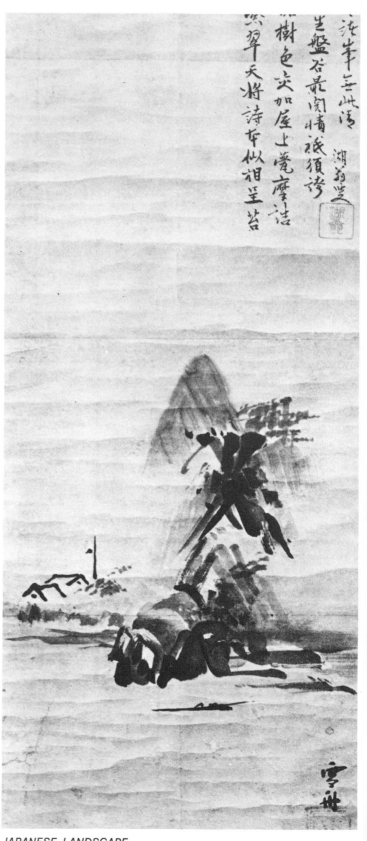

JAPANESE LANDSCAPE

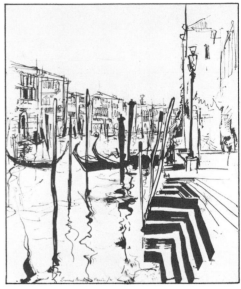

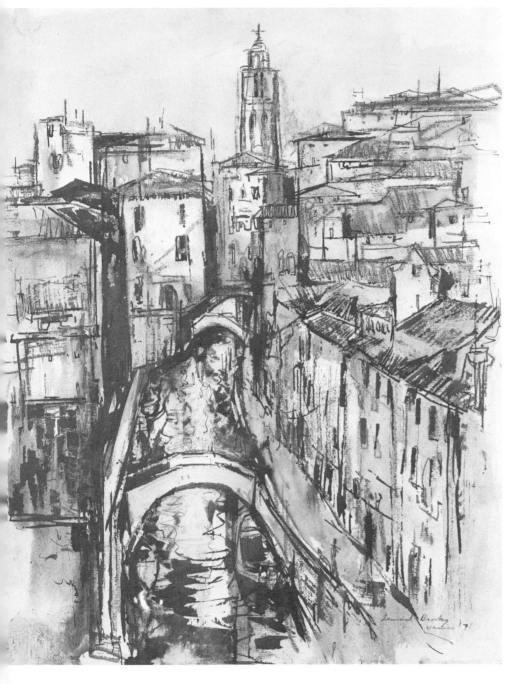

The classical crow-quill and brown or sepia-ink drawings of early artists are well worth studying. Study too the Chinese and Japanese Sumi paintings and reproductions. Quill pens can easily be made by slicing an angled, sharp pen-point from any large crow or turkey quill. Interesting lines can also be made by using pipe cleaners or bamboo-sticks. Even the end of a sharpened brush can be utilized. Shown here are a number of techniques that employ wash and watercolor or inks with varied line-making tools.

THE MANY WAYS OF
Water and color

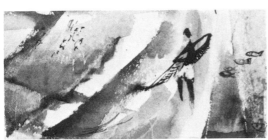

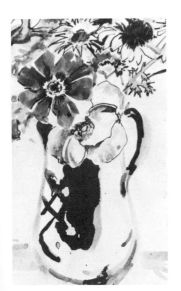

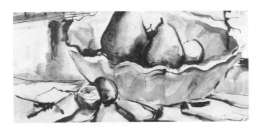

■ Loosely painted, tightly brushed; running pools of transparent washes or brush strokes carefully built up in a mesh of delicate strokes; traditional watercolor or modern acrylics, countless ways of mixed media using chalks, wax resists, collage and impastoed underpainting pastes; all of these are being used today in exciting new ways which have opened up fresh paths of creative painting. Figurative or abstract, or combinations of both kinds of subject matter are equally at home with these new techniques and today watercolor has expanded its bounds immeasurably. Size has no limitation and the boundaries of watercolor papers for watercolor media are banished. Water-based acrylics may be painted on formats of canvas or other grounds at mural size. Sprays and rollers on vast surfaces of unprepared duck cotton or on acrylic gessoed boards are commonplace, and these are, in essence, enlarged watercolors. Immense "color fields" are projected without thought of size limitation by contemporary painters in water paints. The division between the painter in oils, traditionally considered the more "serious" painter, with that of the watercolorist, has ben erased and many of our contemporary top artists have deserted the oil medium for that of the acrylic technique.

Such freedoms have their dangers, and purists of the old school have not been reconciled to the lack of boundaries and limitations that once defined this special art form and technique. There was a nice, safe feeling about working within the rigid rules of academic strictures. For the traditional watercolorist there was an exhilarating challenge in bringing off a brilliant work against the tight rulings of what did and did not make an acceptable watercolor in a watercolor exhibition.

With the event of casein paints and the later acrylics, the question of what was to be considered a watercolor or not became a much debated matter, and in some places still is. Collage, papers tinted with color, opaque and transparent acrylic, a fifteen-foot acrylic wash study on canvas ground — were these to be considered watercolors?

These questions aside, the artist today has many more choices open to him in his selection of water-based painting. Unorthodox and new ways are rapidly becoming standardized into what will become, before long, traditional techniques. There is a healthy interest once again in what has been done in the past as well as the innovations of today, and the younger student and artist is wisely putting it all together to find what is necessary to him and the projection of his ideas and the expressions needful for his times.

THE HAPPY ACCIDENT

■ "Find out what watercolor wants to do and half the battle is over," one of my first art teachers told me. "Let the accidental qualities have their play and anything can happen," said another, with which, looking at my first efforts with dismay, I heartily agreed. But how accidental is "accidental" and when does it happen? How are we to know if it is a "happy" one or not?

These questions often puzzled me. I finally realized that *after* we have experimented with the many ways of watercolor and have learned some control of techniques, we are able to concentrate on letting watercolor take us over, even let-

ting it run away with us as we concentrate on the more important matters of what we are trying to communicate in our painting. Splashes, fortuitous admixtures of two or three colors running together, loose washes running amuck, loose brush-strokes and mottlings of pigments — all of these will then seem to work for us. If the message is strong enough, the technical facilities will seem to fall into the right place — almost like fortuitous accidents — but not quite.

When I used to give watercolor demonstrations in front of a group of students, I always said a prayer before beginning, for I knew that no matter how skilled my brush, there would be times when everything would seem to go wrong, until I let the watercolor have *its* way; then I was all set and could generally pull a badly messed-up passage out of the soup. As long as there was some white paper left and clean water available, there was always hope. Perhaps a too-dark, muddy area could be washed out with a sponge and repainted, here a texture could be scraped with a razor blade; that sour orange accent could be lightened with water, an overworked section touched with a free brushwork. All of these things of a remedial nature were *not* accidental, but the result of previous experiments. Even the final moment when I would take a brush and casually flick a hundred dots over the foreground for textural interest might have appeared very accidental, but it had premeditated controls built in as trained as the wrist of a violinist playing with staccato bowing. Some of the truly accidental qualities of watercolor may be of value when we are aware of

what they are and when they happen. The dispersal of thick pigment or ink in water, spotting a texture of two-color mixture, the marks of loose brushing and dry-brush work — these accidental surfaces can be exploited at will — we have demonstrated some of their possibilities in a number of exercises in this book. Generally it is the combination of all these qualities which are inherent in the watercolor medium that adds up to a final lively statement of what we think of as a fine and fulfilled watercolor.

In watercolor there is not the possibility of covering or patching up that we have in the opaque mediums. The first pencil touch of drawing-in, the lightest wash first applied, the layers of pigment over others — all of these are revealed and shown after the last touch of finishing. The painting must be visualized in our mind more or less as we wish it to be when finished, right from the start. A fine watercolor looks good even when it is half-finished. Nothing is concealed, the artist's intention is evident from his first stroke. Many of the best Cezanne watercolors show in their tentative, unfinished state the delightful suggestion of space, structure and color notation — the hand of the master watercolorist. The experienced painter in watercolors sees his subject as a watercolor, projecting it in his mind's eye before he touches his brush or colors. He knows what watercolor wants to do and he has no need of using stylistic tricks or formulae when he starts to work. The painting itself demands its own fulfillment, the limitations of the watercolor itself brings about its own suitable techniques.

REMBRANDT / *VIEW OF LONDON*

CLAUDE LORRAIN / *LE TIBRE EN AMONT DE ROME*

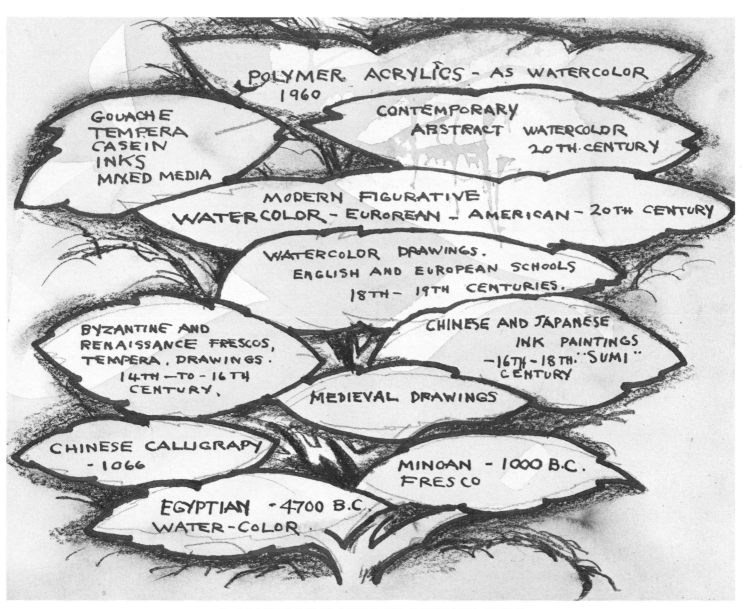

A BACKGROUND TREE OF AQUEOUS MEDIA

■ The amateur or beginning student does not always see the tremendous possibilities for exciting painting using some of the traditional, one-color, simple, tonal techniques that I outline in this book. The unlimited palette of dozens of bright colors seems much more attractive, holding many more possibilities, but it is the wise and sophisticated painter who is able to do wonders with more selective and at times, sparse material.

The Oriental masters, using black and white wash alone, with occasionally a touch of one color for an accent, preparing their fine inks by a fresh grinding from an ink stick with water; the Old Master, selecting his finest Sepia brown, made from the juice of the squid, or the 14th Century artist using his beloved Bistre — all of these seemingly limited, traditional means produced some of the finest art of the ages.

The Egyptians used pigments bound in gum and water on papyrus, as well as a beeswax and pigment encaustic. Medieval illuminated manuscripts followed. Watercolor as we know it today developed out of the tinted and washed drawings made by the artists in various mediums from the 15th to 17th Centuries, where pen and ink, brush and mostly brown tints were used, such as those of Rembrandt and Claude Lorrain.

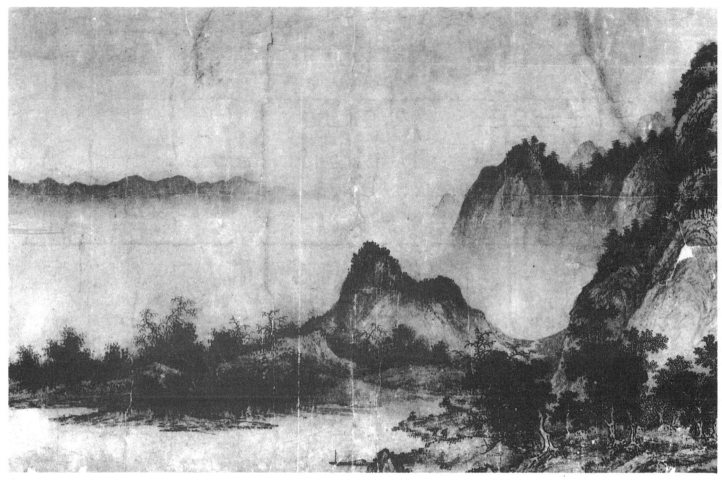

CHINESE LANDSCAPE

EDWARD DAYES (1763-1804) / GREENWICH HOSPITAL

■ The greatest masters of the brush and wash were, of course, the Chinese, who were painting masterpieces centuries ago that look as modern as our finest watercolors today. The background and history of the Chinese and Japanese artist and his art is a fascinating story that every painter should explore and study if he is to understand how greatness can be achieved with simple means. There are many excellent books — for instance read the *Mustard Seed Garden.* A study of the early classical schools as well as the more modern uses of Sumi will be a good start. If you find that these early watercolor techniques fascinate you, it is easy to acquire a few Chinese brushes, an ink stick to grind your own ink on a rough saucer, and a packet of fragile, beautiful painting paper that has its special surface for performing the set strokes and shadings in the direct, deft brushwork of the Sumi painter. If you are lucky enough to have an Oriental master to instruct you, the full wonder of the art will soon be apparent. With time and luck you may come near the glow of inner spirit or

achieve the sense of poetic feeling that he will tell you all artists must have and cultivate before their work will begin to come alive, no matter what hours are spent in technical manipulation.

When you go on to try some of the later watercolor ways, your thinking will change to that of the more scientific matters of the 15th Century artists who had discovered the joys of perspective, the rendering of tone (chiaroscuro), to show volume and depth, or perhaps the excitements of depicting light and shade in the romantic manner of the 18th Century wash drawings of forests and panoramas. Sepia washes over line drawings, or brown inks diluted with water will give your drawings an "old master" look and at the same time provide you with a unity and quality that may surprise you. Try some of these sketches of flowers, landscapes or figures on tinted papers and you will feel some of the pleasure that Edward Lear, Ruskin and other inveterate, enthusiastic Victorians felt when they did the journeys abroad in search of beautiful views and sites to catch in their

sketch books.

Having worked in some of these ways you will soon sense the difference between a watercolor *drawing* and what we think of as a *watercolor.* Turner's work will illustrate for you clearly how the watercolorist emerged in the 19th Century from tightly outlined and drawn semi-architectural studies with pale washes of color over them, to rich, strong washes of pigment, or in some cases hazy, fused atmospheric effects in which line was secondary.

You also will have found, after some experimenting with one-tone or one-color wash, that it has a fascination of its own. It is a medium that has its own charms and creative powers. It will not always be necessary to paint with dozens of colors on the palette. A tube of sepia, lampblack, a bottle of dark brown ink (I like to mix my own tint with black and brown together) or try tonal painting with Sumi ink. This will afford you much pleasure as well as train you in the basics of brushwork for colored, full-fledged watercolor painting later.

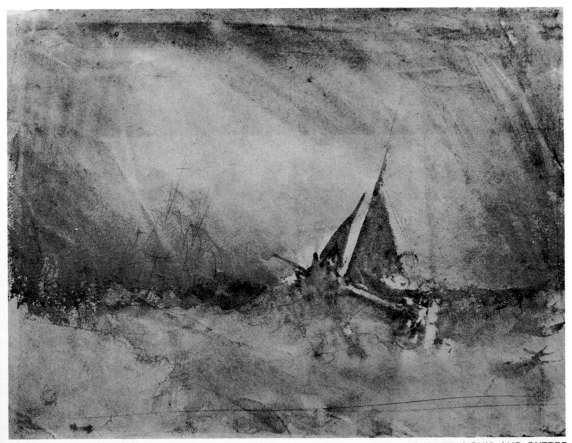

TURNER / *SHIP AND CUTTER*

Winds and windmills

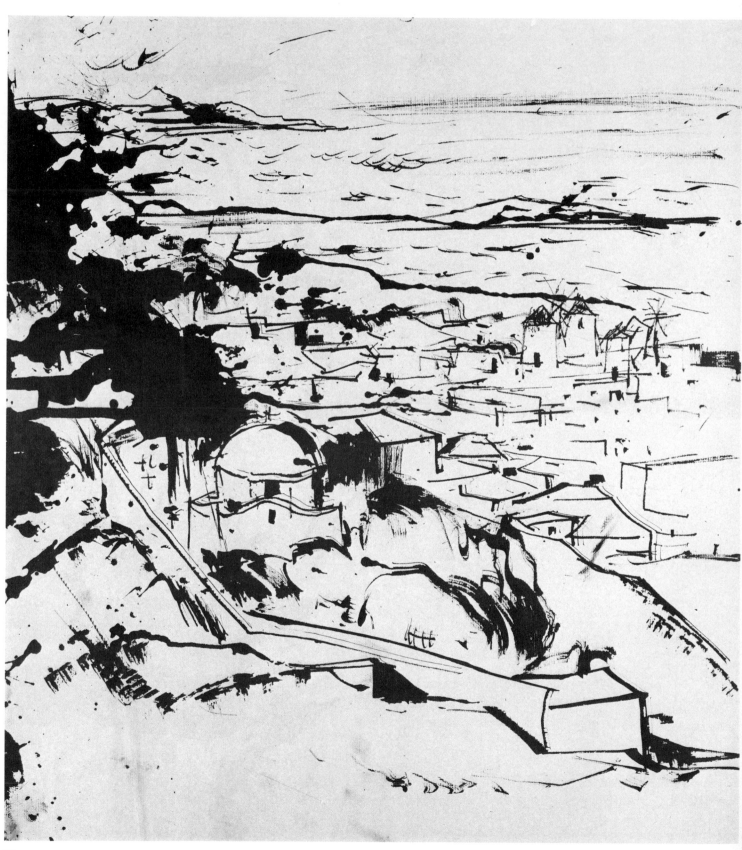

All landscape painters have had their share of battles with the elements. Rain, changing skies, cold or scorching sun, and the wind. In my early days I did penance in the snow, even to the point of freezing my big toe solid one Canadian winter day when I was carried away with doing an oil sketch, working with my hands encased in thick, woolen mitts with my brush thrust through the wool into my numbed fingers.

My last encounter with the wind was not with the frosty northern variety. It swept out of the ancient skies of Mykonos, churning the rich, blue Aegean Sea into high waves and smote me suddenly when I was making a brush and ink study on the roof of the Beaux Artes studio building in that magic, white town. Suddenly I was asprawl, my paper torn from its board, the bottle of ink dumped across my sketch that I was just finishing. When I picked myself up and ran for the paper sailing through the air I expected my sketch to be ruined. I shook the ink off my black-stained hands and bespattered clothes and beat a retreat from the roof, getting inside with my things and retrieved ink drawing.

Below in my studio I had a pleasant surprise. The wind had hurled the ink across my page with such variety and force that Nature had inadvertently helped me with the finishing touches. The sketch *did* look and felt windblown, spattered and alive — that was what I had been after. I changed a few accents of the still-wet ink with a smudge or two, and left it intact as it was. I reproduce it here at left, and you can see how it does have a rough vitality of its own.

Later that day when the wind had abated I ventured onto the roof again and tried a color note of the vista streching across the white windmills to the far mountains. This time I sought a less vulnerable corner of the roof-top.

The Mykonos wind sets the mood for a spot sketch made in watercolor.

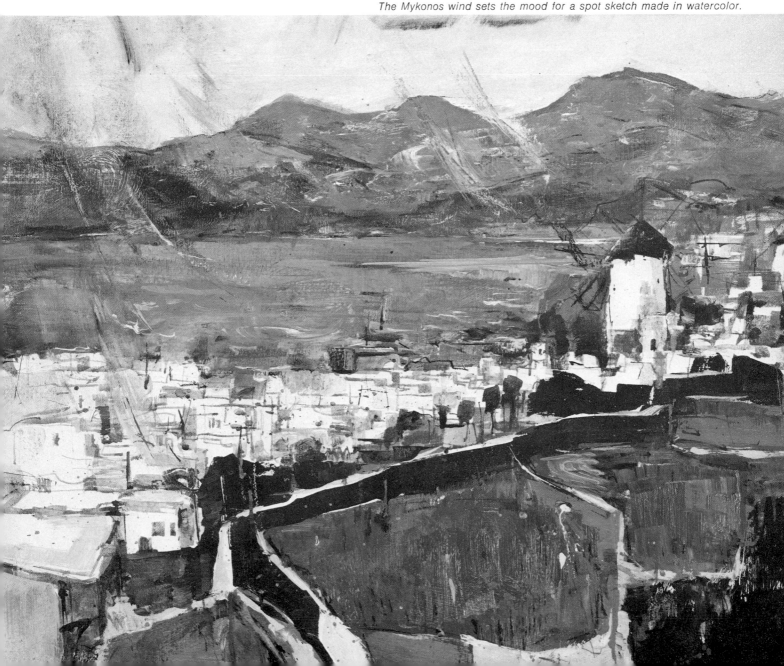

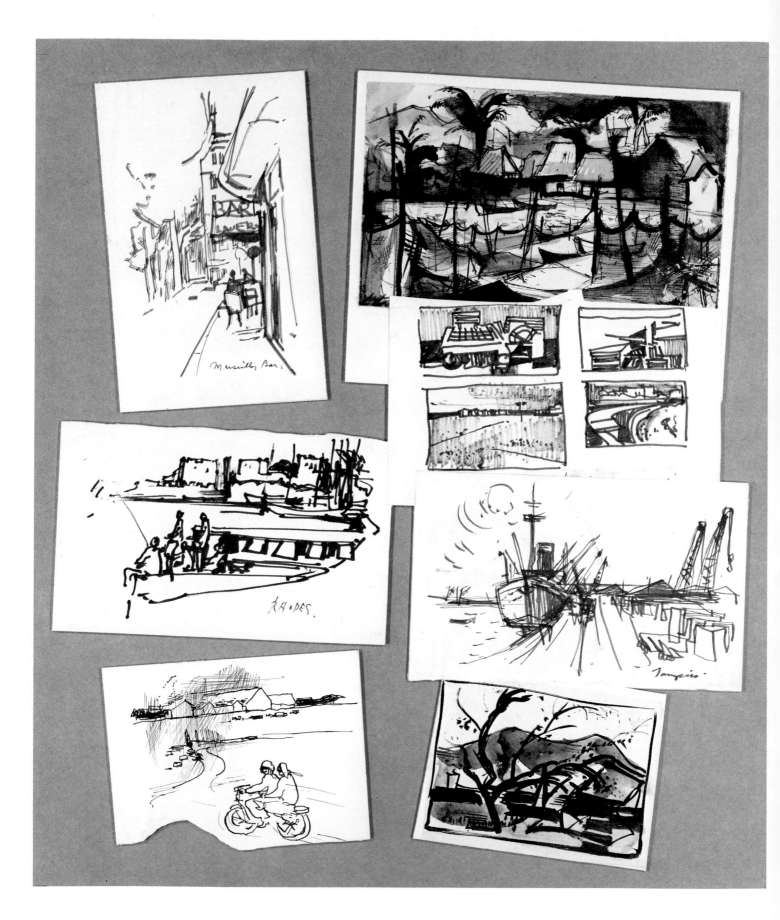

■ Some pages from a travelling sketch book demonstrate how I collect material and notes for later work in the studio. These are distilled, tucked away in my memory, and later are combined to create a more meaningful statement than that possible to gather on the spot. Collages, large acrylics or watercolors can be developed in the comfort of the studio from this material, even years later. The very fact of having done them fixes color and form of a particular place firmly in the storehouse of sensations from which we derive inspiration for new work.

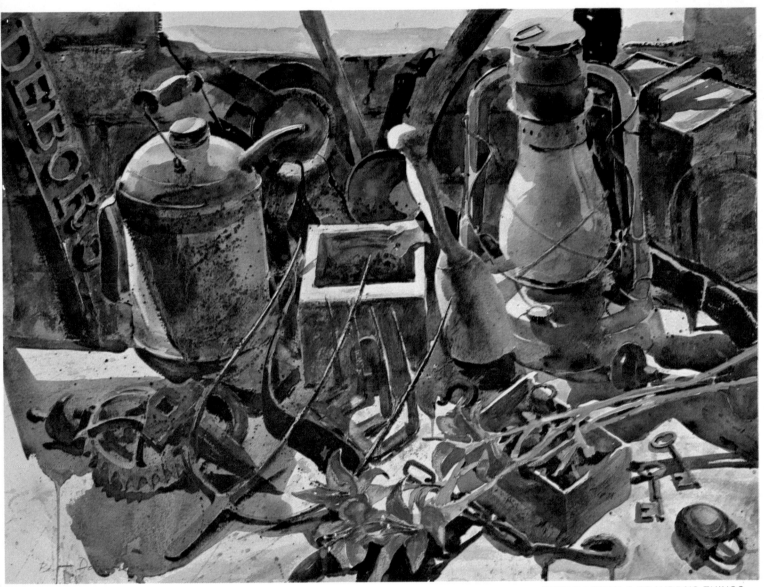

Experimentation with arrangements of still life objects can provide endless subject possibilities.

BERT DODSON / *GRANDPA'S THINGS*

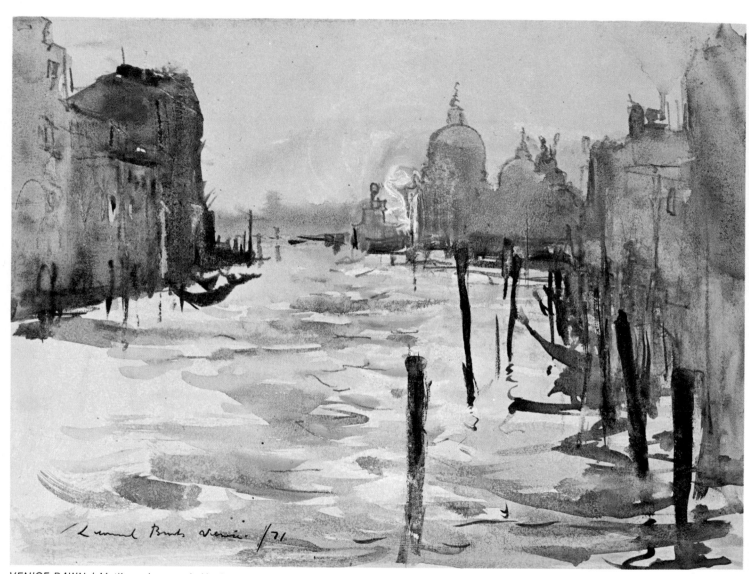

VENICE DAWN / Motif number one in Venice
was painted on the spot at sunrise. Done on
a cream-tinted Strathmore paper with some
touches of opaque white added to the
watercolor.

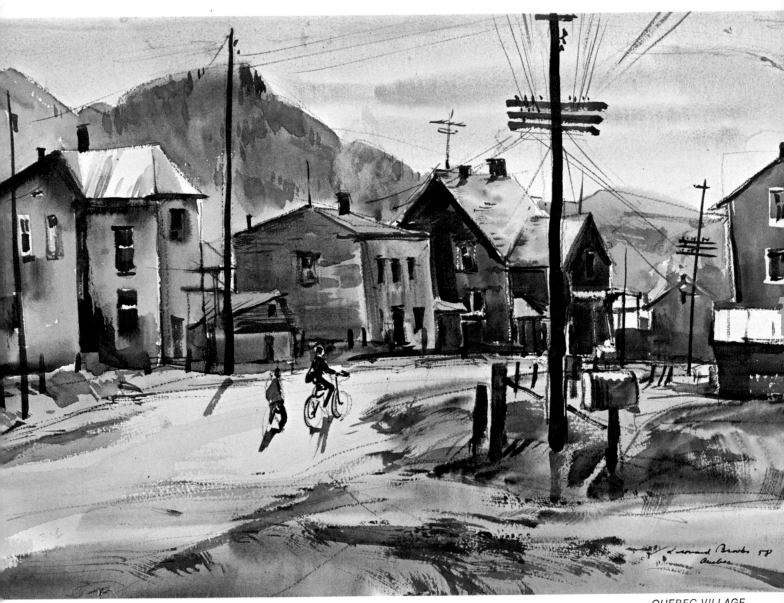

QUEBEC VILLAGE

■ The cold clear air of a spring morning in a small Quebec village. The sun is directly overhead, the light bleached and high-keyed, the shadows harshly defined, not a typical watercolor subject but worth a try. Here are some of the traditional devices we have experimented with in the previous exercises. This was done on a water color pad of medium smooth paper. Frankly illustrative, it tries to make a summation of many details in direct washes with no fussing or overworking. The clouds, road, light roof tops and houses are brushed in with a light warm wash to begin with. As these dried the medium tones are worked on, gradually building up to the darkest darks. Details of posts, wires, post-box are put in at the last. Overhead lighting is kept consistent and the figures of the two boys added at the last moment. Some dragged strokes of dry brush are used in the grasses and middle distance. The changing light and mood made fast work a necessity. This sketch was completed in less than an hour.

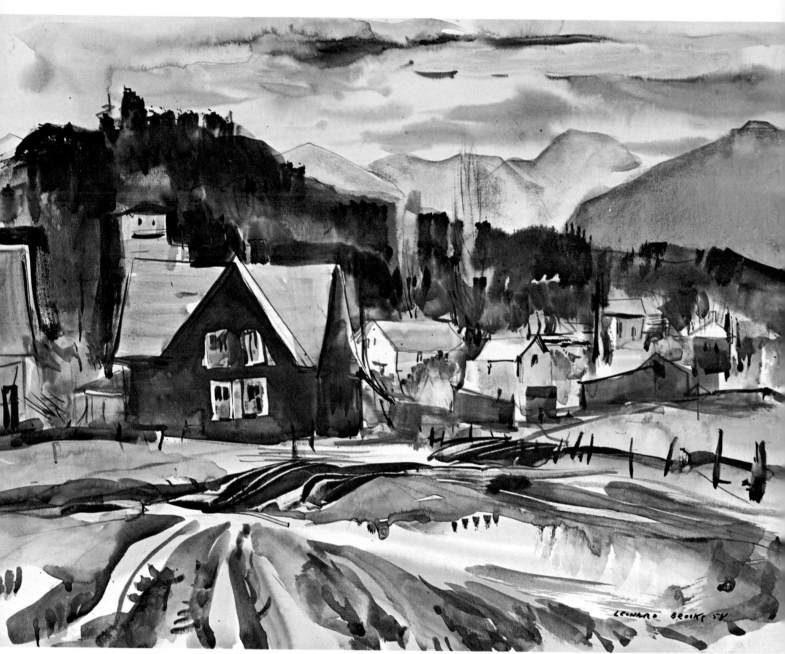

Direct watercolor sketch using strong,
contrasting tones from white paper to darkest,
rich, transparent darks possible.

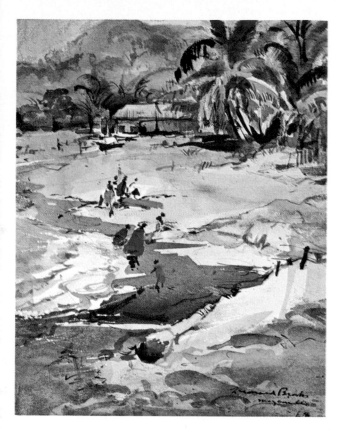

TROPIC BEACH / A small (6″ x 7½″) water-color made with a miniature sketching box with a detailed technique on smooth paper.

QUEBEC SPRING / A 14″ x 20″ sketch made in a spring drizzle on the spot. No trouble about keeping the paper wet here! Color runs and stays wet with soft edges helping the feeling of the day's mood. A few touches of accent are put in with small brush and razor blade scratches when the paper dries.

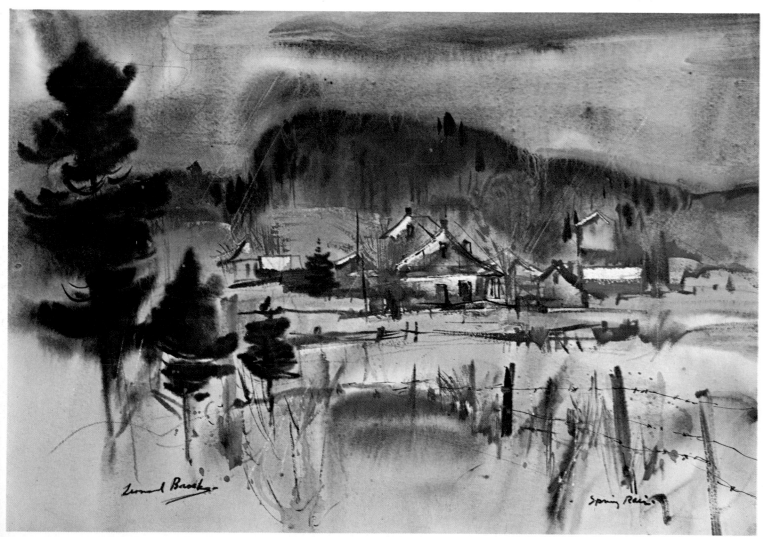

Paper demonstration

■ The paper you use determines the texture and quality of color. The color itself will be changed by off-white and tinted papers. Some colors, even from the same tube, will look differently, lighter or darker on various papers as shown in the color strip.

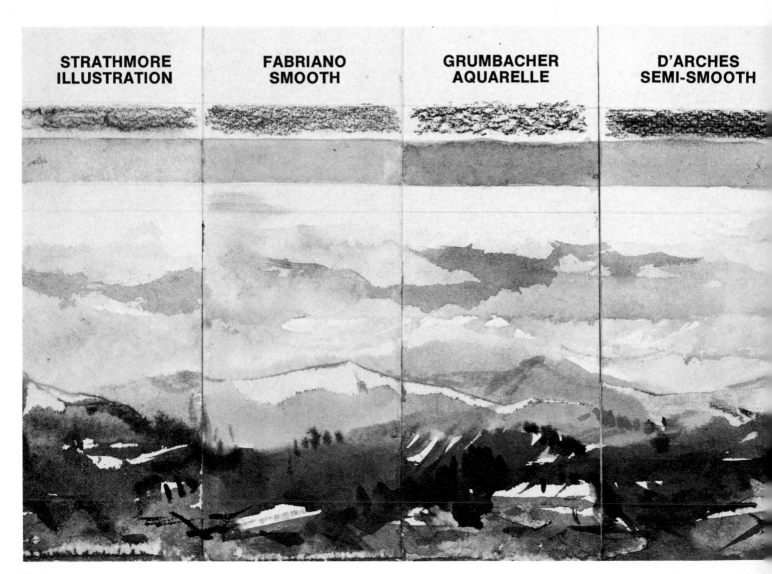

STRATHMORE ILLUSTRATION FABRIANO SMOOTH GRUMBACHER AQUARELLE D'ARCHES SEMI-SMOOTH

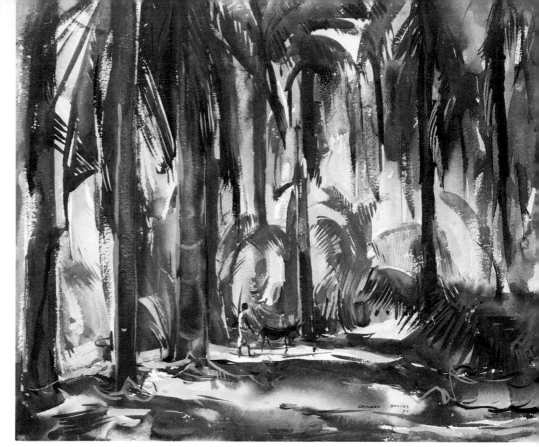

Palm Jungle

■ This is the kind of full page "one-go" watercolor that demands plenty of traditional skills. Bold direct brush work, a bravura handling of color and wash gives a freshness and transparency of color over the brilliant white D'Arches rough paper. Such a sketch is exciting to do and sometimes comes off satisfactorily. Often, however, it can lead to nothing more than a display of skilful brush-wielding and virtuosity, an example of nervous energy sporting itself with verve and often joy. Whether this adds up occasionally to doing work that may be called art is another question. Certainly, it is not easy to do, and it is not without reason that watercolor is referred to as "the Master's medium" when done at its best.

PALM JUNGLE

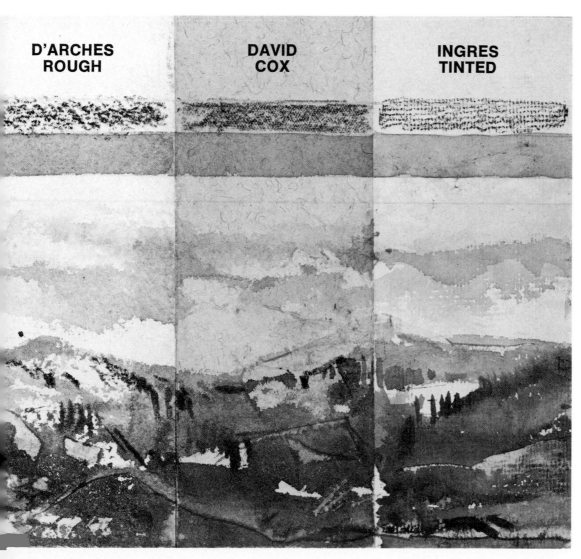

D'ARCHES ROUGH

DAVID COX

INGRES TINTED

The Little Park

■ Here is an exploratory, demonstration sketch made to indicate some of the useful techniques most valuable in doing a rapid transcript from nature in watercolor. I have purposely chosen a complicated and difficult subject that will lend itself to some technical manipulations for practice. A green, sunlit interior woods, flickering with a thousand lights and shadows on foliage, reflections, shadowed pathway; let us study it well before we begin to paint it.

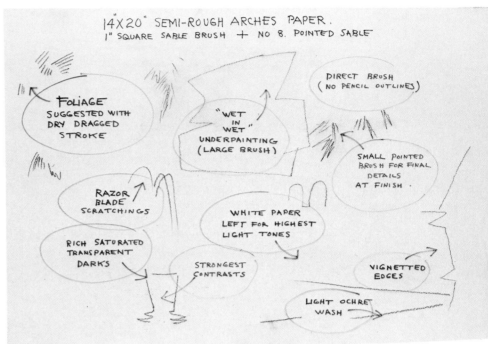

14"X20" SEMI-ROUGH ARCHES PAPER.
1" SQUARE SABLE BRUSH + NO 8. POINTED SABLE

DIRECT BRUSH (NO PENCIL OUTLINES)

FOLIAGE SUGGESTED WITH DRY DRAGGED STROKE

"WET IN WET" UNDERPAINTING (LARGE BRUSH)

SMALL POINTED BRUSH FOR FINAL DETAILS AT FINISH.

RAZOR BLADE SCRATCHINGS

WHITE PAPER LEFT FOR HIGHEST LIGHT TONES

RICH SATURATED TRANSPARENT DARKS

STRONGEST CONTRASTS

VIGNETTED EDGES

LIGHT OCHRE WASH

Some of the techniques used in doing the LITTLE PARK (at right) from nature.

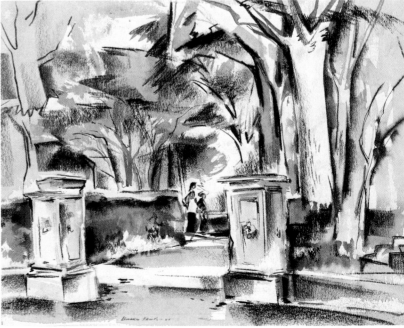

A page of quick notes to study tree forms and the structural base for composing the sketch LITTLE PARK.

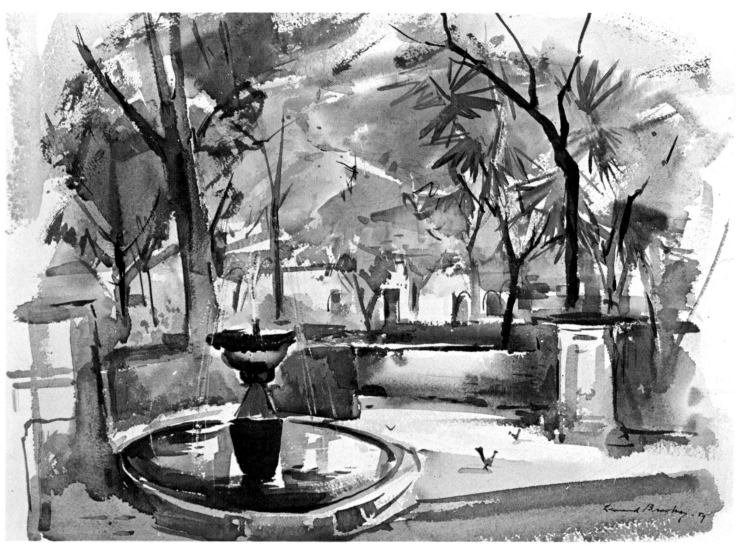

THE LITTLE PARK

Here the art of suggestion will be necessary. How can we suggest those myriad leaves with a few brush strokes, how to make a strong statement of light and dark contrasts to suggest sunlight, how to catch some of the mood and feeling of this pleasant place? If you really sense the moment and then let some of it come out of the end of your brush, you will be participating in what the Japanese artists call "Katsuboku"— bringing life to the ink. Reaching for the essence of your subject, bringing it alive with the sensitive variation of your brush and hand is what will redeem your work. Awareness, the silent prayer, the hopeful striving to do your best. When you do succeed with a sensitive interpretation, your painting will impart some of your intensity and reveal itself beyond its technical proficiency.

The controlled brush

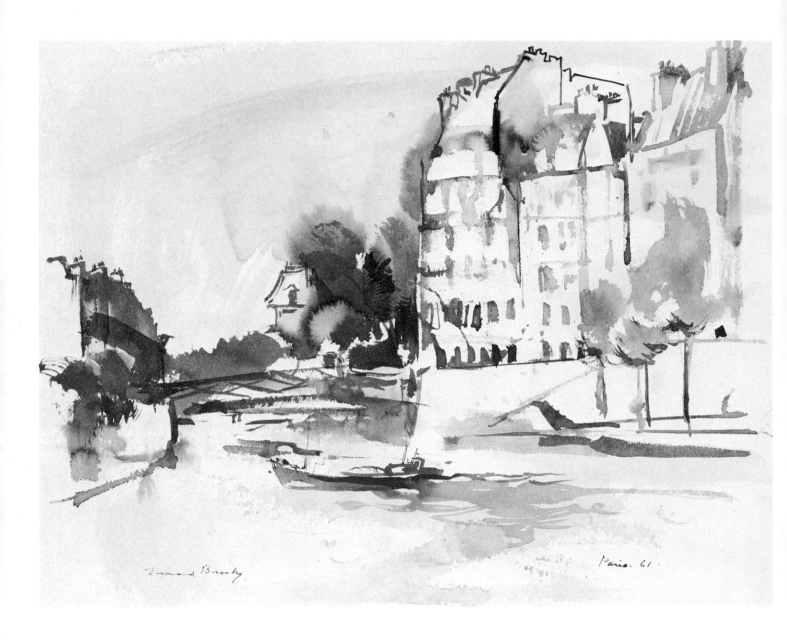

The mood changes. Today we are different people. No splashing of paint and free brush strokes for us now. It is a day for precise, careful painting. We feel the need to escape the bravado of gesture-making. Only the calm, neatly exact building-up of a painting inspires us. Let us be safe and secure with our controlled manipulations, knowing where we are going, snugly sure of ourselves and what is going to happen to our painting if we plug away at it industriously. No chance of it getting out of hand with the approach we are going to use this time. No risks or surprises. We know what we want and how we are going to accomplish it. Thus we talk to ourselves when we come into the studio, preparing ourselves for another day of effort.

A small painting will be best. We visualize its compact size, its satisfactory, ingratiating finish handled with all the dexterity we can summon up. How beautiful it will look matted and framed exquisitely with a gold edge! We can't wait to select our theme, preferably taken from a note or sketch already roughed out. No accidental qualities are going to intrude on this new work!

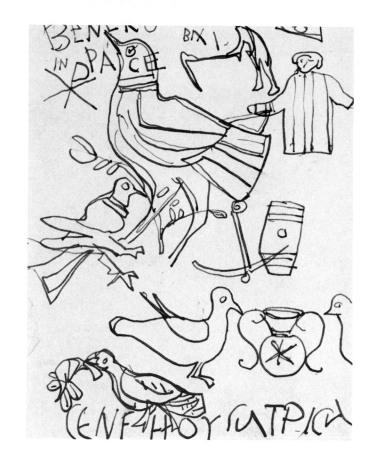

We thumb through our sketchbooks until an idea strikes us. What is this? These drawings I made in Rome from the carved, incised stones of early Christian tombstones. Birds, figures, ancient markings. I remember how they intrigued me at the time and how I had promised myself to put them into a painting some day. Subtle grays and ochres, delicate, faded surfaces. And those touches of brilliant mosaic nearby in the ancient church wall! Here was material that could be put together with love and care — a souvenir of Rome, when the time came, and that time was now, this morning. Small brushes, watercolor, a fine piece of Japanese paper, semi-smooth that takes washes beautifuly and allows fine brushwork over the wash; a pencil for light drawing in, plenty of clean water; we are ready to paint.

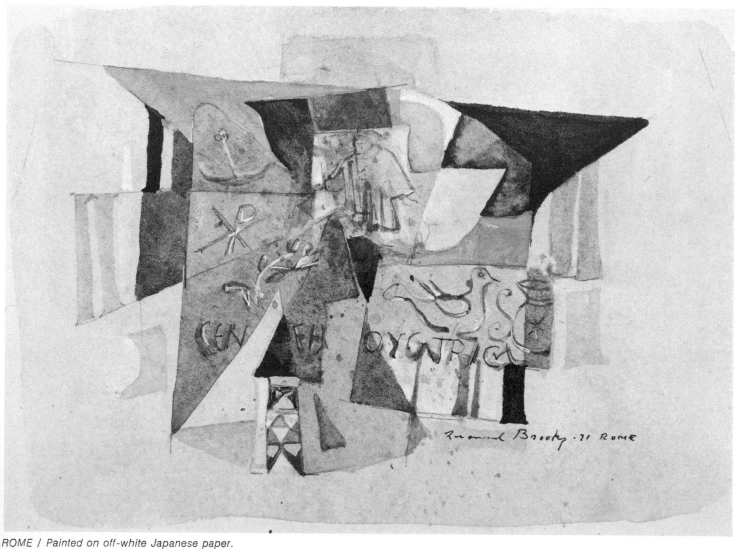

ROME / Painted on off-white Japanese paper.

So the pleasant morning goes by, working with precision and care to copy the drawings from the sketchbook, developing the small watercolor until it seems to have caught for me some of the idea I was trying to express. In the past I have always found it valuable, if not essential in my personal work to have something to begin with, an idea, a sketch or note such as my "Rome" drawings. This does not apply to everyone, and perhaps you will not need such derivations from nature's infinite and multiple sources. Later in this book we will explore further the problems of abstraction versus figurative work.

Precise brushwork and formal handling take over from accidental, loose technique.

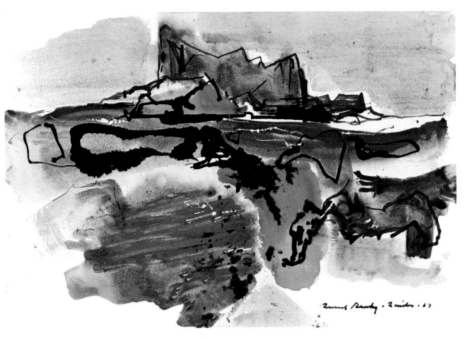

Loose washes and marking pens for rapid execution of this sketch of a rocky shoreline in Crete.

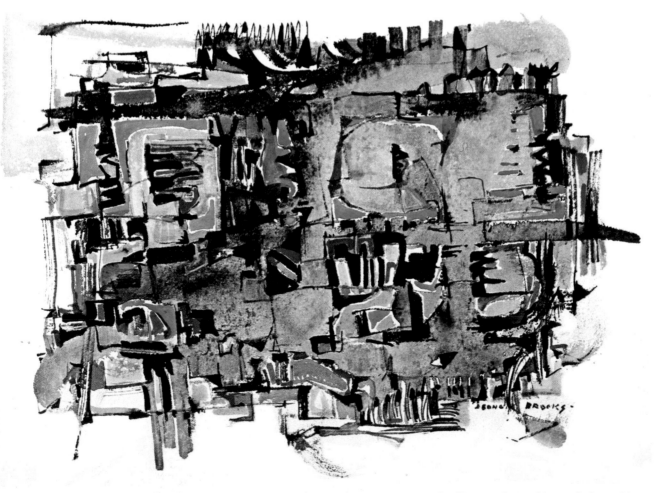

A complicated pattern is taken from a mountain village and stated in semi-abstract terms.

Salvaging old sketches and water colors

■ There is a gold mine of material await-
ing you in that old bundle of early
sketches and failures you have undoubt-
edly stored away somewhere. These can
be utilized in a new and interesting way
if you have the courage to tear them up
into pieces and to start all over again.
Recently I junked a group of Japanese
paper sketches as well as some heavy
weight water color paper on which the
colors had gone berserk in the past. The
recycling of these bits of tinted papers,
some in black or brown, some in color
provided an interesting experiment when
they were reassembled as a collage base
for new watercolor and acrylic paintings.
Shapes and textures were shifted around
until they formed a composition based
on the memories of Roman ruins. These
were pasted down with acrylic glue and
the washes and lines were then super-
imposed. Some of the bits of paper I
used *were* torn up sketches of ruins made
in Rome so there was an authenticity of
texture and color in the final sketch.

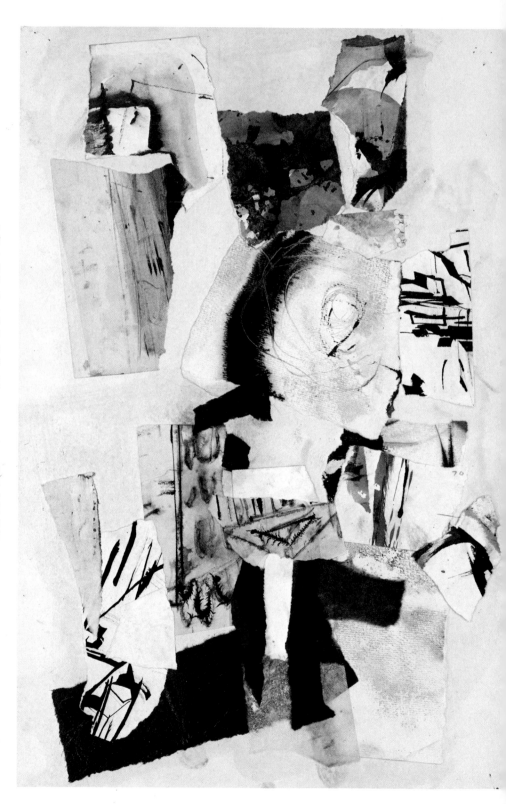

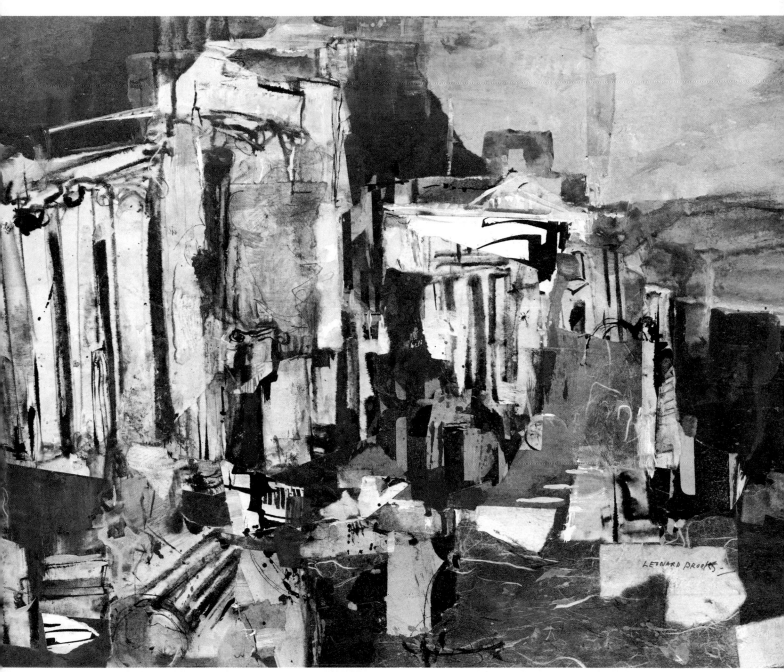

*Rejected watercolors and wash drawings are
cut up and torn to shapes to be assembled in
new form into new paintings.*

Painting with acrylics

The use of acrylic paints today by amateur and professional artists is taken for granted, but it is only a matter of at the most twenty years since the acrylics became commercially available to the artists. Thanks to the industrial search for improved paints to be used in domestic life, for cars, furniture, interior and exterior protection, the scientific development in the chemical laboratories found synthetic resins and emulsions that would be compatible with organic and inorganic colored pigments. Mixed together they became permanent and insoluble paints, drying rapidly, easily diluted in water and open to many varieties of application on most clean surfaces.

Today there are numerous books dealing with all the aspects of acrylic techniques. I have listed some in the bibliography that will give you detailed information on the chemistry and make-up of the plastic paints as used by artists as well as a number of books dealing with the purely artistic approach to their use. In this book I would like to consider its use as part of the study of aqueous media and to show some of the various ways I have found useful to me in my own work. I was fortunate in having experimented with the acrylics at their outset for the Mexican artists had already begun to use synthetic paints as early as the forties when I first went to Mexico. Orozco and

Siqueiros, Gutierrez and others were experimenting with lacquers, ducos and the first plastic paints such as Vinylite and Rhoplex emulsion. Some of these experiments ended in disaster with cracking and flaking or fading of paint. On the other hand I have just seen some work painted thirty-five years ago with this dubious material and the impasto and color of the paint is as fresh and unsullied as the day it was painted. I know, because I painted it. Traditional authorities such as Ralph Mayer may deplore the use of most of these materials, in fact some still throw doubts on the latest acrylics, feeling perhaps that we should wait a few hundred years or more to

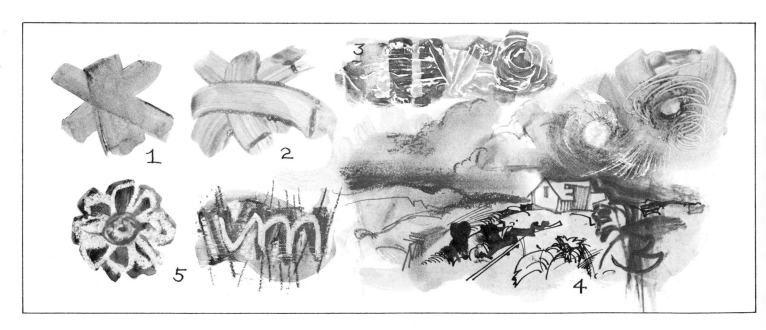

1. Acrylic washes made with acrylic pigment and water. The transparent watercolor technique may be used, but remember that acrylic fixes itself irrevocably and cannot be washed out later.

2. Adding acrylic Gel to the water gives the wash a broken texture and mottled paint stroke.

3. Modeling pastes with washes applied in transparent glazes when the paste is dry. The surface is scraped down with a razor blade to reveal the white gesso paste.

4. Acrylic washes combined with charcoal, pen and ink, brush and pen or marking pen. The combinations of technique in mixed media are infinite.

5. Wax crayon with washes over the white wax strokes.

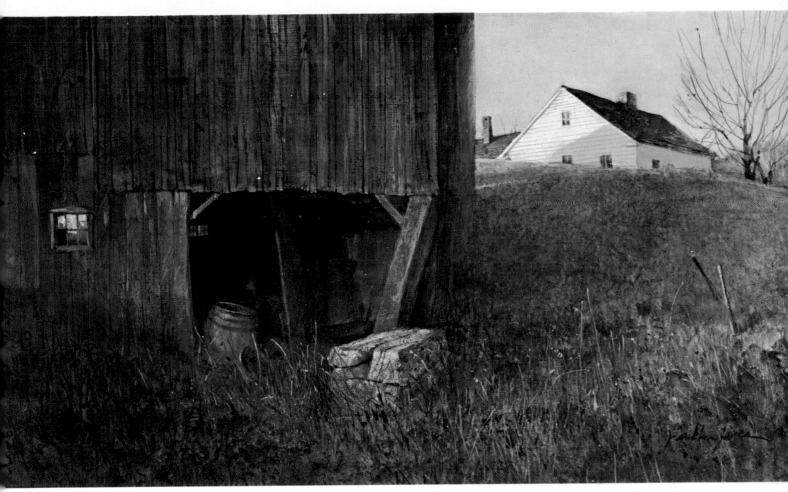

FRANKLIN JONES / *Centenarian.* *Acrylics used in a series of transparent glazes.*

really see what will happen in spite of rigid tests and practical proof of durability. They would prefer the painter to go on using the tried methods, the oil painting techniques of the masters, even though these have proven their fallibility and probably will get worse with time.

Frankly, without the adventurous and often risky experiments by the painters themselves, little progress in technical means for the artist would be made. Working for the improvement of a car surface of a most durable kind by vast corporations able to spend fortunes on research, benefits the artist who has neither the facilities nor the time to do so and still paint creatively. But the artist himself must still deal with the particular problems which are his when he faces a canvas or a mural, and someone has to try new media and the possibilities it has for the painter. If we left the development of material and techniques to the conservative minds of the traditional art chemist authority, we would have made little progress with acrylics or any other paint and would still be using only egg yolk or milk-curds to paint our pictures. Furthermore, in this age of change and modern life we need the new materials, the fast-drying paints, the vastly expanded color range of pigments, the variety of choice in mixed media to project the

new forms and feelings of a new generation and way of life. I am sure that the old masters, the early oil painters, the first artists to use ready-mixed tubes of paint instead of having to grind them by hand, would have welcomed the new materials that modern technology and know-how has made available to the contemporary artist. Beyond this, perhaps many artists today do not really care whether or not their work is so permanent that it will last forever. Let it be meaningful for his lifetime, function for a generation meaningfully, let it be appreciated and let it be disposable, if necessary. Heresy? With the millions of paintings in the world today, and the proliferation of more, good, bad and indifferent, many young painters feel this way and I must say I can hardly blame them. With the commercial promotion of quick fame, high prices and widely publicized works of art as an investment, and the lack of interest in the unpublicized more serious young artist, there is a certain amount of cynicism on the part of many a young painter when he is asked whether his paintings will "last forever" or not. It really doesn't seem to matter to him, and he couldn't care less what happens to his work a hundred years from now.

Luckily he doesn't have to worry about that too much any more. Modern technique

with acrylics seals his paint in an inert and practically permanent seal of plastic. It dries as hard as glass, yet is not brittle. It can be painted over without cracking, and the varnishes are compatible and provide a further seal. The simplest manipulations on almost any surface except an oil one ensure adhesion, and the problems of the oil painter with his vegetable oil, dangerous, yellowing varnishes, slow-drying, destructible canvas grounds and decaying canvas, are overcome and dispensed with. A minimum of technical know-how will provide permanency for his work.

If you are using acrylics for the first time you might consider some of their qualities and the many ways you can paint with them. Unlike oil paint, they have a versatility that should be understood. As the paint comes to you in tube or jar it is a thick pigment, some brands thicker than others, but all of them resembling a rich paste not unlike oil paint squeezed from the tube. This is the powdered pigment mixed with an emulsion or binder, partly water, which has in it dispersed resin similar to that in "plexiglass." The paint can be diluted with more water until it becomes quite transparent and when applied to paper or canvas appears much like ordinary watercolor. The big difference is that it sets firmly and hard when

ACROPOLIS / A large, detailed painting using collage and acrylic washes.

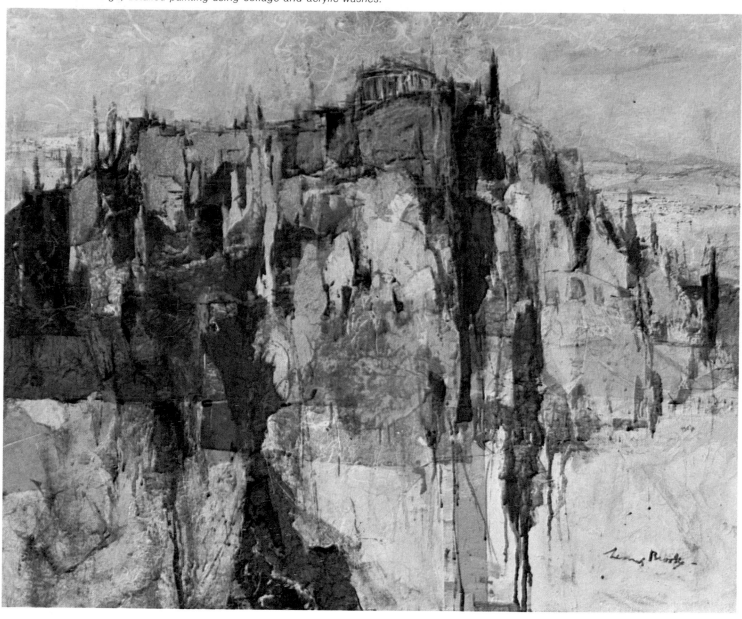

dry and cannot be washed off. If you wish to remove it, it is necessary to paint over it with white and begin again. By adding prepared, milky emulsion to this transparent dilution, it is possible to make bubbly, textured, transparent surfaces that are valuable in breaking up flat, even washes. This transparent quality is valuable in making "glazes," by putting washes of color over thicker mixtures of acrylic, or in building up layers of rich, stained-glass like effects. The underlayer does not muddy when overpainted as it would in traditional watercolor paints.

The under-layers dry rapidly. Even thick impasto, built up with modelling pastes or heavy pigment using a palette knife or spatula, will form textured surfaces for glazing after only a few hours instead of the usual long wait for an oil surface to dry.

Acrylic dries normally with an even, matte surface but a varnish emulsion can be added to it as you paint if you wish to increase the gloss of the final color, or you can spread either a matte or gloss varnish over the surface when the painting is complete.

I have used the acrylics directly out of the tube with little or no addition of water.

This technique will produce, with some differences, an effect much like standard oil-painting, although it takes getting used to if you are accustomed to using oil paints.

Let us then list some of the advantages and disadvantages of the acrylic media before we begin to use it. You will add some of your own as you find out how it suits your personal way of working. Advantages: Quick-drying. Easily washed out of the brushes with water, making for less muddied color. Add water to dilute thick paint, and to make glazes or watercolor effects. Permanence in overpainting

70

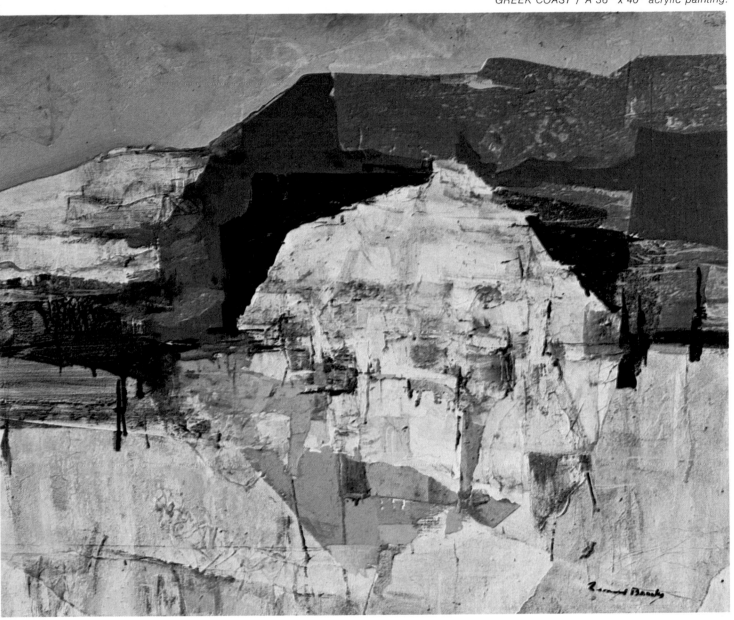

of layers because of its unique binding facility. Complete adaptability to texture-making, mixing with pastes, marble dust, sand or imbedded collage material. Ease of varnishing, control of shiny gloss or matte finish on paintings. Choice of many surfaces (except oily ones) for grounds to paint on. Vast array of new and brilliant colors now made for artists' use, giving extended palette of colors. Paper palette for mixing is easily disposed of, or with a glass palette the paint removed with a soaking in water and peeled off with a scraper.

Some disadvantages: Paint cannot be scrubbed off or removed easily as can a watercolor wash. It can appear a bit garish or hard as compared to the subtle wash of a true watercolor pigment, unless handled with experience. Colors, once set out on a palette, cannot be saved and must be scrapped as they dry too rapidly to use. They cannot be kept in a water-color box for instant use as watercolor cakes or tubed pigment can be. Some tubed acrylics dry in the tubes if not used constantly, although this happens less with the newest acrylics on the market. They cannot be diluted, once hardened. They do not have the good, familiar smell of linseed oil paints and at times seem less sympathetic to the painter accustomed to the feel of oil paint. Acrylics can, in unskilled hands, develop a "hard" look, perhaps from the difficulty in making smooth, blended transitions in tone. However, I suspect this is not the fault of the acrylic pigment, but in the trained oil painter's trying to employ the slower, controlled methods of working. These are some of the obvious for-and-against things listed above, but there are others scattered through this book that will be mentioned in relation to specific paintings and projects.

Color

■ It is complicated to choose a palette of colors most suitable for your particular needs. To make a selection from the hundreds of different colors available to you needs experience and some knowledge of the potentialities of the pigments. What may serve you in watercolor may not be of much value in acrylic, as each has its own qualities, each its own peculiar charm, opaque or transparent feel. I would suggest that you begin with a limited number of colors plus black and white and then add slowly to the selection, trying new unknown colors in small tubes until you know what you require. There are always discoveries to be made. Recently I came upon a new pigment that had never before been available to artists, a white, warm and cream-tinted, that has become one of my favorite whites and I find it essential to my work. It is called "Unbleached Titanium" (titanium dioxide) and is made by Bocour. There are new colors brought into being constantly with new and permanent dyes, brilliant colors that provide an extension of the color range for contemporary work. Pre-mixed charted hues are on the market, colors that are scientifically assessed as to value and hue. There are also such differences in the various makes of colors that you will find radical differences in a cerulean blue in one manufacturer's list when contrasted with another. Blacks differ in richness, browns may be warmer or colder, and yellows deviate in their intensity. Try to use a consistent palette from one manufacturer, because there are variations in the makeup of binder and the consistency of pigments. Some are watered down with fillers and lack full intensity of hue. Watercolors should always be of the finest quality, for they more than acrylic need fine preparation to give the required transparency.

Here is a basic listing of colors for your initial acrylic palette:
Light and Medium Cadmium Yellow.
Ultramarine and Cobalt Blue.
Cadmium Red Light and Alizarin Red.
Yellow Ochre, Umber or Sienna.
Viridian Green.
Black and White.

With these eleven or twelve pigments you have the basic hues for most color mixing. In acrylics, later add to the list the more brilliant (and at time too garish) colors and use them circumspectly; the gay purples, oranges, rose and pink magentas that are lively and useful from time to time, but only when controlled and handled with taste and experience.

Generally the best color schemes come from a well chosen set of simple color ranges. Overmixing and indiscriminate adding of colors together results in muddiness and a negating of pure color. Do not always reach for the white to lighten and the black to darken colors; often the use of an *opposite* or *complementary* color will do the job without weakening the intensity of the mixed color. A touch of green in a red, for example, will gray the red beautifully, as will a touch of orange in a blue, or a violet in a yellow.

There are many books on color with detailed mixing instructions. These are useful for experiment, but the exploration of your own feelings about color and actual practice with the pigments are the only true gauge of your color sensitivity, and only you can develop your color preferences into a satisfactory result in your own work.

Use lots of water, keep your brushes clean, and tackle the job, knowing that at worst you can only spend some time, a bit of paper or canvas, and remember that we learn from our mistakes, by learning what *not* to do the next time.

Sketching from nature provides the artist with the knowledges and understandings for the later development of his more abstract works.

Modeling pastes and textures

One of the most valuable and fascinating techniques added to the painter's vocabulary, is the use of acrylic binders and material to form textured surfaces for underpainting and coloring. How Braque would have been able to use such textures, for he had a penchant for adding such materials as sand to his oil paint to provide roughened surfaces and variety to his paintings. Now the painter is able to mix marble dusts, sands, plastic chips, tissue papers and other material to mould or form corrugations and broken surfaces of every kind. Paper collage combines form underlayers of surface glued to acrylic grounds with acrylic glues, the whole process making a compatible binding of a permanent nature. Lines, impressions and trowellings can be made into the wet pastes that will dry as hard as a cement wall. These pastes can be colored and tinted before applying them to the ground surface or painted later with acrylic washes or thick paint. They can be sanded, polished or engraved. Dimensional pieces can be made by pouring the paste mixture into moulds and carving and sawing sections to your desired shape for mounting.

Some of the materials you may wish to experiment with for texture-making are commercially prepared. Modeling pastes, acrylic prepared white gesso for making grounds to paint on, and other special moulding pastes are on the market. You can easily make thickened, heavy pastes of your own by adding sand, celite, and powders of fine stone. Be sure to not overload the emulsive binder with too much material and test it out to see that it is sufficiently coated with adhesive liquid before using it, or some cracking and flaking can occur. I have found I could make durable textures with Elmer's white plastic glue and marble dust for large underpaintings. If you are to build up very thick surfaces it is wise to do so on prepared masonite or board rather than canvas. Some of my experiments with textures are shown here as suggestions for your acrylic explorations.

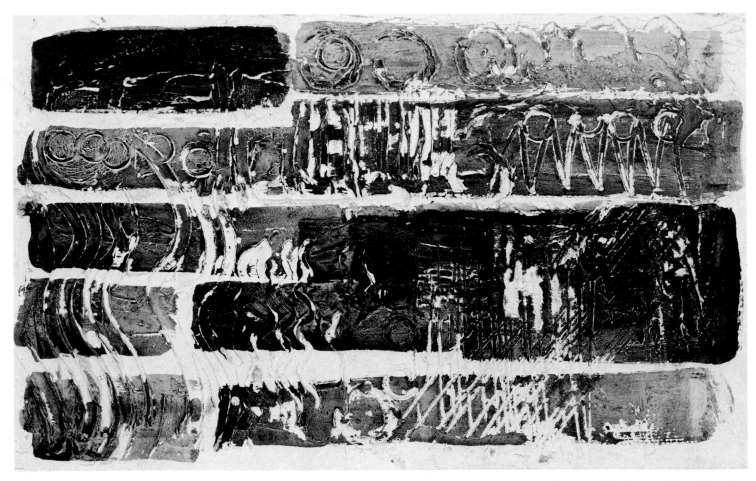

A practice page of texture-making with paste made from acrylic emulsion and white marble dust. Scratches and indentations are made before the paste hardens. Three or four hours will ensure enough hardness to put on transparent glazes or other color.

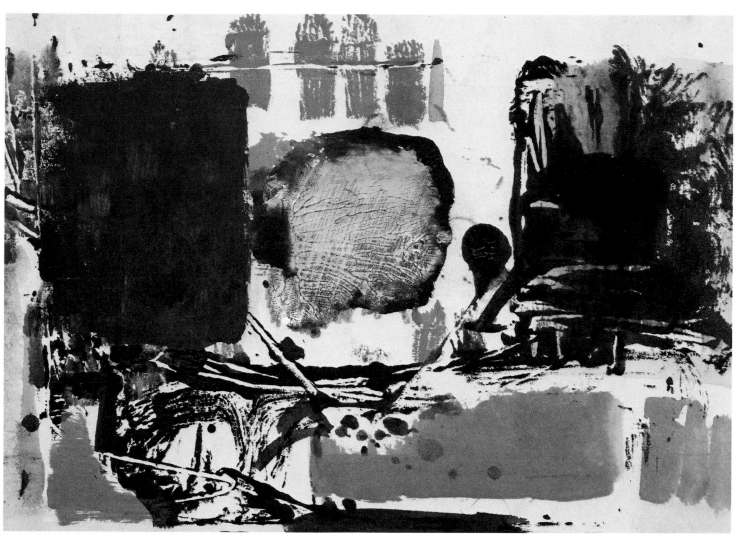

Offset printing of acrylic pigments from a piece of painted glass or paper on to another paper surface. Rich textures and surfaces are made in this manner.

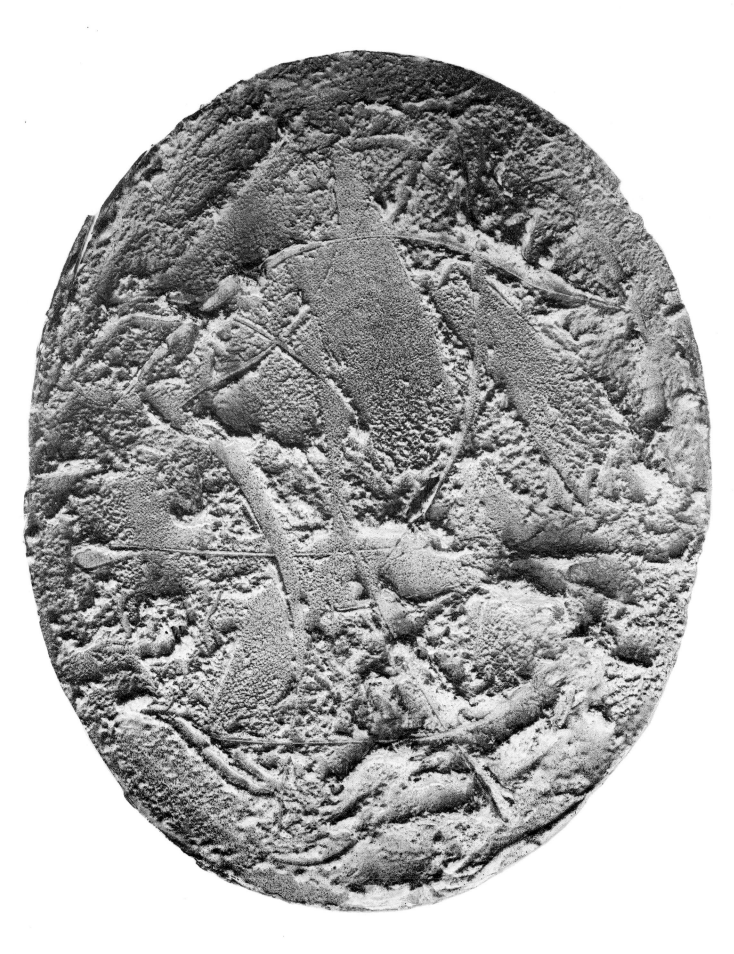

SPECTRAL LIGHT (At left)
A small canvas uses the under-texture of modeling paste to build up a variety of surfaces. I used spatulas to groove the thick paste while it was wet and before it dried, a matter of three or four hours. Over this white surface thin glazes of blue and yellow were painted in acrylic paint. Spray cans of black and white were used to give an appearance of relief and dimension to the rough paste texture. A final coating of matte spray sealed the canvas in an even, smooth coating making glass unnecessary.

GEORGE SOTTUNG / *Snowline*
Here the gesso underpainting is allowed to show through in the finished painting, helping to create an effect of snow and texture to the weathered old house.

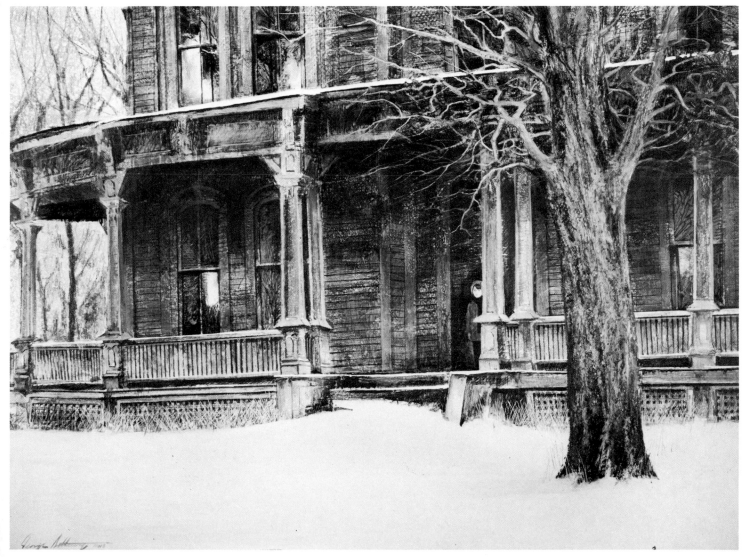

POPPIES

A vase of fragile, brilliant poppies and mixed flowers standing on the dark background of a flagstone floor provided the subject matter for the painting shown here. The fragility of the red petals contrasting with the rugged, dark shapes of mottled stone made an exciting challenge in texture-making with mixed media.

The background shapes were put in first using acrylic paints with rollers, spatters with a flit gun for a spray, and thin glazes of transparent color over cut-out shapes of thin collage papers. Careful drawing studies preceded the drawing in of flower shapes over this background.

Precise modeling and definition of the design forms were painted in with small brushes and opaque acrylic. Finally, accents were touched in with pastel pencils and the painting fixed with an acrylic transparent varnish that sealed the colors with a matte finish and even coating of protective film.

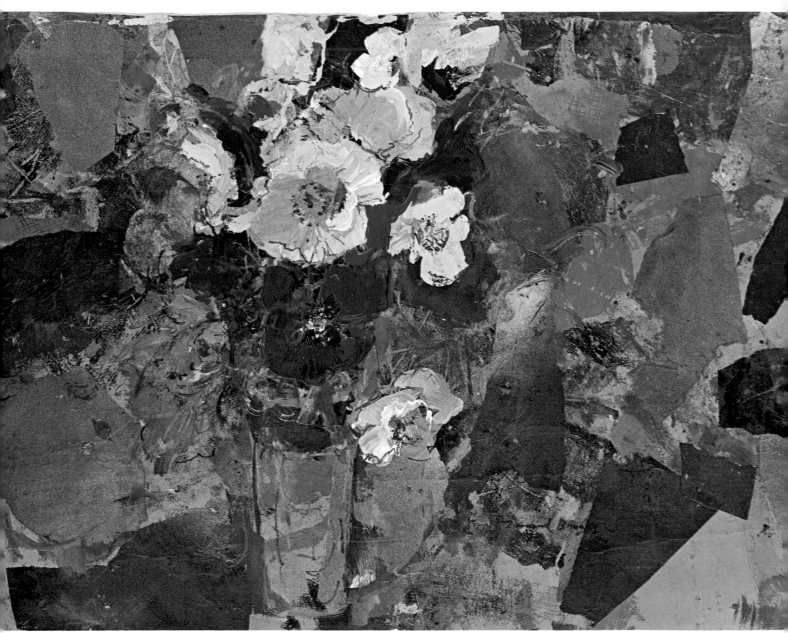

POPPIES / Collage and acrylic.

POPPIES (At left)
A Combined Collage and Acrylic Sketch.

Problem: To put down in a rapid impression the intense red and translucent, fragile whites of a flower bouquet.

Preparation: Several rapid pencil drawings made from the bouquet to study the particular shapes and decorative possibilities of the flowers.

Choice of a suitable background that would intensify the color yet fuse as part of an overall pattern of rich textures of visual interest.

Materials:

Acrylic reds, white, burnt umber, a blue and violet.

An assortment of colored papers prepared with acrylic colors, sprayed, rolled and brushed on a number of sheets of white, Japanese papers. These are cut and torn and assembled on a heavy card and glued down with Acrylic White emulsion. These are shapes suggested by a broken mosaic of stone flooring on which the flowers stand.

Brushes — Nylon half-inch square ended brush, pointed No. 3 Sable, steel painting knife.

A size 20″ x 24″ Gesso Acrylic Canvas or board.

A morning's work should see these preparations readied, the drawing sketched on paper, and the canvas ready to be painted on. Large shapes are brushed in quickly, trying for simple, large forms first, avoiding details. Working without reference to the actual flowers (I like to have them in the studio, but at a distance), I try to put down the quality of the group as a unity, not separate, individual blossoms. Observe the relationship of background and flower forms, striving for an over-all color mood, leaving details until the last. These can be touched in with the sharp edge of a palette knife, the small brush, or the pastel pencils can be used to provide fine detail such as the stalks, petalfolds, etc. Spray these lightly from time to time with acrylic spray.

"Poppies" was painted from beginning to end in about one hour. Such a sketching session, planned ahead of time, working rapidly, will help you master the acrylic technique. Choose a subject of similar color contrasts, set up the problem, and try to complete the project in a morning's work.

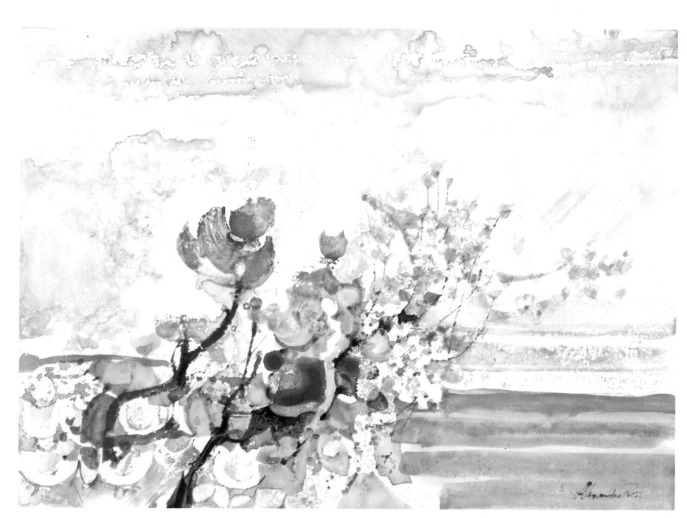

ALEXANDER ROSS / *MORNING BECOMES ECSTACY*

In this acrylic painting, the artist has painted transparently on an acrylic gesso-coated surface. This resistant surface creates a "puddling" of the pigment which can be utilized for special effects.

DUBROVNIK / A complex acrylic collage on red background uses walled-town shapes and narrow streets in strong patterns of ochre, black and white.

MORNING SQUARE / Netting cloth-textured paste and papers combined with acrylic washes and impasto exploit a mixed technique.

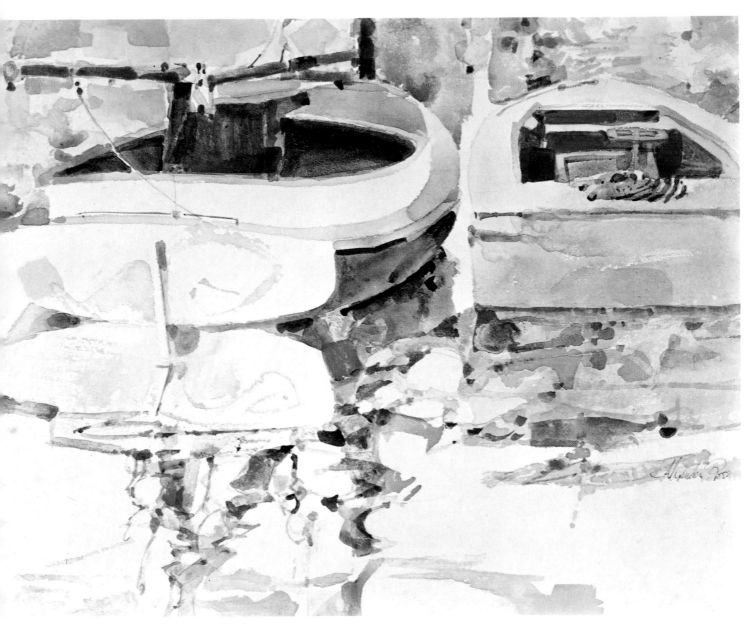

ALEXANDER ROSS / *REFLECTIONS*
The qualities of transparent watercolor can be duplicated in acrylics, including bleeding and blending of tones in wet washes if done quickly, as shown here. Once dry, one color can be applied over another without a muddied blending.

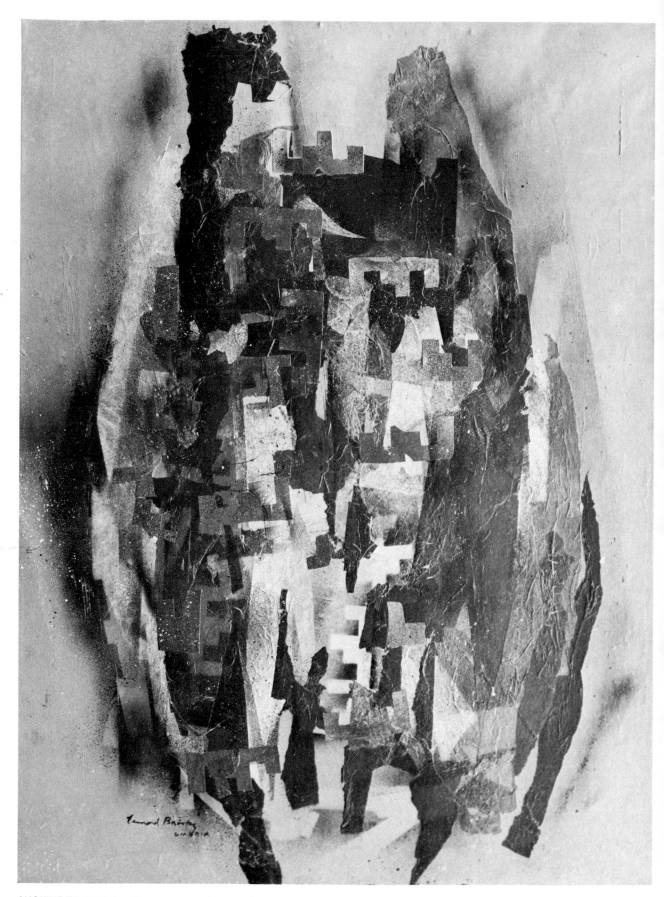

ANCIENT TOWN / Acrylic sprays used over cut
paper stencils, gold leaf underlay on gesso,
some cut-out shapes of derelict castle forms
combine to make this large, vertical canvas.
A warm tinted acrylic background was painted
on the canvas first.

82

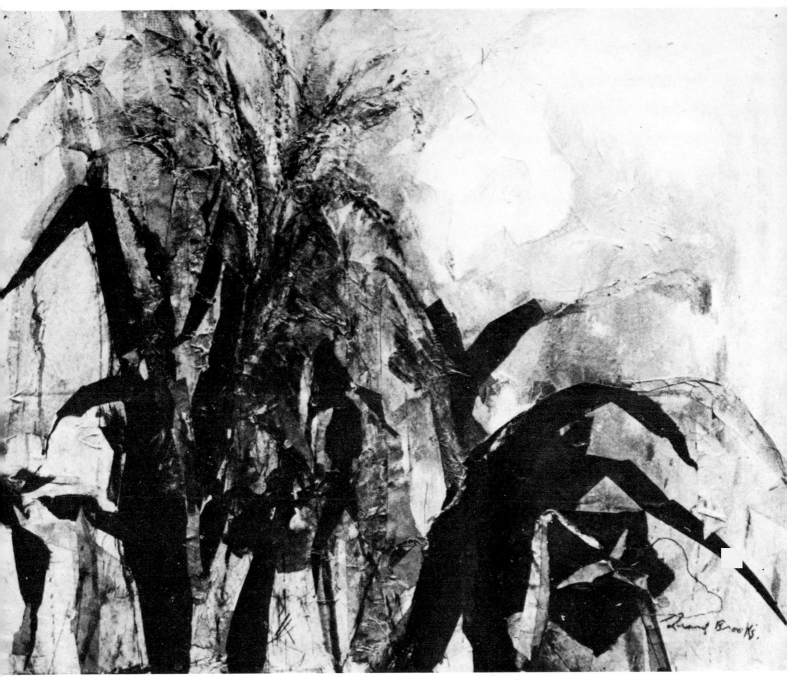

MORNING LIGHT

Sun and sky silhouette the dark corn stalks in a strong, decorative pattern. Careful drawings preceded the painting of this canvas which was executed with acrylic mixed method — some collage, some thick gesso paste to build up the textures of stalk and leaf against the smooth, brilliant sky color, washed in first. Such a subject, dull and ordinary in the glare of light at mid-day becomes alive and exciting in color at another hour — light is the magic key.

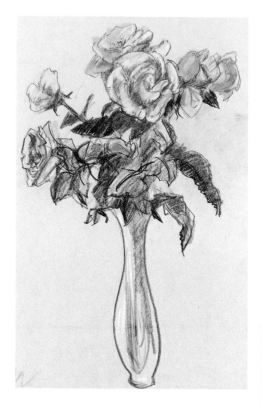

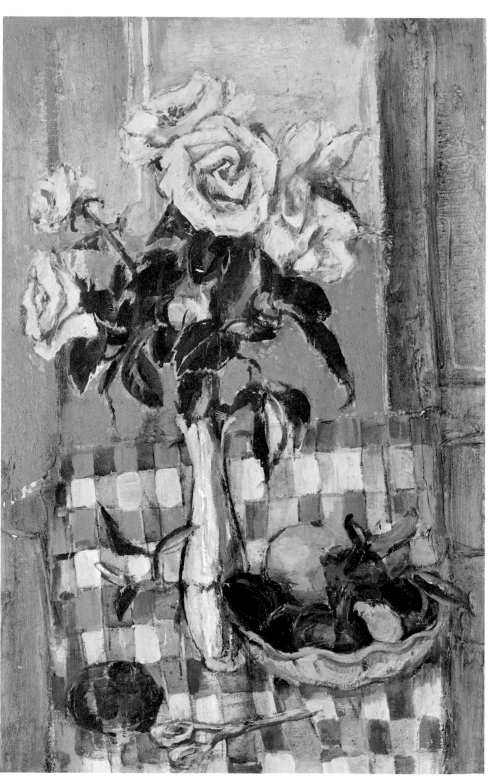

A careful drawing is made and traced down for this figurative painting that is painted in a technique similar to traditional oil painting. Thin washes first, thick paint gradually built up over the first wash-in of transparent color. Glazes are added to enrich the color glow and a final varnish set over the finished painting.

YELLOW ROSES

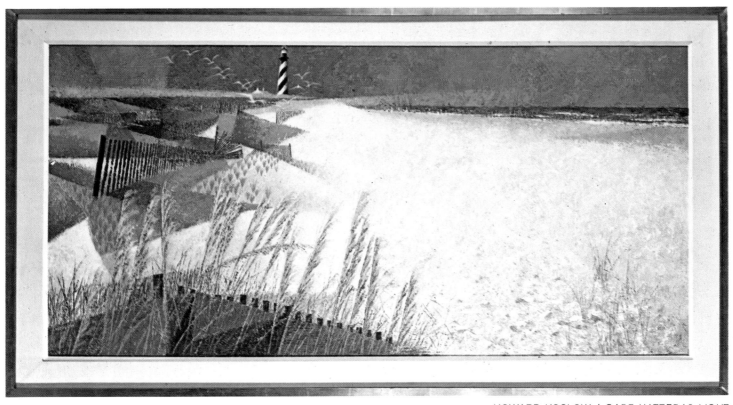

HOWARD KOSLOW / *CAPE HATTERAS LIGHT*
Acrylic, applied with painting knife.

ROMAN STUDIO WINDOW

Here I used acrylic modeling paste to build up a textured ground before touching color. Tiles and smooth walls, flat sky smoothed out — all of this painted in neutral paste and indented and marked with a spatula and knife before it dried. Transparent glazes of acrylic pigment are washed on over this, with a few touches of polymer acrylic emulsion added to ensure binding of the color when it dried. The shadows were built up in many layers to give a rich dark. When completed, the painting was varnished with a matte varnish. Uncoated, smooth canvas on a stretcher was used for the ground. Size 16″ x 20″. An affectionate, realistic study made to remember the daily vista from my studio in Trastevere, Rome.

A group of acrylic paintings using the many techniques suggested in this book.

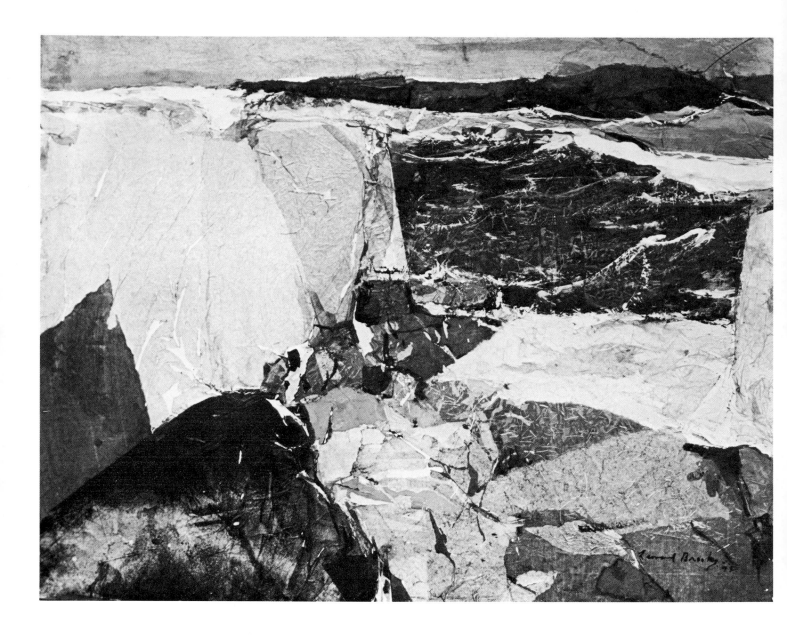

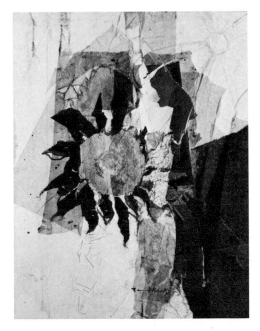

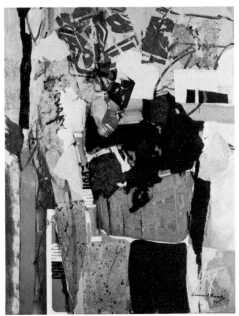

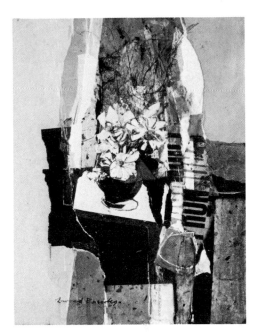

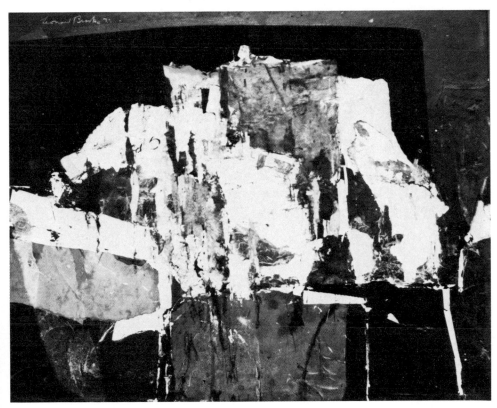

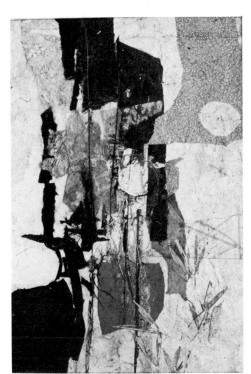

Hard edge acrylic

■ Acrylic used with its full opaque covering power and not diluted to a transparent wash provides the artist with a smooth, even coating of brilliant matte color that lends itself to the needs of the contemporary styles of "hard edge" painting. This technique uses the clean, precise fields of flat, even color in pictorial statements varying from utter simplicity of shape to the most intricate of "Op" (optical fool-the-eye) patterns. In a reaction to the free slashes and automatic painting of the abstract expressionists these precise paintings use the cool, impersonal expressions requiring complete technical control and pre-planned execution. The unique mark of the individual is ruled out; brush marks, sensuous textures, or accidental qualities are ruthlessly forbidden on the canvas. Planning and execution demand patience and something of the love that a sign-painter has for his clean brushes and exactitude of technical prowess. There is no doubt that these canvasses, impersonal or not, have impact and a direct appeal to the eye with their vast areas of bright, flat color, stripes and eye-catching repetitions done in intricate, patient patternings.

Working with sprays and smooth, clean brushwork, the immaculate surfaces lie matte and unshiny and their clearly defined edges give them the name of the "Hard Edge" school. Acrylic allows the quick drying surface of paint on a smooth, white gesso acrylic ground to dry quickly, and many coatings can be built up rapidly for maximum brilliance and smoothness of paint. Use housepainter's brushes of a good quality bristle or nylon fibres and keep them spotlessly clean. Be sure to mix up sufficient color batches in tin or plastic cups to avoid running out ,for there is nothing more frustrating and time-consuming than trying to match a subtle color exactly to finish an area or later to touch up, if necessary, an area already painted.

If such formal painting is not your cup of tea there is no reason for you to experiment in this idiom. On the other hand, it might be rather fun to try — and it will help you to appreciate the many fine works by today's artists who work in this particular formal manner.

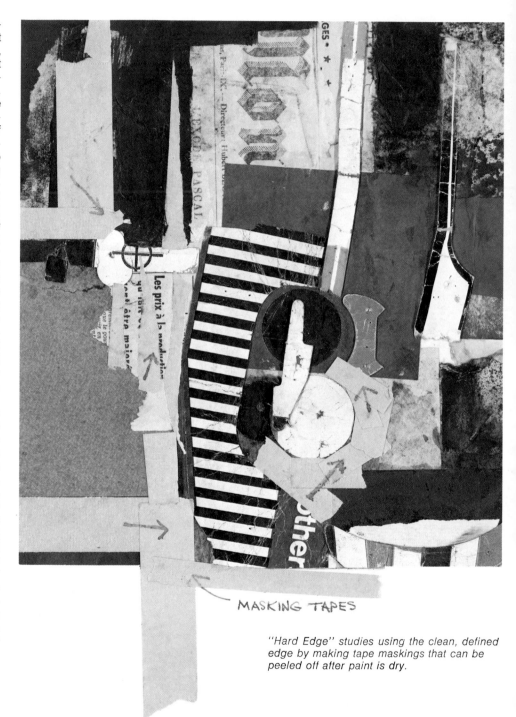

MASKING TAPES

"Hard Edge" studies using the clean, defined edge by making tape maskings that can be peeled off after paint is dry.

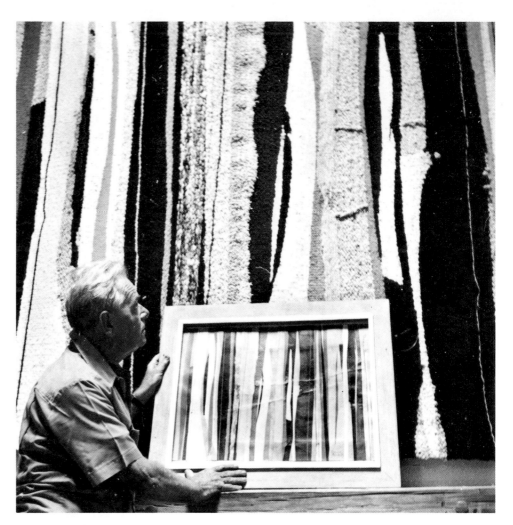

For the designer-artist, working with the craftsman and artisan who can transpose his ideas and work into another medium, acrylic lends itself remarkably well to the new media which may be imposed upon it. I recently have had the great pleasure of having my paintings and collages moved into another dimension by a group of excellent craftsmen, brilliant Mexican weavers trained in the latest technique of contemporary weaving and the use of materials. Wool, fabrics and other materials translate the textures and colors of the painter into large wall hangings from the painting.

The painting shown here was made in Rome, after many studies in Umbria. I had moved my sketches, drawings and notes of this antique Italian province into a new interpretive phase of work . . . acrylic came to my aid. I dyed strings of cotton in many colors, made acrylic papers and cut them up into strips, haunted the art stores for new papers, and eventually put together a series of abstract paintings which I felt said something pertinent about my Roman experience.

The panel shown here has now become a ten-foot weaving. Working with an expert, sensitive weaver and his family, we have explored the color, texture and possibilities of the original idea that I put down several years ago. Wool was bought as it was shorn from the sheep, burrs and all, cleaned, washed, carded, made into yarn. Permanent Swiss colors were used to dye the wool, and eventually the vertical stripes and painted lines found themselves translated into woven fabric — an exciting transposition for the artist to see.

Size is an important factor as an element to consider when turning a sketch into a large picture. What will "blow up" well from small to large needs an experienced eye. Visualizing a small sketch as a major work is sometimes aided by having a color slide of the sketch thrown up on a projection screen where the possibilities become evident. A canvas can be substituted for the standard projection screen, and a rough outline in charcoal drawn over the projected painting to the size required to save time in the enlarging process. Lacking color slide and projector, the simple grid method will do as well. Place a tissue over your small sketch and mark it off in rectangles. Mark off your large canvas in the same number of rectangles of the same proportion. Fill each large rectangle with the detail seen in its small counterpart. When all are filled they add up to a well proportioned enlargement of the original.

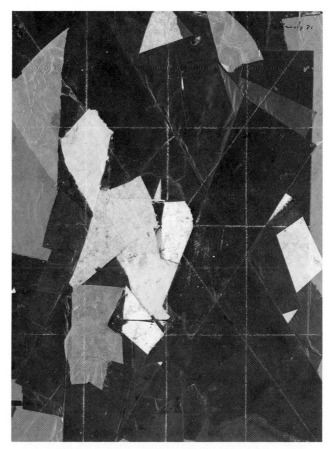

Cactus

ACRYLIC PAINTING ON CANVAS

■ Although I do not always use notes and sketches made directly from nature, I have illustrated here a number of steps used in doing the acrylic painting *CACTUS*. The intention was to do a quite figurative and detailed study of the color and texture of the very prickly plant set in the briliant light of my cactus garden. It was done on a 30″ x 36″ canvas in a full morning of work, from first drawing on paper to the last touch of acrylic brushwork. The procedure I used will suggest a basic technique for later developments.

The subject. Quick large drawings from the plant analyze the large forms and search for the curved patterns and repetitions to be used in the painting. Observational notes — written as well as drawn — will help you understand the special qualities of texture and color.

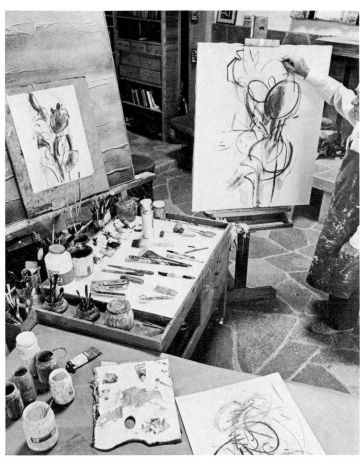

2. *A drawing is made on the canvas in charcoal and fixed.*

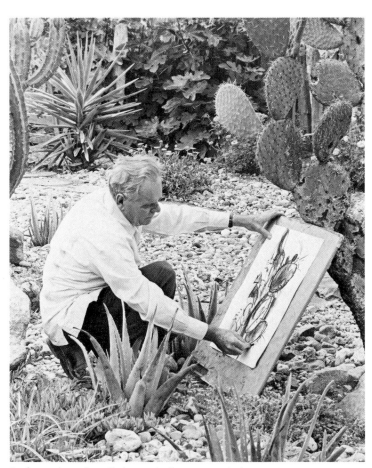

1. *A number of preliminary studies are made from nature.*

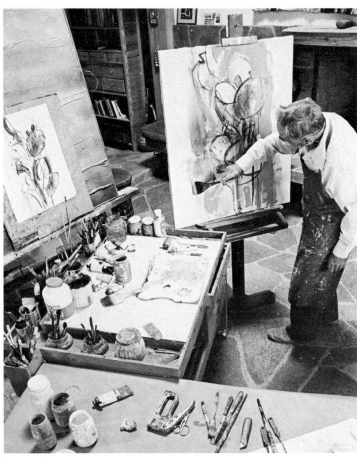

3. *The design is established tonally with a few broad neutral gray washes.*

I prefer to work away from the subject rather than in front of it as an aid to capturing the essence and feeling of object or place. Using memory *plus* "reminder notes" helps to cut away the distractions of changing light, superfluous details and the discomforts of working on the spot. The canvas is set on the easel in the studio, the palette of colors, the brushes and rollers, the drawings pinned up for consultation when needed. The first large forms are swept in with charcoal lines and sprayed with acrylic spray fixative on the acrylic gesso white ground of the canvas.

Thin washes of acrylic color and water are washed in to indicate the background areas using brush or, at times, a plastic roller. Forget details and outlines at this point.

A useful trial-and-error method is to cut out colored papers, assembling them on the canvas until they suggest what the final painting may look like. This will also help simplify the composition into large areas upon which the detail will later appear. Work with the canvas horizontally or staple the papers onto the canvas temporarily.

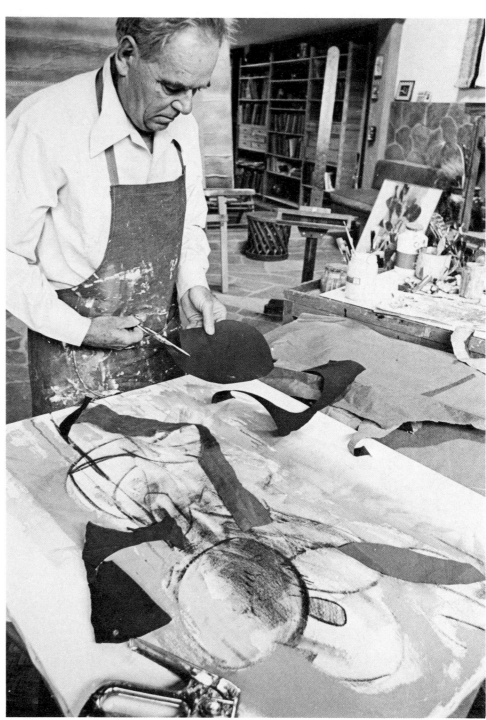

4. *Japanese papers are cut and torn to shape and moved about the design until the placing seems satisfactory.*

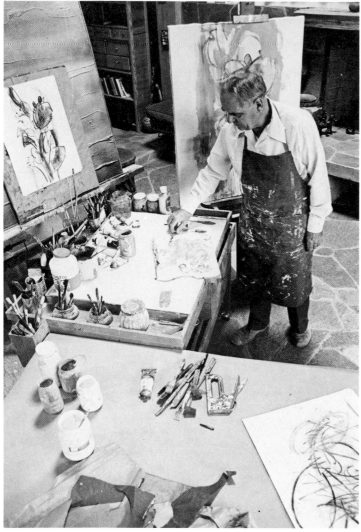

5. Color mixing.

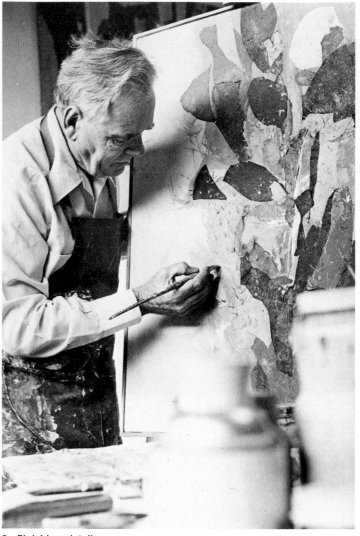

6. Finishing details.

Batches of thicker acrylic are mixed and brushed or rolled over the canvas after tracing down the outlines of the cut-out papers and removing them. In this subject the effort to paint high-keyed light called for the highest-toned, bright colors of the background first. Some acrylic gel was added to the pigments to give body to the thin washes and to provide a textured dispersal or "bubbling" of broken color.

The roughing in of shapes and colors now begins to be refined. The canvas is set back on the easel and smaller brushes are used to make the details of spines and linear outlines. Touches of palette knife make sharp, clean edges. Impasto and thick pile-up of overpainting and scumbling will give body and interest to the textures. Thin glazes of acrylic paint with water and gel medium will tint and change color areas. The frequent use of

a paint rag or sponge is valuable to wipe off unsatisfactory areas while still wet. *When* to stop is the problem now. Over-working can too often spoil a painting and it is wise at this point to step back constantly and see what you have achieved, and how far you wish the development of surface and detail to go.

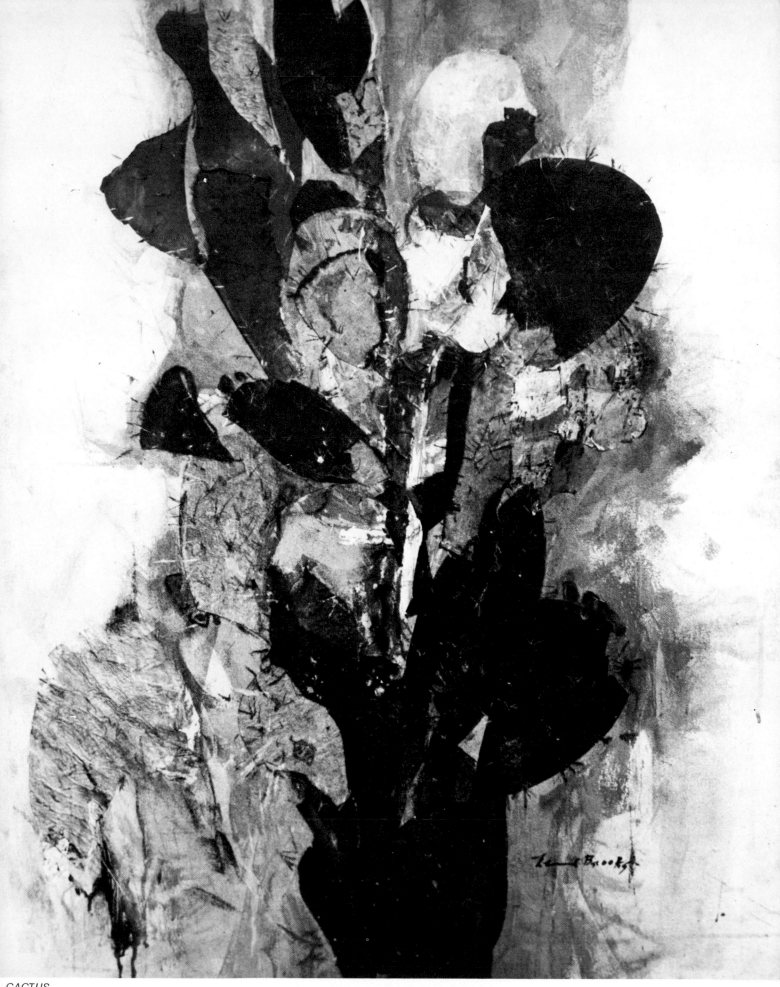

CACTUS

The Islands, Greece

■ The mixed technique of using collages and acrylic pigment in combination is an important and expressive media for the contemporary artist. Using polymer glues to prepare canvas or other surfaces with gesso polymer grounds, binding chosen papers, cloth and other material to form infinite varieties of textured surfaces, and then finishing the painting with overlays of wash or impastos of acrylic pigment is now an accepted and recognized technique. If the artist is careful to use only the fine unfadeable papers, and prepares his papers with color beforehand, especially the bright reds, blues and yellows he would like to use, and uses a final sealing matte acrylic varnish over all, the painting can be as permanent as any straight acrylic water and color picture. If we add marble dust or inert sands and powders, nylon chips, Kleenex pulp, or other inert matter, including the commercially prepared modeling pastes made with acrylic binders, we can build thick textures to three-dimensional qualities, although if this is to be done it is better to paint on heavy Masonite or other rigid surfaces instead of on canvas. Ordinarily, thin coatings of acrylic texture will not crack when bent or rolled, as the pigment has a rubbery, stretchable quality when

dry, (unlike brittle oil impasto). This is another valuable adjunct for the painter who wishes to roll and store or ship his work. I have rolled six-foot works for later restretching, without damage to the canvas.

From time to time, I prepare sheets of thin, fine papers — Ingres, Strathmore and others, with even coatings of acrylic color, brushed as it comes from the tube for maximum brilliance. These papers form a nucleous or palette for my torn and cut shapes in my collages. Also, if I am in doubt about a bright accent fading from a dubious paper I have used, I coat it with a matching acrylic color over the paper, when the painting is complete, ensuring permanency. Other papers are left in the sun for days to bleach or change before using them. I have some old, cheap poster papers printed twenty years ago, and bleached on the walls of Mediterranean towns, I have found no changes in color or tone from their well-bleached condition when I first gathered them for use. That was *not* the time I nearly got into serious trouble for ripping off a particularly succulent, brown, faded and splotched poster that happened to be a printed city ordinance, and a suspicious gendarme wanted to arrest me, nor was

it the time I plucked a lovely piece of discarded, brown sacking from a dust-bin outside a doorway somewhere in New Orleans, and a bewildered and irate janitor appeared suddenly and rapped my knuckles with his broom while asking me rather roughly what it was that I was doing. Custom officials, too, have shaken their heads unbelievingly when they have come upon a bag of precious rubble and collage materials that I gathered on my travels and had saved and hoarded in plastic bags like a mouse. In it I kept scraps of gold-leafed papers, beloved, left-over bits of special, textured papers, remnants of lettering, cloth swatches, and favorite Japanese papers of high quality that I know I'll not find when I set up my studio on a foreign shore. I spent a month on a freighter happily assembling small acrylic collages in a tiny cabin, and wanted for nothing needed for my work, though ship and sea were barren of any inspirational touches of colored papers or discarded, torn-up old paintings and collage material.

THE ISLANDS
So to work on *The Islands*, this time in the studio surrounded with material set out conveniently before beginning. I have

1. Charcoal indications are roughed in to indicate composition, dusted off and sprayed with acrylic fixatif.

2. A few thin, pale washes of acrylic and a neutral color are brushed in. These may or may not show beneath the papers.

3. Large areas of varied white papers are affixed, making sure to adhere them to the gesso ground without air bubbles or unwanted folds or ridges. Dark areas of island shapes are cut out and moved about to desired position. Stapling with a small stapler will allow the collage to be seen at a distance while on the easel.

94

consulted my sketchbooks, found a small note or two of the dark, whale-like islands, caught in the high-keyed, brilliant Grecian morning light. I have decided that contrast must be the key for the painting, a few simple forms, a touch of color for accent only. I will use only my finest white Japanese papers, some of them showing textured, silky, undigested fibres, a sheet or two laced with gold thread, a few dark brown and black tissues. The progressive photographs show the procedure I used to do the canvas. The first steps are similar to the ones *(page* 90*)* in the *Cactus* painting. The illustration of *Morning Light (page* 83*)* was also done in the manner shown here, preparing cut shapes before pasting them with acrylic white emulsion and finishing with acrylic over-painting.

It is wise to experiment with smaller works until you learn some of the many techniques possible. Like all methods there is no merit in just doing a "collage." It can easily fall into a series of tricks and gimmickry. If it adds something to your innate language for expressive effort it will become meaningful and worthwhile incorporating into your painting sessions.

If you look at the reproduction of *The Islands* closely (next page), you will see a dark, geometrically-shaped wheel symbolizing the sun. It was a bit of black plastic I added at the last moment. Did it work? Did I really want it in? We looked at it later, my painter friend and I. I didn't mention it. "I like it all but that dark accent," said Y . . . "it feels like an afterthought." And it was. So I took it out and the yellow gold sun came back as I had originally intended it to be. Luckily I had just stapled the plastic on and it was easily removed from the canvas.

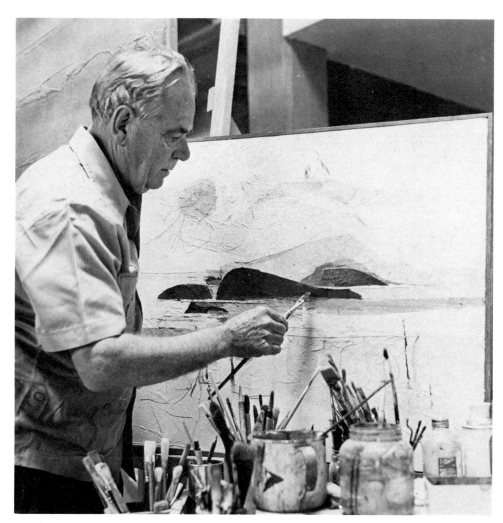

4. Layers are glued down, edges torn, cut, folded and the wet paper moulded to the desired texture. It takes experience to know how these papers look when wet and when dry, and how colors change after being coated with glue and a final matte varnish. It also requires much experience to know how some papers dry transparently or semi-transparent and show underneath layers.

5. The large forms are pasted down, the collage has been dried in the sun, and discreet and sensitive additions in paint are washed and touched in to pull the composition together. Have a sponge at hand for corrections and wrong touches, for lines can often be quickly removed with water, although some colors will stain the papers beyond correction in this manner.

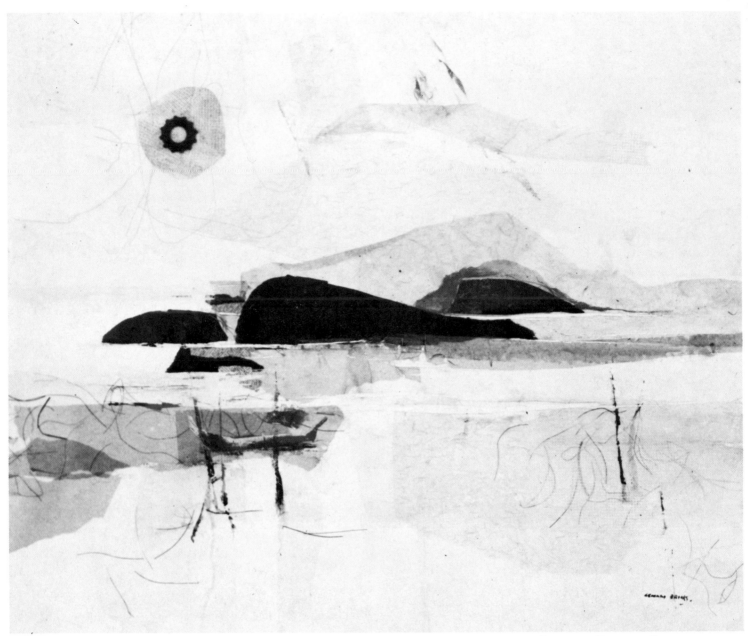

THE ISLANDS, GREECE / An acrylic-collage built up on a surface of Japanese white papers on canvas. (See preceding spread).

WIND SONG / This six foot painting is an abstraction based on the autumnal winds and dancing leaf forms.

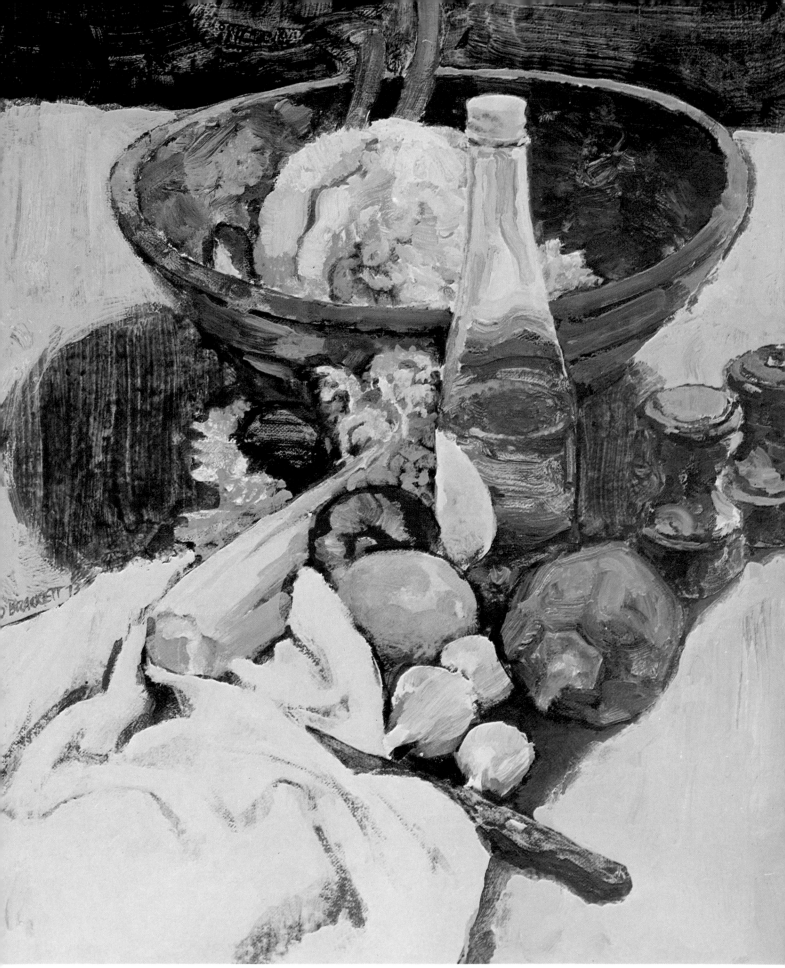

WARD BRACKETT / *STILL LIFE*
Here the artist has employed the pigment
thickly in some areas and thinly in others,

using acrylics much like oils. And, like oils,
the pigment can be scumbled over dried areas
or diluted and applied as glazes.

Realistic or abstract?

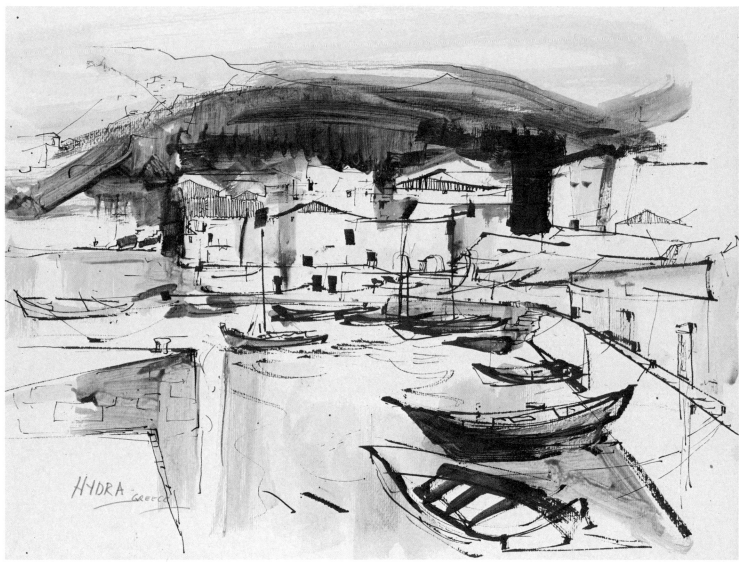

HYDRA, GREECE

In this on-the-spot sketch done in Italy, the acrylic has been used in a transparent watercolor technique. Once the brush drawing has dried, it can be painted over with washes which will not pick up or dilute the pigment beneath.

■ Visitors to my studio are often puzzled when they see my sketchbooks or framed drawings and watercolors that I have done, some recently, on my walls. They seem surprised that I, as an artist who exhibits mostly abstract paintings, still, as I have always done, make careful observational drawings and paintings from nature, figures, objects, landscapes. Often, in answer to their queries, I have to explain to them that I still find it necessary to refresh myself constantly with the real-

ity about me, to gather fresh material that eventually appears in the abstract forms and colors I love to use.

Actually, as I have evolved in my ways of seeing and thinking about painting over the years, I find that the impulse that sends me to contemplate nature is the same as that of my efforts to paint the "non-visible" elements of completely abstract motifs. The fundamental problem remains the same to me. Writing deals with words, but the form it can take may

be sonnet, free verse, concrete poetry or a novel. In painting, the form that finally emerges is predicated on making order and unity out of the plastic elements of color and form. I find too, that there are days when I want to work neatly, carefully noting detail with close observation and attention. Other days I need to express myself freely, impetuously, to fall all over myself in an urgent need to get something down on paper or canvas, to let loose with a big brush and paint.

98

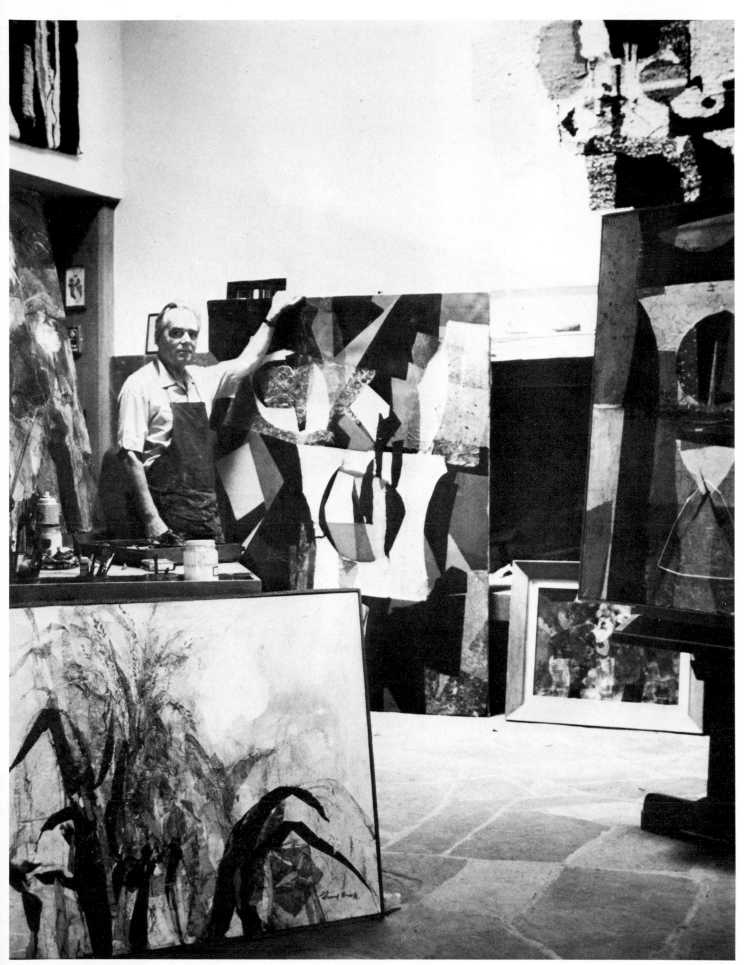

Leonard Brooks in his studio.

ABSTRACT SUBJECTS

Acrylic techniques combining collage-acrylic, glazes, impastos of thick paint, rollers, etc.

I have never liked repeating myself too much in my work, boredom set in too easily if I do, and I do not envy those artists who find the "secret" of their paintings early in life and go on making repetitions of it for the rest of their lives "ad nauseum." I like to solve a problem, move on and evolve. Over a lifetime of work, cycles of change are inevitable for most artists. I welcome them, although it often means going through periods of indecision and floundering while these changes take place. We are fortunate if the flow of creativity surges anew and pushes us along with many a tumble over rocks or tossing in a wild eddy, as well as the bliss of floating in the backwater of quiet contemplation and unharried work from time to time. Storing up material, the gathering of a backlog of sensations and painter's experiences in mind and eye, is an art in itself. Colors, forms, moods, discoveries . . . what a wealth of glorious materials a finely-tuned, mature artist has buried within himself! "I don't paint *from* the flowers," said Braque to a visitor seeing his vases of blossoms in his studio. They were there as reminders and he turned his back on them to paint, for his head was filled with memories of a thousand bouquets loved, considered and digested, awaiting the time he felt the urge to paint them.

LEONARD EVERETT FISHER
SHADOW OF A RIBBON
Collection: The New Britain Museum, Connecticut. In this hard edge acrylic painting on gessoed masonite the artist has combined abstract shapes with an illusion of 3-dimensional reality.

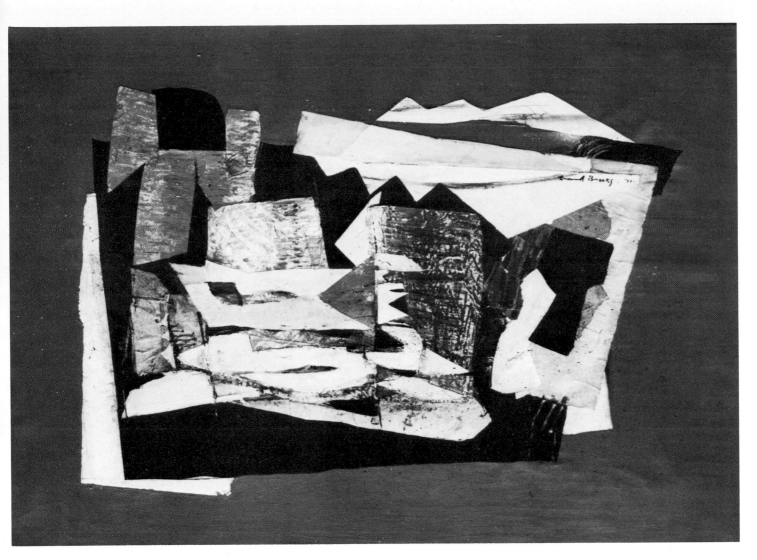

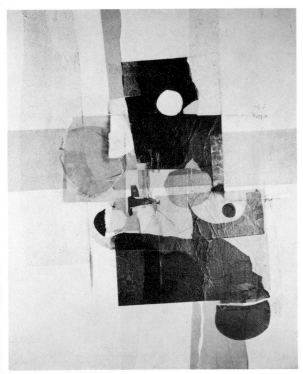

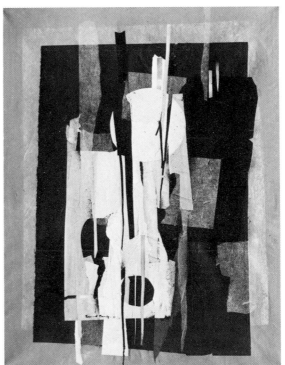

MUSIC / Linen strings and cuttings from acrylic papers are mounted on canvas before overpainting in this collage acrylic.

Composition

■ Composition — the putting together of single elements into some kind of order, of giving significance to the over-all effectiveness of pattern so that a satisfactory visual whole is obtained — is not the mysterious operation many beginners consider it to be. On the other hand, formulation of precise rules and methods of achieving fine compositional results is one of the most neglected and confused branches of the art of painting. Such rules and theories as do exist are of little value, pertain at best to particular paintings. What often works perfectly in one painting has no relationship to another and fails to function in it. So, most of the rules do not help us much and at times may hinder our instinctive feelings for composing. Classic styles of painting become outdated and have little reference to the problems of contemporary expression. The very breaking and reversal of rigid rulings often creates new and valid compositional forms. The break from traditional figurative painting brought about new problems of abstract thinking about space, the picture plane and negative space and the control of pictorial depth.

Yet, having stated this, we can consult such a masterwork as Paul Klee's *Landscape with Yellow Birds,* the definitive exploration of visual language that deals in depth with most of the problems of visual design, form and the mechanics of projecting line and color in a truly creative manner. But even he constantly reminds us that though we may document, explain, justify, construct and organize, we do not succeed in coming to the whole. Intuition remains indispensable, he insists.

What then can we say about composing? We know that it consists of feelings, human emotions that are tied up with our physical selves as well as our mental agitations and imagination. Time, interval, rhythm stem from our very breathing, and motion and balance propel our walking bodies in perfect sequence of motion. The simple beat of a drum awakes our sense of order and formal patterning of sound as does the primitive border of lines and dots on an African shield. Visual excitements or boredoms exist even in nature, and it is in the instinctive selec-

tion or rejection of our choice that we become artists. Knowing this and becoming sensitively aware of such elemental foundations for picture-making is the first step. We have these hidden assets buried within us, awaiting cultivation. We are fortunate if they have not become obscured by too much teaching of a wrong kind or by formulae and rules imposed on us at the outset of our studies.

Composition is much easier to demonstrate than to talk about. A badly composed painting can often be pulled together with a few corrections from an expert eye that senses what is wrong. An accent too dominant, a dull transition of a moving line or a cluttered area, the lack of controlled space, the boredom of an over-insistent repetitious pattern — all of these weaknesses are of a subtle nature and must be considered within their own context. The experienced teacher casts his eye on the painting and asks himself, "Why doesn't this work?" "Why does that succeed?" He may suggest a change discreetly, based on his years of picture-making, his sense of order, structure,

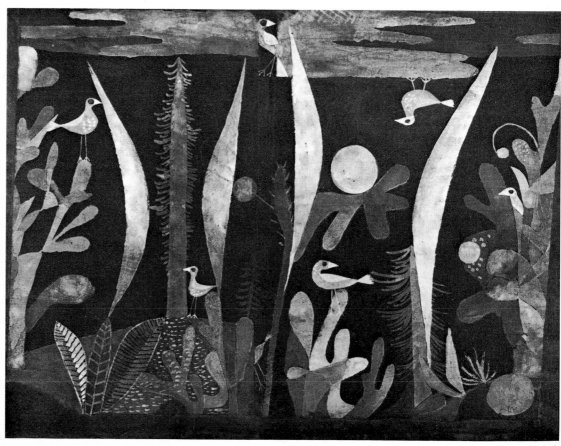

PAUL KLEE / *LANDSCAPE WITH YELLOW BIRDS (1923)*

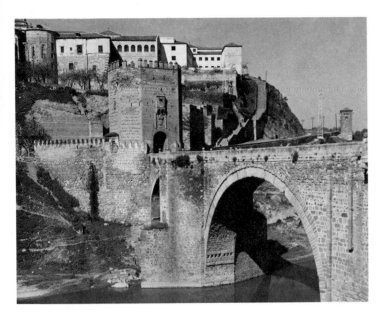
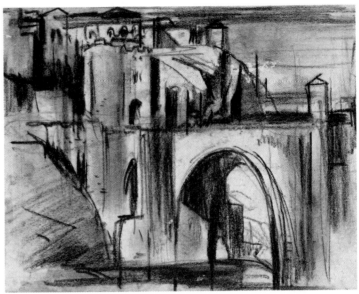
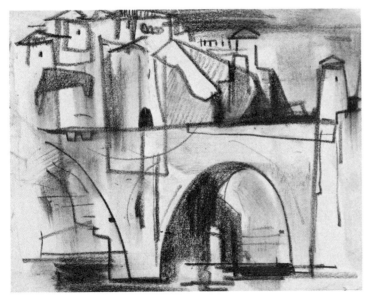
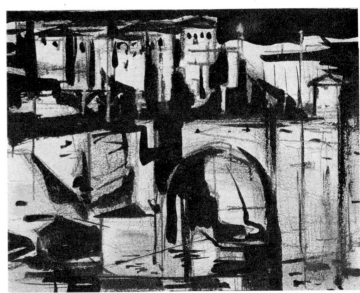

TOLEDO BRIDGE / Traditional thumbnail notes to analyze line and form of subject.

sensitivity to space-filling on a flat surface. He does not provide a rule that can be applied blindly for he knows how the factors change with each newly conceived effort. It is this ability to criticize constructively that should be developed in the student's training. The art of composing becomes much easier once the student has learned how to face his work objectively, asking himself why this particular work failed, or happily, turned out

to be the best work he has ever done.

Once aware of the true meaning of composition, your enjoyment of looking at paintings of others will be increased immeasurably. Reading the notes of painters will often clarify the many problems of the composition in their paintings. Sessions devoted to the art, using black and white to work out fundamental space-filling will soon develop your inventive sense. Studying fine paintings that appeal

to you, to find out why they give you pleasure, often helps reveal the secrets of controlled pictorial counterpoint. The use of the basic elements in their simplest forms — the circle, triangle, square, the straight line and the curved, the combination of horizontal and vertical lines in different formats — such exercises will augment your ability when you are ready for the more intense moments of your serious work with brush and paint.

The story of a shape

■ Some time ago I was involved in helping some young movie makers do a documentary of my studio and working life. The following is an excerpt (as it was taped) from part of the script that we made which may provide an insight into the strange beginnings of a work of art, those incipient and unaccountable moves behind the daily adventure of being a painter. Was my discovery I wonder, any different than stumbling over an irresistible composition on a street corner, or a vision suddenly evident in a flash of a dream?

(From the taped interview)
"You were asking me about 'found' objects, how artists attach themselves to odds and ends — not just shapely pieces of driftwood — but what most people look upon as real junk. Yes, I did cart that piece of white, polished bone here back from a Greek island — couldn't resist it — and that long strip of serrated wood on the wall is not an African spear, but part of the guts of an old player piano that I salvaged. Perhaps I should tell you about the 'shape' I picked up in Rome, and how it provided me with months of inspiration for paintings.

When we spent a year in Rome recently, I used to walk a lot along the river banks of the Tiber, especially on Sunday mornings when the place was deserted, only one or two fishermen trying to net small fishes in the dirty, surging water rushing by the Vatican towards the sea. There is no road for cars along this part of the Tiber, a godsend for a safe stroll and an ideal spot for sketching, apart from the air of antiquity and the shadowy ghosts of countless famed artists who have drawn and painted Rome, looking over your shoulder.

There are even bushes and wild flowers growing in some stretches, and of course, lots of junk, old, torn posters, cartons and other debris tossed over the high cement banks that tower up to the streets above where the traffic roars by. Anyway, I loved this spot, spent hours prowling about like a tramp, enjoying this ancient centre of the once great Roman Empire as much as any Emperor ever did.

Then I found this "Shape"—nothing more than a rusty small piece of cut-out steel which caught my eye, lying on the ground in the weeds the way a bright pebble or shell on a beach might do. I amused myself noting that it was not part of a Centurion's armour, alas! But it was a Roman artifact, a modern one, probably part of an electrical parts stamping. I

THE FOUND SHAPE

thought how it would have bemused a Centurion if, wandering along this same spot some centuries ago, he would have picked up this same shape by chance. It would have been as much of a mystery to him as it was to me, I thought. I tucked the small piece of steel into my sketching bag for further examination and continued on my walk.

A few weeks later I was painting north of Rome in Umbria, drawing some of those marvellous medieval walled towns

perched on high crags and mountain sides, often deserted or inhabited by a few old peasants. I found the piece of metal still in my sketching bag. It seemed suddenly very familiar to me and this was puzzling until it struck me why. The turreted-shaped and cut-out metal profile imitated almost exactly the crenellated walls and steep cubed village houses I was sketching. The silhouette was an ancient walled castle steel shape! I tucked it back in my bag and went on sketching.

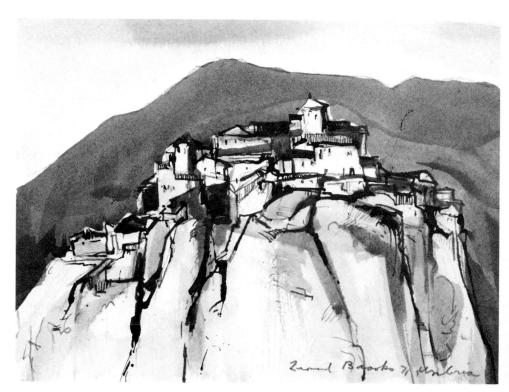

104

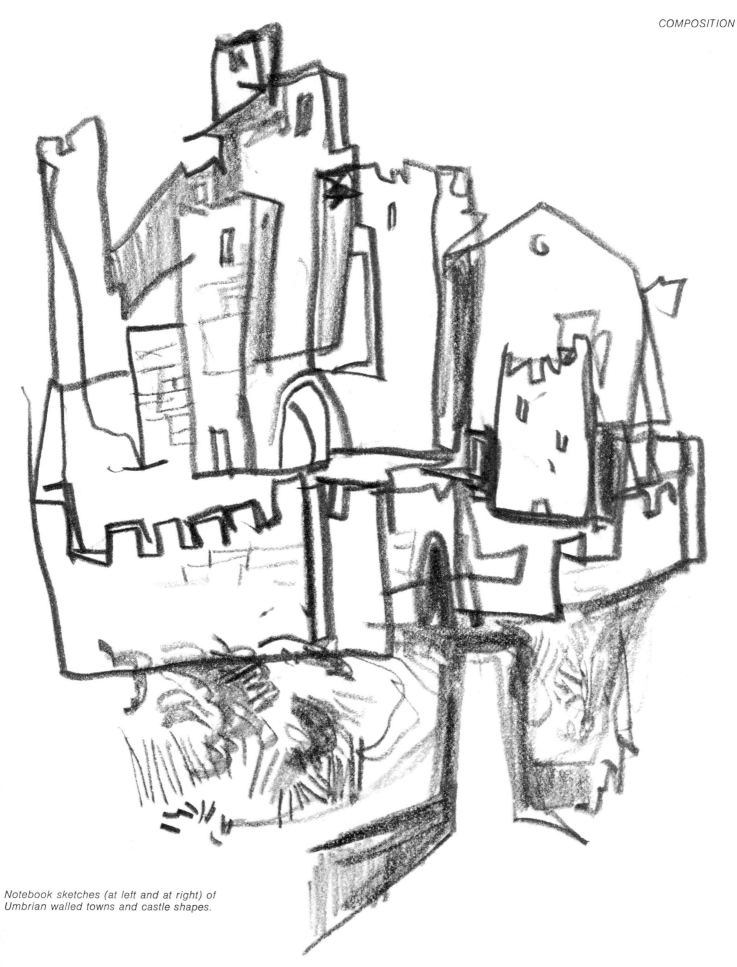

Notebook sketches (at left and at right) of
Umbrian walled towns and castle shapes.

Mounted shapes sprayed and designed for a symbol of Italy for a catalog. The Shape suggests many new variations.

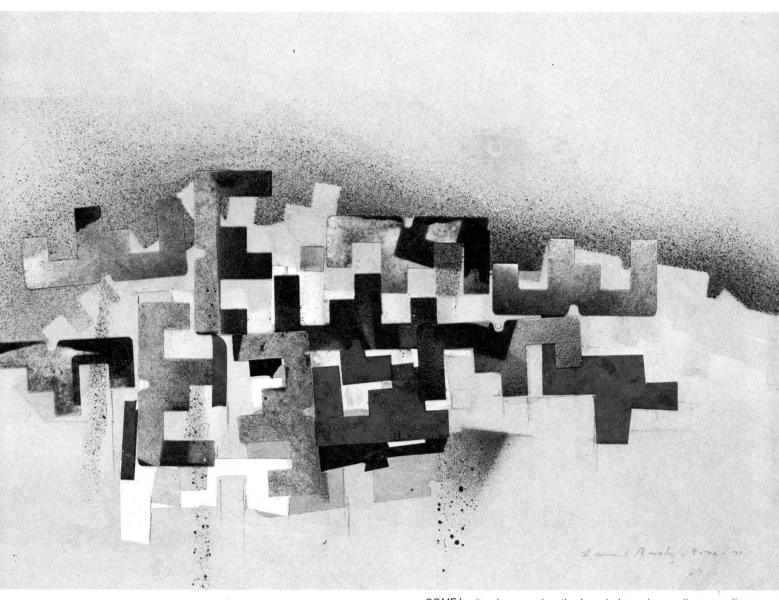

ROME/ *city shapes using the found shape in a collage acrylic.*

Later, back in Rome, on another walk, I found myself passing the same spot where I had originally found the shape. I scratched around under some weeds and leaves and found not one more, but twenty or thirty "Castle symbols"... obviously a box of discarded Shapes had been tossed over the wall at one time.

So I was all set. I took them to the studio, traced them, interlocked them, stuck them down in a collage, sprayed them with different colors. I used them as design templates, and sprayed color around them as stencils. I cut out small

versions of the Shape, and large versions. I saw them assemble into modern apartment buildings or form part of some of the best paintings I did in my year in Rome . . . a "Medieval Walled City" series which formed the greater part of an exhibition I had later. I felt as happy as Braque must have felt when he found that mysterious bird form take him over and appear in dozens of his paintings almost without his direction — he even painted them on the Louvre ceiling.

What I am trying to say is that this is the way art is generated sometimes,

mysteriously, madly, and to some people it would appear very crazy indeed. Of course, if I say to these people, "how do you think a composer picks his notes out of the air and develops them or a poet discovers his poems? We have to start somewhere, and anything is legitimate that produces the final result we are after. If an old rubber boot, a feather or an old piece of steel is the beginning . . . let's have it, by all means. And that's the story of the Shape I found."

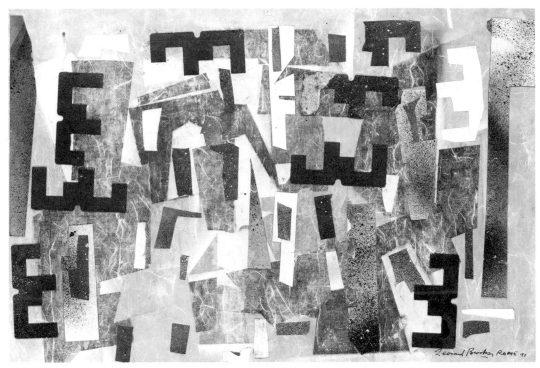

An abstraction using the same found shape.

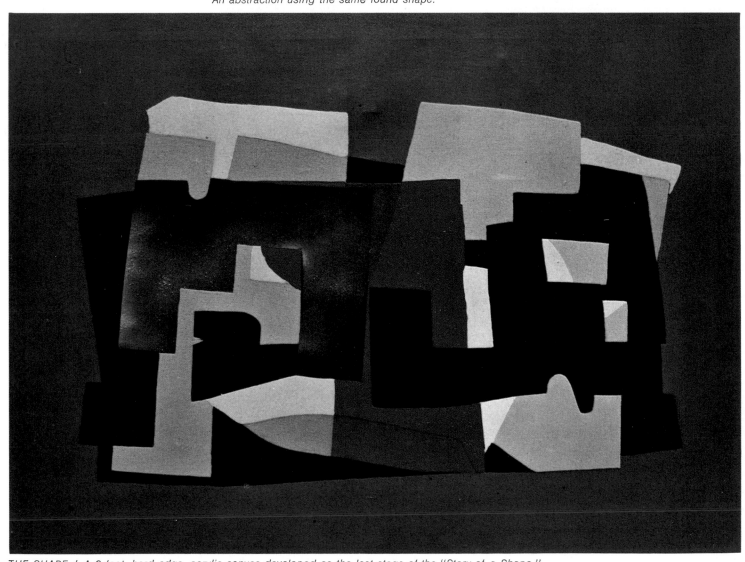

THE SHAPE / A 6-foot, hard-edge, acrylic canvas developed as the last stage of the "Story of a Shape."

Textures

The varied textures of nature provide constant surprises and new material for the artist. Observation and memory, sketches and notes, photographic documentary — all of these combine in the experienced artist's eye and mind to make his painting.

■ Enrichment of surface with variation of form and texture give visual excitement to our subject, be it figurative and realistic or abstract or purely non-objective. The photograph of a tropic shack provides us with surface agitations in plants, wood, stones and debris. Similar interest is created when we work in a non-objective manner. We strive to create our own broken textures and forms. These may be predicated on actual experiences of seeing (the sea shell, beach watercolor reproduced on Page 37 is an example), or we may create new and imaginative surfaces of our own as shown in the two illustrations on Page 110 at top.

SPLASH AND SPATTER — rollers and paint, to invent excitements of textural qualities.

FREE FORM in circular mode forming lively, rhythmic pattern in overlaps of textured space.

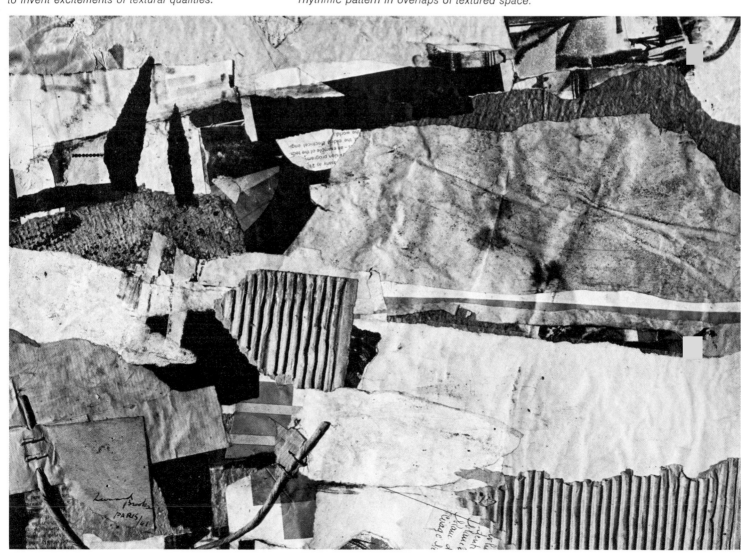

BEACH TEXTURES / Corrugated board, acrylic stained materials and sand form textured surfaces of dimensional relief collage.

Photography as an aid

■ Many artists enlist the aid of the camera in their work. They may use it to make a record of a person or a place they have painted, or details of architecture or costume or even a note of color for future reference. Some painters, super-realists, use the photograph to provide them with material which they copy as faithfully as possible, often to the point of ridiculousness. Why not blow the photo up to the size of the painting and let it go at that? The photograph is generally more interesting than its patient, faithful rendering in oil or acrylic.

Photography is also used by artists as well as photographers to make interpretations by means of processes of negative reversal, color overlaps and black and white reductions, which often make it irrational for the black-and-white illustrator to compete with its finest artistic results where exactitude and precise definition of reality is the ultimate result wished for. The really creative photograph makes its own statement and is complete in itself.

I have never used photographs with any degree of success. I have always preferred the use of rough notes, even a line or two to refresh my memory or to use at a later date. I did use a camera during the Second World War as a naval war artist for the Canadian Navy as it was impossible to draw or paint on a tossing Corvette in mid-Atlantic on a winter day, or to catch detail I needed when action came my way. But I was never happy with this aid. Today, many fine prints are available to me from my wife's files (she is a noted photographer). But I seldom consult her portrait, figure or landscape prints or color transparencies, even ones she has taken at my insistence when we have come upon a subject we both liked. Instead, on our travels, I prefer to collect postcards of all kinds, some taken fifty years ago by some itinerant photographer presented in a simple, direct vision. They have their own style, at times a mediocre and shabby recording of facts, and later when looking over my postcard collection they leave me free to renew my feeling for a strange corner of Morocco, or a decayed Umbrian mountain village, or wherever. I do not feel the urge to transpose their content into paintings, but can feel myself back in the country and time from which they came.

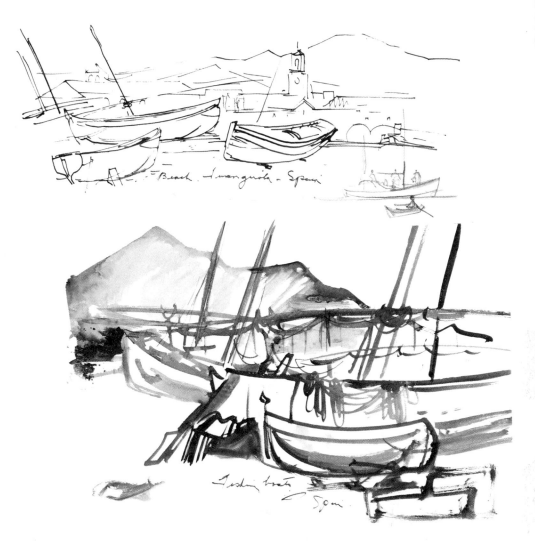

POSTCARD

I did know one painter who carefully set his Kodachromes by his easel in an enlarging unit and painted form them . . . and these paintings looked like it. I also knew a fine and famous artist who used his snapshots of New York life, slums and bridges as a source for fine paintings renowned in many galleries. Perhaps you can find your camera a help with your painting. There is no law against it. Perhaps happily it can be another phase of expanding awareness on your part, and if so, why not use it?

Local postcards and snapshots can provide needed detail. Generally, a rough sketch drawing, and written notes are more valuable to capture the essentials for later work in the studio. I make these in line, wash or crayon in my sketchbooks.

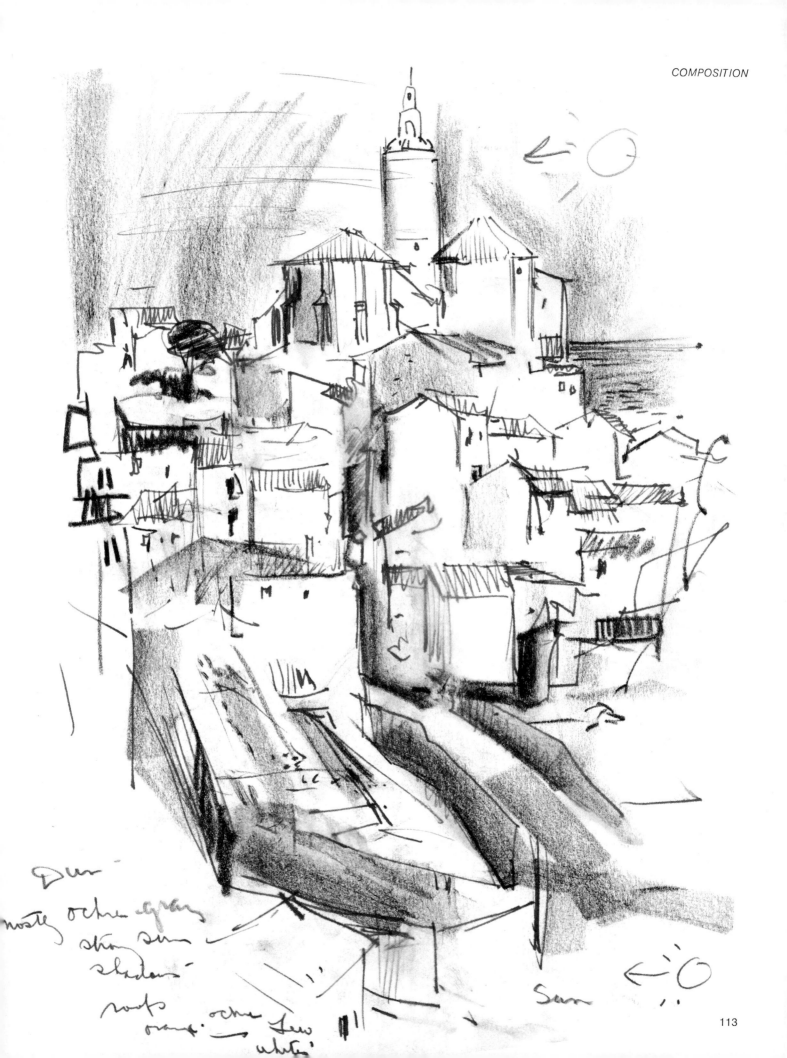

Stoking the creative fires

■ Sitting around awaiting an inspiration may be a pleasant and romantic thing to do. It is one way of recharging the creative batteries. Too often, however, it can become a tiresome period of frustration and most painters search diligently for a system that suits their particular needs to get out of the impasse. Many of my painter friends have described to me their particular ways of breaking the blight of non-production when ideas and inspiration are lacking, which happens to most painters at some time or other.

One artist I know makes himself draw with the left hand; another starts his drawing with his eyes shut just to see what will happen. Others like to work over old canvases or to start a painting upside down just to see if they can jolt themselves out of repetitive habits and surprise their eye with a new form or line unlike their usual one. Many depend upon the traditional habit of looking through old note-books and sketch-books where ideas have been stored up with forethought for just such an arid period. Often a slight jotting of a subject or composition will entice the brush into a new struggle. Leonardo da Vinci wrote of the wonderful suggestions he found in the stainings and markings of old walls as a start for the imagination to get to work. I know of one painter who will never work on a blank, white canvas or page, but always has prepared beforehand tinted and broken textured surfaces for his paintings.

I find a helpful aid to my beginning a painting in the technique I have developed for acrylic-collage. The building up of a prepared ground with layers of Japanese papers of varied weight and texture gives me a surface full of possibilities. The reverse technique also helps. Scrubbing in thin layers of light acrylic textures in off-whites or rolling out a ground with rollers and paint provide a beautiful, attractive surface on which to build collage papers or paint. Of course, the important thing is to have a statement you wish to make — but it is surprising how setting up the right conditions will encourage the statement to emerge once you give it a chance and a *start*.

A warming-up exercise

When you study music, you have to practice scales. It is not the loveliest sound in the world, but when it is done consistently it pays dividends later. A real professional knows how a period of warming-up prepares himself for freedom of expression when he wishes to concentrate on playing without problems of technique to hinder him.

Here is one of a series of exercises I use in a similar manner occasionally. I cover a large page with freely drawn lines using a pen or brush. I find this especially useful before trying a large, abstract canvas. With differently sized and shaped format — rectangle, oval, square — I fill in lines and accents with as much variety of movement and space-filling, avoiding repetition. Lines cross, interact, double back on themselves. No reference to figurative matter is intended. Use the wrist and let the lines flow, drawing quickly. This may look like a very simple thing to do but all I can suggest is that you try it yourself. I have watched too many students completely inhibited about this kind of gesture making or ending up with very dull stuff indeed from an inability to let go and release themselves from repressive, cramped drawing. Such exercises and "doodles" will release timidity, give the hand confidence that will carry over when you tackle a loose, vigorous watercolor or wash drawing.

After you have done a number of exercises in this manner you should be able to try a more serious version of freely conceived structures. Perhaps you feel confident enough to try a painting directly on a canvas, painting it without preliminary sketches or plans. Somewhere within you the urge to do a large, circular motif may be dormant or a painting based on long horizontals opposing curved, rolling contrasts. The smaller doodles may have started you thinking about the excitements of space-filling with sensitivity and meaningful design. You perhaps are beginning to understand how a broad, forceful stroke of a well-charged brush of paint may transmute with fluidity and energy some of the emotions of the artist. The mystery of how such strokes and markings, integrated in a rapid statement, ordered into relationship with other strokes and masses, can convey a spirited feeling of rightness, completeness, or — only too often — mere splashing about and vacuity, has set men pondering about "what is art?" for centuries. There comes a point where talking or writing about this mystery doesn't help much. We just know that it *is* so, and in essence this is what art is all about. We know that it is right and could not be any other way. Someone once said that Picasso couldn't toss his socks over the end of the bed without making them look "interesting." A ridiculous statement with elements of truth. He *was* a man who

Warming-up exercises fill various size formats with free design forms.

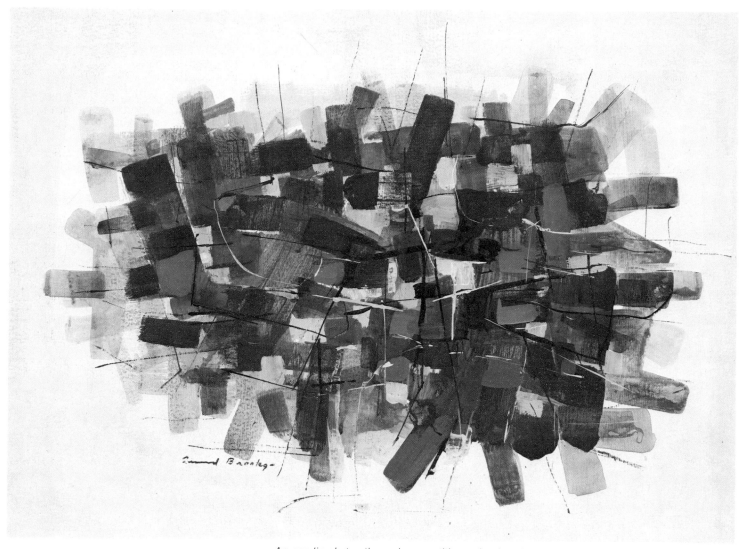

An acrylic abstraction using repetitions of colored lozenges in a pattern of transparent color.

made gold from dross almost without trying. Invariably he transmuted the things of his world about him into a new and refreshing image. What more he might have done if he had worked in the realm of complete abstraction, we will never know, for he confined himself to figuration, or at most, to a far-removed distortion and emphasis of a reality based on people or objects. These musings aside, let us get to work with our calligraphic painting and brushwork. Try a tinted paper and a one-color wash. Begin somewhere, get the painting underway with a large brush and lots of water. Plant the seed and let it grow, one branch sprouting from another, one mark demanding the next. Search for the inevitable next stroke to

come, the fruit following the flowering bud. Don't be afraid of spoiling the paper, there is plenty more where that came from and you can easily scrap the effort and begin again, or wash the marks away under the tap.

Don't overwork the page. Stop from time to time and consider where you are going, stop in fact before you put in afterthoughts and "touching-up" strokes. If you have never tried to work in this manner before you will surprise yourself from time to time, particularly if you put the work aside and look at it at a later time. After years of brush-handling and experience in working with gesture and freedom, the thrill and excitement of inventive composition will grow greater.

Nervous energy, the possibilities lying in the sub-conscious mind, the stock-pile of visual elements, forms, single and combined, memories of things, places . . . everything experienced will be concentrated at the end of the brush wielded by a sensitive hand and mind. And some of it will come out on the paper before us if we allow it to come to life.

A number of reproductions are shown in this book that illustrate the freely abstract and calligraphic approach. These began and ended in an organic growth. The end result, color, form, design, grew from first stroke to last without a preconceived planning. The search for the inevitable right mark, shape, accent to form a right completion making up the whole.

Transposition

THE QUESTION OF CHOICE

■ One of the big questions you must ask yourself is — as every painter does from time to time — where are you headed with your work? What is *your* direction and destination? What are *you* trying to say? This seemingly obvious question lies at the root of much of the problems facing students. It can be the reason for their frustrations and much of the mixed-up, inconclusive nature of their work.

The word we must remember constantly if we wish to clarify our own particular direction is *transposition*. To transpose. To interpret the material we see about us, to bring it forth from deep within us from the many experiences of our feelings and emotions, and to move these raw materials into the world of visual, plastic form is not easy. Discovering the degree and kind of transposition we require is one of the great secrets of a unified and truly creative result at the end of our toil. Knowing how to absorb and store material for future use is an art in itself too.

Paul Klee wrote in his Bauhaus notebooks that merely noting things in order to remember them was vastly different than "trying to reveal what was not visible." The fundamental point of artistic creation, he argued, was in this difference.

Transposing has many degrees and we may wish to take our subject far from its beginning, orchestrating, amplifying, or simplifying to an essence in order to make our statement more coherent and communicative.

Whatever we begin with — a subject of realistic nature, an idea, a mood, an abstract motif — all of these must filter through our individual straining nets and come out marked with some stamp of our own marked on them. Part of the dilemma which occurs when we begin the sorting out process comes from the many choices we have before us these days. So many ways of thinking and working! But now, *before* we begin, is the time to decide what we are after and what special idiom and transposition we shall utilize. Let us take a particular case and follow through some of the ways we may use to help our decision.

An organic build-up of strokes in automatic sequences, free from realism or subject matter. Such paintings will help you in painting from nature such subjects as the small cloud study (at right).

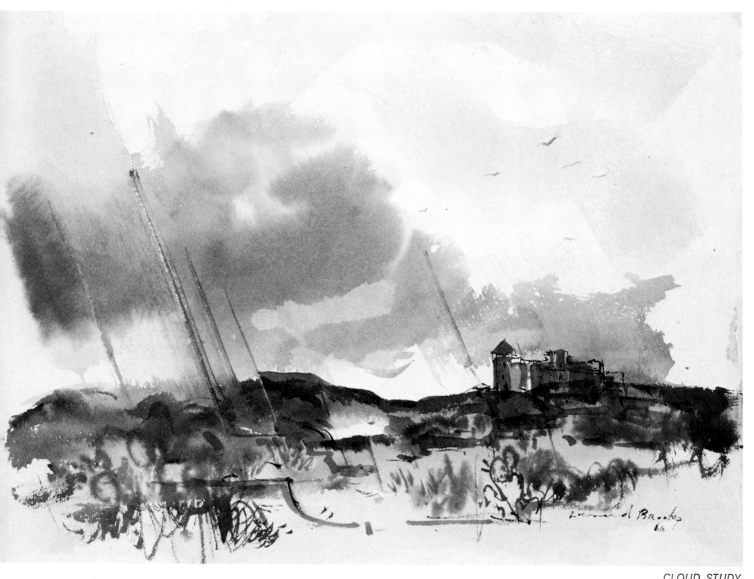

CLOUD STUDY

The apple is before us. We pick it up, polish it, feel its roundness, bite into it. We enjoy its color, form, its light and shadow. Now we must give it its new entity. We are going to put it on a flat surface, put a line around it, or color it, or cut it out of paper and paste it down. How far shall we take this rosy fruit . . . or face . . . figure or landscape from its original objectivity into our painter's world?

Do we want it redone in the most representational manner we can manage, literal and photographically imitative, carefully and correctly tinted and drawn? Should it be fused as part of a composi- tion, lost in a new pattern of lines and forms; shall we discard it altogether and only remember a sensation of red and roundness, that a rosy hue and roundness is tucked away in our subconscious mind for some future use? Or do we want to meet it half way and do a Cezanne all over again, searching out the "significant form," the solidity of an object in three dimensions skillfully reduced to its symbolized two-dimensional space on the picture plane and in pictorial space?

I think that if you are aware of the many variants and possible ways of interpretation, plus having the knowledge of many media and techniques at your beck and call, your chances of successful finding *your* answer to these questions will be easier than coming to them without a sufficient background of possibilities open to you.

Studying painters and their works and theories, visiting art galleries, experimenting with various ways of working may not make you a great painter, but you will at least have expanded your inner vision and store of knowledge — you will have prepared the way for the choice you must always make for yourself —"what do *I* want to do?"

Janitzio

Many years ago I was sketching in Mexico on Janitzio Island. We took a photo of the subject and I made a painting for future reference. At that time I was ending many years of working from out-of-door subjects . . . trying to use them as a springboard for meaningful design and color to express the mood of place and the sensations I felt in front of Nature. I had learned how to select, how to reject, and how to get something more than a literal copy of a place. I had disciplined myself to analyse and dissect what Nature placed in front of me and had dominated the many problems of painting such as drawing, tone, color, and the handling of many different media to the best advantage.

If you consider the photograph you will see how the struggle to extract the pictorial possibilities of this place were aided by quick drawings and analytical notes. At that time, what came out of it was a painting that was well done and handsome enough to be in one of my exhibitions later on. Somewhere, it is in someone's collection being enjoyed, I hope, as a sensitive interpretation of that part of Mexico.

Some years later, while working in my studio in Rome, I was thinking in one of my "red" moods, and I started to do a small, collage acrylic. Some days I *have* to do a painting in reds, other days in all blues, or whatever. Somewhere in my subconscious mind different colors are hidden and at certain times demand release — much as we might want to whistle a sad tune at times, or at other times hum a happy melody. "When I have soaked up too much green," Picasso is supposed to have said, "I become saturated, and have to paint green paintings." I will never know what distillation of recent impressions made me *have* to paint that red panel and that it had to emerge into an exciting combination of contrasting shapes . . . simple, large blocks of color, angles and some soaring verticals playing across these forms. This was the germ of the painting in my mind's eye, and I had done many paintings before with some of this basic design content. Now I wanted to do another . . . had to do it to get it out of my system. When it was done I called it JANITZIO. You see it reproduced on Page 119. Some time ago, I came across this painting in my portfolio and it greeted me like an old friend. I discussed all this with a fellow artist visiting me at

1. JANITZIO / A photograph of a subject for transposition.

2. A fishing village provides an exciting motif for the sketcher. Fishing-net poles, strong diagonal shapes and verticals form a strong pattern of shapes that lose their identity as walls and bricks, and become new combinations of interlocked light and dark design. A quick analysis of these patterns is made with brush and ink.

3. Another step in transposing the subject. A tracing is made over the black and white in Fig. 2. This is then reversed to see the pattern anew, and the shapes freed from the fixed camera seeing. Shapes are also lost and fused as the effort to fill the space in a dynamic breaking-up of the picture's two-dimensional flatness.

4. The subject is reduced to a simple linear grid of varied shapes of a geometric nature. Details are obliterated and the structural possibilities move toward an abstraction, a freer interpretation.

this time, going over with him the basic composition of the subject photographed so many years before.

"Janitzio," I said, and then thought to myself, ". . . but evolved and changed — form and color absorbed and filtered through a network of a thousand such memories and studies of mood and place. Diagonals, vertical thrusts cutting the large geometric planes . . . a few accents added to the broad, simple areas, strong contrast of color freely chosen by me, not forced upon me by the reality of the moment."

Some part of me had fused these impressions I had gathered to myself over the years and they had emerged as an entity to be appreciated for itself without benefit of its history or reference as to how it came into being.

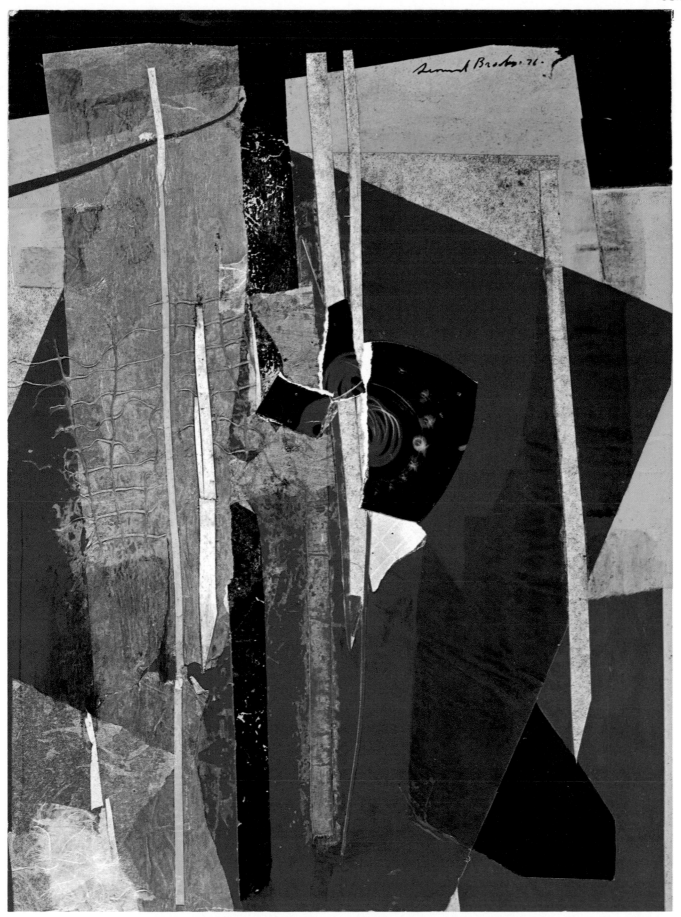

JANITZIO / Here is the painting that came into being many years later in which the structural lines and large, open forms brought to life the mood and memory soaked up and stored in the artist's deep well from which may come his "inspiration." This acrylic uses some collage elements. Note the nylon yellow netting and torn paper accents.

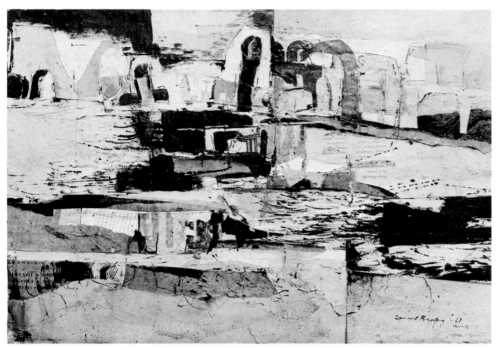

BROOKS / *HADRIAN'S BATHS*

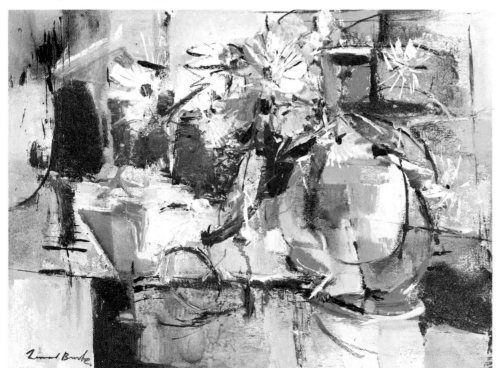

BROOKS / *FLOWER STUDY*

Acrylic washes are painted on glass and an offset print is made on dampened paper by pressing the paper on the painted glass while the colors are still wet. Interesting underpaintings may be made in this manner.

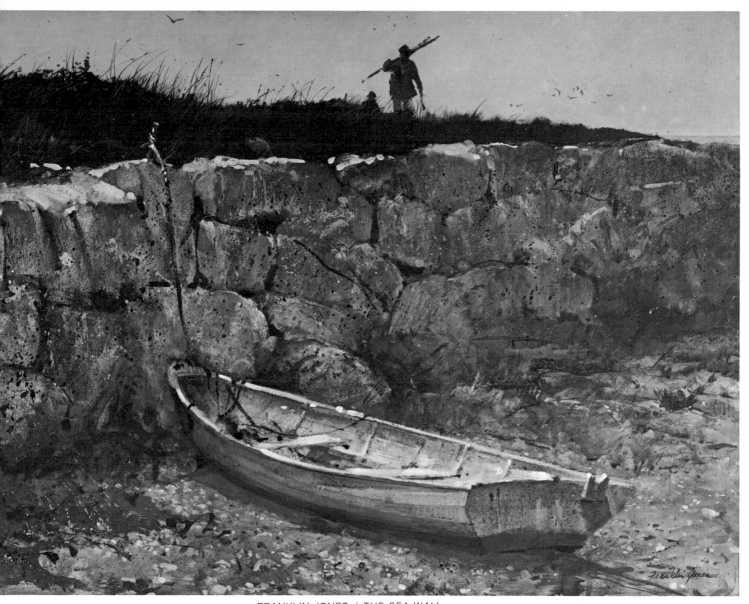

FRANKLIN JONES / *THE SEA WALL*
In this acrylic painting, spatter has done much to create the effect of weathered, exposed rock.

■ There are many ways in which markings can be used to enliven acrylic color areas. Controlled and accidental, the acrylic paints, watercolor or inks are used to break up flat passages of color or tone by overwriting which is applied in many different ways. Sometimes the painting is placed on the floor and spottings, flicked dots and dashes are added, isolating the area not to be painted by a layer of newspapers. Small brushes are flipped rapidly to obtain a broken series of dots, larger brushes dribble lines and dashes. Agitations of the surface similar to those suggested to be done in previous wash exercises will suggest further textural devices that can be utilized to give design interest and textures. It will take experience and experiment to know just how to flip the wrist and brush with the right speed. Try it out on newspaper for control, changing the amount of water and pigment in the brush and its density. Lines and spots can be made with the quill pen or bamboo stick; paint applied with pipe cleaners will make an interesting broken line. Try the sharp edge of a steel or rubber spatula. Press paper that has been painted and offset it on the canvas.

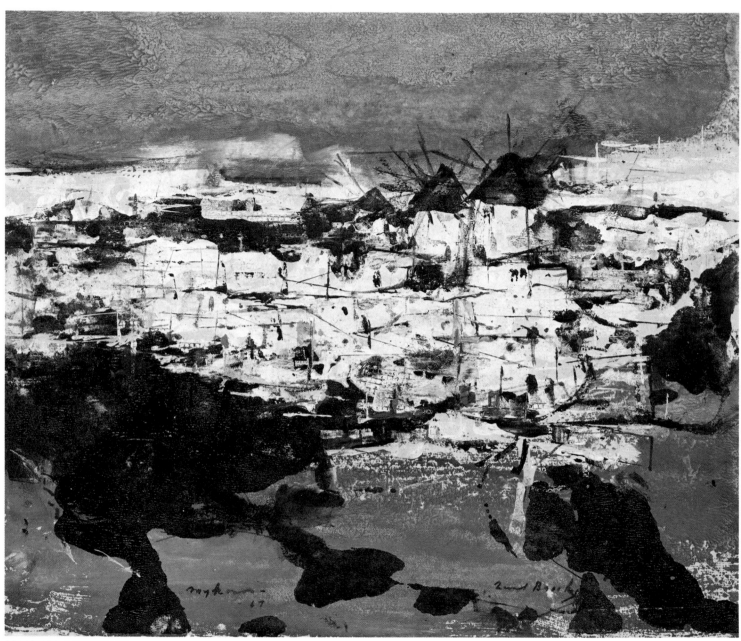

MYKONOS LANDSCAPE

Monotypes — Acrylic Offset
Painting acrylic on glass or a smooth, plastic
surface and offsetting it by pressing down a
dampened paper will make interesting prints.
Details, if blurred, can be touched in or lines
added. Degas did many monotypes in oil on
paper in this manner.

Casein and gouache

Some years ago, before acrylics were put on the market in a form that artists could use, casein came into prominence as a valuable new medium for the artist. I remember well the excitement when Shiva put out his line of fine pigments in tubes for artists, and how I was privileged once to visit him in his Santa Fe home and workshop where he was experimenting with new colors and the associated varnishes and emulsions to be used with the casein. Today you will find it difficult to come upon this product in most art supply stores, as it has been mostly superseded by the acrylic paints. Casein is a derivative of the traditional tempera color that was used for centuries. It is described in the encyclopedias as, "a protein precipitated from milk . . . forming the basis of . . . certain plastics." Casein is not to be confused with fresco or true gouache.

I have illustrated several works executed with casein. At quick glance, the originals have not a marked difference from acrylic, but to the painter as he uses them there are many differences, advantages and disadvantages that he must consider. Casein, used often before acrylics as an adhesive for joining wood, was also used in a limited way for an artist's color binder. It is made by heating skimmed milk with the addition of hydrochloric acid. In powdered form this glue ground with colored pigments made the casein as it was developed for the painter's use, and is similar to gouache in many ways. Gouache or tempera is a generic term for the several opaque water based paint media that leave the surface of the painting with a matte or non-shiny density. Sometimes the yolk of an egg is used with preservatives to bind the color, or glue size, casein or other binders that now appear will be made obsolete by the invention of plastic emulsions. Some painters still practice the art of egg tempera or straight gouache painting, finding its limitations and slower processes a useful deterrent from too much facility and ease of execution, or because they find subtle differences and qualities in using an old master technique to that of modern technology.

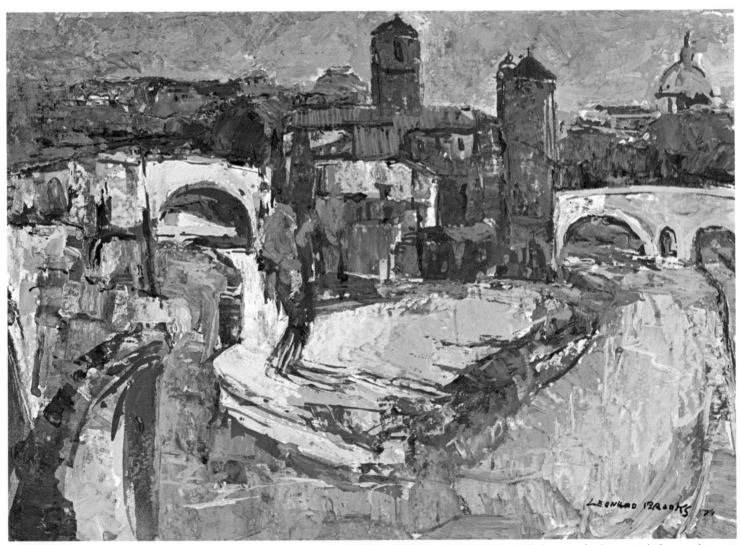

THE TIBER, ROME / A small sketch made in gouache in one painting on the spot.

Fresco is the ancient art of painting with powdered color into wet plaster, and is another branch of the vast water and color media.

Perhaps you would like to try working with casein. Here are a few notes that you might find of value derived from my own experience with it. Let us list the disadvantages first.

When you squeeze casein on to the palette, it dries rapidly. You may add retarders to keep it moist, but if you are sketching in a hot climate, you will find the pigment dries on the palette before you have finished doing your sketch. In the studio it is easier to manage and a wet cloth over it can even keep it moist till the next day. It has a tendency to "muddy up" your color mixtures unless you rinse the brushes often and thoroughly — unlike acrylic that rinses clean and the pigment dispersed rapidly with a quick twist of the brush in water. It does not set hard at once and overpainting on an area will disturb the underpainting unless you isolate it with a wash of emulsion or matte varnish that seals the undercoating before putting thin glazes or washes over it. Colors have a habit of hardening in the tube if left too long, and I have thrown away many a solid tube of casein that was simply not useable after a few months of being left on the shelf.

Yet, in spite of the above drawbacks, casein has an ingratiating quality, a velvety surface when properly handled that

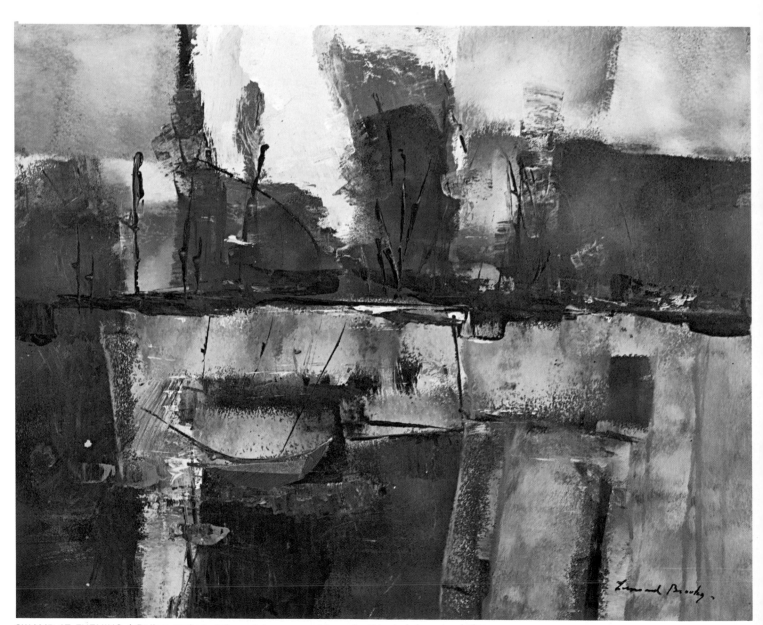

SWAMP AT EVENING / Rollers and gouache paint were used to make this dark-keyed painting.

JULIAN LEVI / *CLEAT*
Gouache on gesso panel.

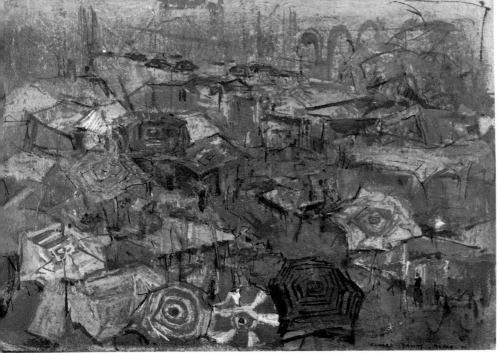

ROMAN FRUIT MARKET

Casein paint was used to make this sketch of colorful umbrella shapes in a Rome piazza market place. Casein paintings may be varnished with a casein varnish that leaves the painting sealed in a matte coating similar to acrylic varnish. I have also sprayed acrylic fixatif over casein paintings.

is very satisfying to the artist who likes the quality of surface finish in his work. It can be handled in a watercolor technique, transparently or semi-transparently. It can be built up with opaque overpaintings and scumbles of thick paint until it glows with contrasting surfaces. It is an excellent medium for fine, detailed work as well as broad, loose handling, and many artists find it an important way of setting up underpainting with textures and impastos that can be finished later with oil glazes and oil brush work over the initial imprimature. Its matte quality can be varied with varnishes of various degrees of brilliance, and its adaptabliity to many kinds of surfaces, paper, gesso, and other non-oil supports, makes it valuable for the traveling artist who wants work to dry quicker than oil on his sketching trips, and yet be more than a quick color note in watercolor.

The black and white sketch shown at right is a preparatory study of a cold, moody day in Venice made during the October rainy season. During these gray and cold days the colors of the ancient houses and churches sing out in rich ochre and Venetian reds against the dark sky. The ink sketch was made on the spot before attempting the casein painting on Page 127. This was painted in an hour of rapid work using loose, broad washes of semi-transparent casein color on illustration board. Over these the over-writing of details was made with a smaller brush and the details of windows, roofs, etc., added at the last. A consistent sketchiness was kept throughout and the painting was not touched up later in the studio. Such "one-shot" efforts are exciting to do and if they come off fairly well seem surprisingly finished when seen later after a period of time away from the subject. The essentials have been put down rapidly, minor details dismissed and only the main essence of mood is strived for.

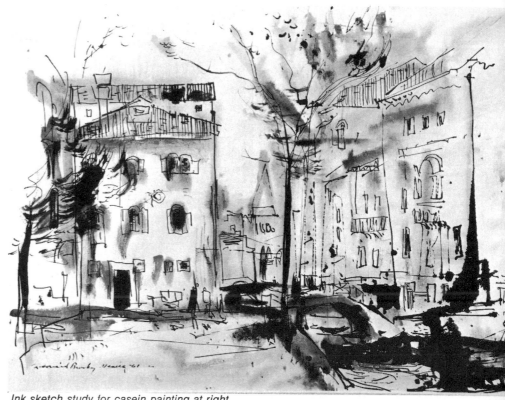

Ink sketch study for casein painting at right.

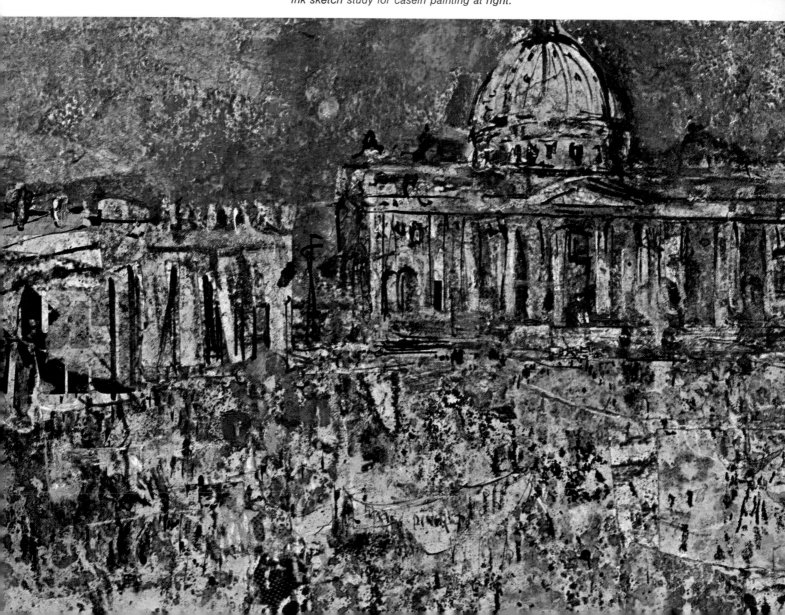

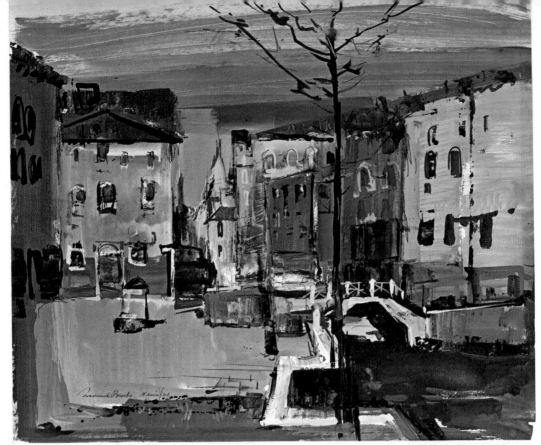

VENETIAN OCTOBER / Casein.

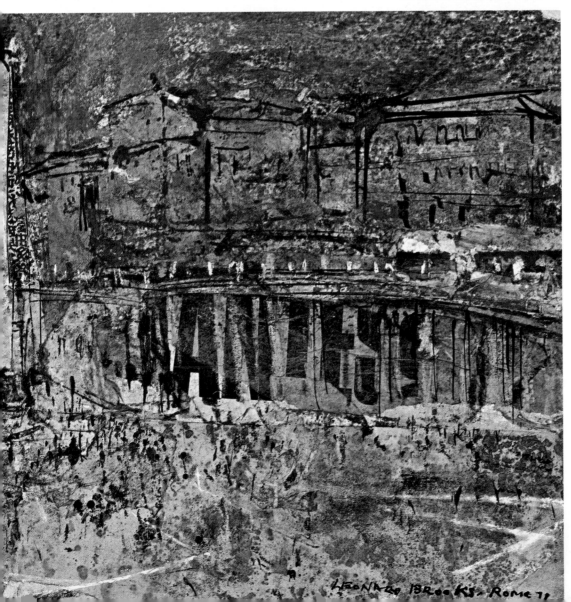

THE VATICAN / Casein.

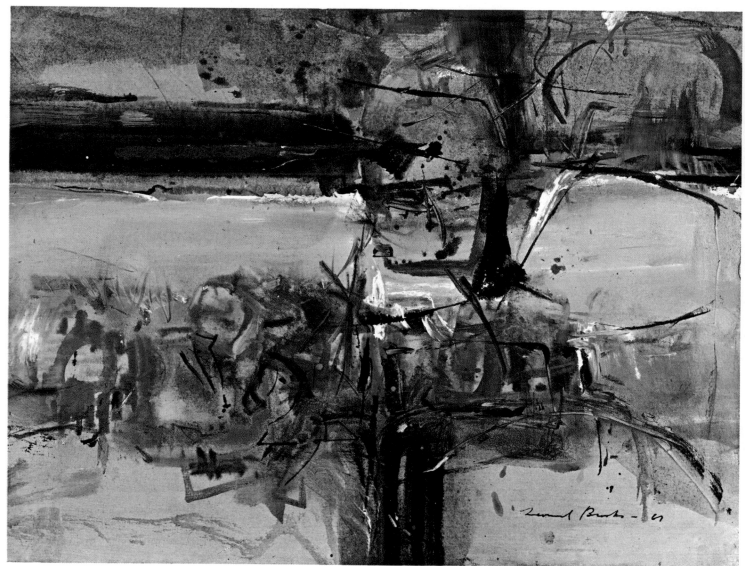

ABSTRACT LANDSCAPE / Gouache.

WASH DAY, VENICE (at right).

Inks and marking pens

■Colored inks, generally used in commercial illustration have merit for quick notes, though most artists distrust their permanency and their rather garish brightness, you will have fun working with them in your sketchbook as you will with watercolor nylon-tipped marking pens. For rapid sketching or combined with washes of watercolor or acrylic they are very adaptable and convenient to use. Marking pens with dilutable watercolor pigments are useful as well as the non-soluble type of marking ink though these can fade badly.

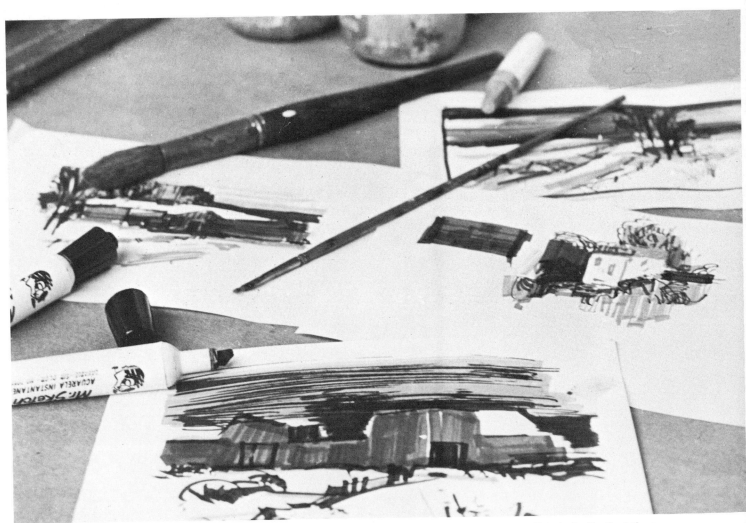

Marking pens using watercolor inks are useful for rapid sketching, but many are not permanent and will fade badly. Test them.

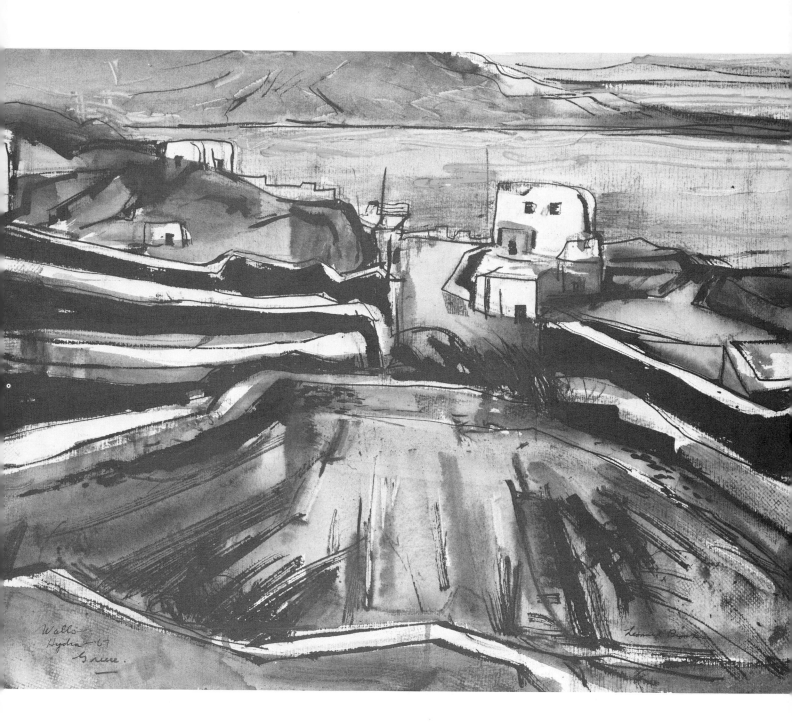

Walls
Hydra 67
Greece.

131

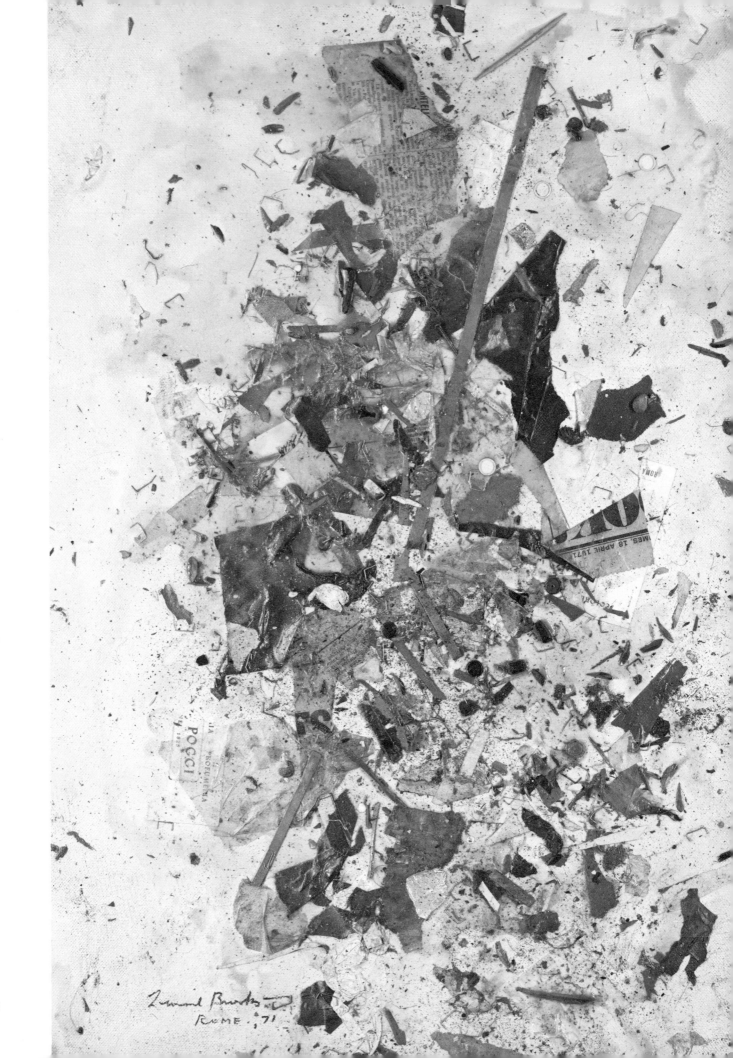

Being yourself

■ What shall I paint? This may sound like the most unnecessary and sophomoric of questions, but I am always amazed and surprised at the dilemma many students get themselves into when they are studying and trying to find themselves. So many choices, so many different ways of seeing, thinking and executing work! Theoretically, no object or idea is tabu. If you have fresh and valuable responses, more than the sky is the limit, and with talent you can make fine paintings of any subject and perhaps even come up with a masterpiece predicated on any material. The spate of "Pop" paintings made new visions of such homely things as Pepsi bottles and hamburgers by using sharp, new focus, by outrageous enlargement, or by mimicking the objects themselves in plaster. It is questionable whether or not they will become "masterpieces", but some significant work did emerge that was provocative and refreshing.

Before the sixties many more artists rejected realistic subject matter, and literary, figurative content was pushed aside in favor of the inner searching that had brought about Abstract Expressionism. Lately the cycle has turned and many young painters have found their direction in a kind of smooth, super-realism that is derived from photographic seeing carried to its zenith with skillful, illustrative techniques — a complete contradiction to the large, emptly, "non-art," giant canvases, stripes and nebulous, floating fields of color favored by many post-abstract expressionists.

Any of these styles, when springing from an authentic source can produce fine art. They can also, when weakly imitative or forced onto an individual as a "fad," produce meaningless daubs and second-rate efforts. Freedoms can end in chaos; tight, realistic, untalented realism can end in mediocre illustration.

A beginner should not be discouraged from trying anything that interests him, but what I especially like to encourage in a student is an interest in volumes, lines, colors and textures that can be found anywhere, aside from a subject's specific literary values. Generally it is a detriment to have too much of a story to tell in literal terms. It is almost impossible for a tyro to have fresh, good things to say about the subject as such; strong, realistic values are hard to dominate aesthetically in paint unless magnificently presented.

Of course there is such a thing as too much strictly "painting" subject as material and there is such a thing as too little. An artist can, within the scope of his talent, paint his environment to the limit, and then become completely bored with it. But this is not a problem that confronts a beginner who has much experience ahead of him before a chosen theme wears thin. A man with a thousand drawings and many paintings behind him will go on searching for a refreshing renewal. The beginner may find himself flitting about too quickly and too widely in his search for a genuine interest and workable theme and never paint anything worthwhile. The serious painter, beginner or professional, will carefully and devotedly feel his way, exploring his world and himself as a painter.

STUDIO MOSAIC (at left)
"Found material," actually the sweepings of my Rome studio floor after some weeks of working there inspired the vertical panel reproduced here. A thousand colors and textures, cut papers, collage ends, thumb tacks, pins, pencil shavings, linoleum chips, staples, etc.— all these seen on the marble floor glowed like a rich mosaic. Somehow I was able to get them imbedded in a coating of acrylic emulsion, and by judicious dropping and moving on this glue, was able to assemble the pattern onto a prepared canvas sheet. The accidental cohesion of color and texture made up a rich surface and a souvenir of my studio days in Rome.

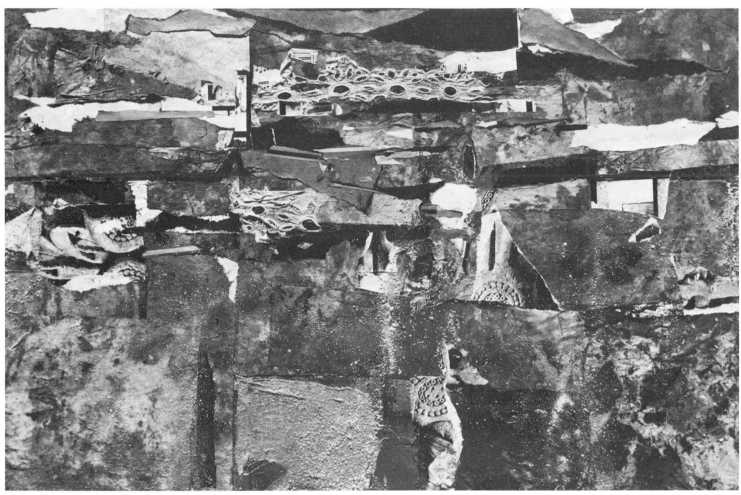

QUARRY

Torn photographs, lace, stained cloths and papers are used here with marble dusts and sands added to the acrylic pigments to give variation and life to the painted surface.

A summing up

Throughout these pages we have written and demonstrated some of the many ways of using water and color, and you can appreciate what a vast world of possibilities awaits the artist today. From the tight and meticulous rendering of the academic tradition to the latest techniques of acrylic pastes, sprays, rollers and vast canvases of mural size; combined methods, collage and mixed techniques ever expanding; all these ways are acceptable today and the excitement of a new experiment may awaken new, creative powers within your personal world of expression. Yet there are risks in these freedoms. Limitations have their value. There is always the danger of too much attention to technical procedures, to novelty and fashionable modes. Somewhere in-between, the truly aware painter finds his means and uses them to his advantage. The early attempts to use acrylic are quite recent. Around 1960 many artists bought polymer emulsion and ground powdered colors into it. There were no tubed acrylics available then. A workshop in Mexico developed the first commercially prepared jars for artists' use, and we marvelled at their adaptability as we first used them for murals and easel paintings. The plastic glues opened the collage technique to new horizons (no messy paste or glue), giving a transparent, inert adhesive that served as its own washable, protective coating. Cans of pressure sprays gave easy access to dispersed, soft, linear drawing or sharp-edged stripes, and boundaries of clean edges; adhesive tapes eased the formal

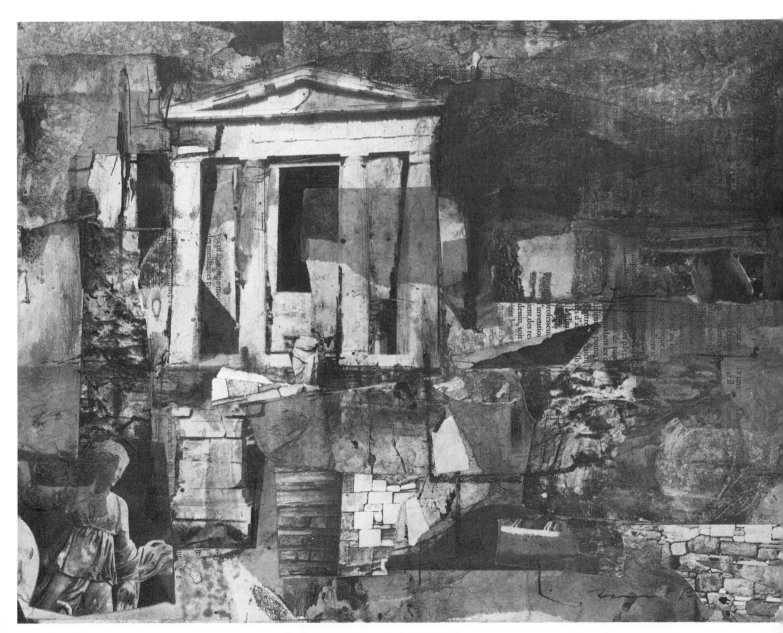

135

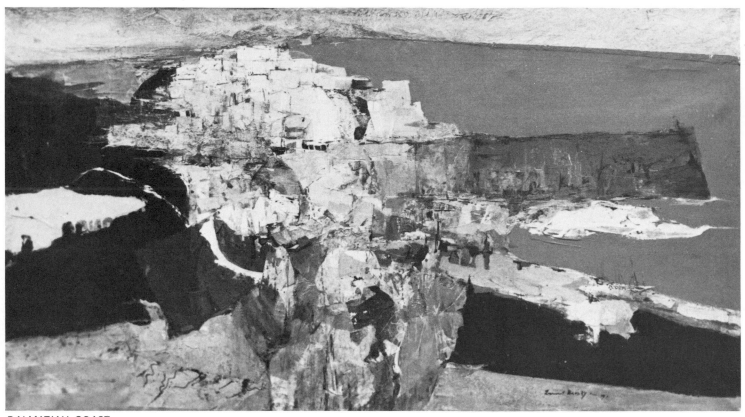

DALMATIAN COAST

painter's technical execution of precise deliniation in quick-drying paints. The limitations of paper size became negligible when waterpaints could be used over vast canvas surfaces, charcoal lines fixed with plastic sprays permanently. The contemporary painter can and does use these new means in part or whole heartedly. Or he may prefer to stay within the confines of tested routines of technique using his favorite content and subject matter. His very rejection of modern usage of new material may be, in its way, his own form of rebellion and a needed security for going in his own particular direction. For some methods the painter needs little more than his

standard watercolor box of paints and a few good sables and some hand-made watercolor paper. There are still worlds to conquer with such simple means as I have tried to show in our earlier chapters about the fundamental techniques as used by the great, early masters of ink painting and wash. Also, the traditional painter in watercolor who wants to enlarge his scope and express himself more deeply can do so by the use of contemporary innovations. By fear of leaving traditional means he may be missing the opportunity for his finest expression, the best of which he is capable. Learning these new ways and breaking old habits will contribute to his art.

The final choice is, of course, the prerogative of every individual painter, amateur or professional. I would like to think that this account of some of my experiences with water and color will help you in finding *your* personal technique and expression. Whether it be a quiet projection of contemplated nature in an idealistic mood and rendering, or a sternly organized interpretation in purely aesthetic form; be it simply beautiful color or the most inspired, individual offering — water and color awaits its practitioners as it always has since man sought to put down his dreams and images. What we do with it is entirely up to us.

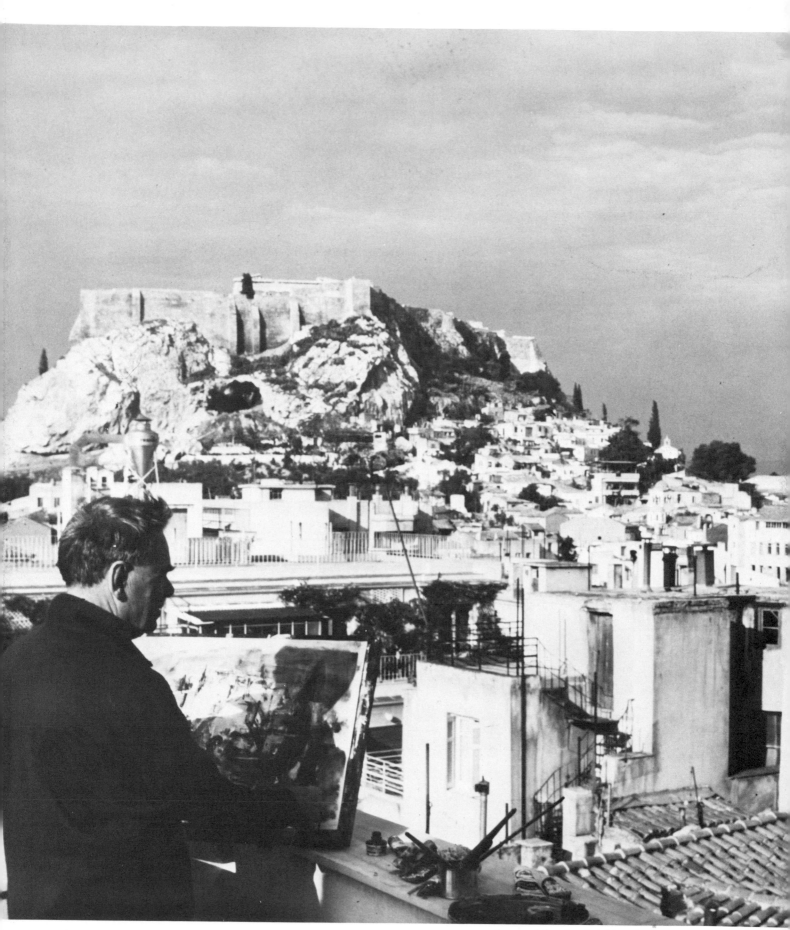

Leonard Brooks sketching the Acropolis, Athens.

137

BROOKS / *ANDANTE*

*A musical mood, collage-acrylic made to
evoke the slow, sad notes of the* andante
*from a favorite Beethoven quartet. The sombre
notes brought the mauves, blacks and grays
into dominance, the shapes springing into
being without too much conscious analyzing
of why. Such paintings demand their own form
and have their own expressive life, symbol
and form, divorced from ordinary subject
matter.*

BROOKS / *ANGILLARA, ITALY*
Sketch in acrylics, used like watercolor

BROOKS / *MAZARILLO*
Wash on Japanese paper

Bibliography

ACRYLIC WATERCOLOR PAINTING. Wendon Blake. Watson-Guptill Publications, New York.

THE ART OF COLOR. Johannes Itten. Van Nostrand Reinhold, New York.

THE ARTIST'S HANDBOOK OF MATERIALS AND TECHNIQUES. Ralph Mayer, The Viking Press, New York.

BISSIER. Werner Schmalenbach. Harry N. Abrams Inc., Publishers, New York.

CLAUDE LORRAIN. Sabine Cotte. George Braziller, New York.

COLLAGE. Herta Wescher. Harry N. Abrams, Inc., Publishers, New York.

COLLAGE AND ASSEMBLAGE, TRENDS AND TECHNIQUES. Dona Z. Meilach and Elvie Ten Hoor. Crown Publishers Inc., New York.

A CONCISE HISTORY OF MODERN PAINTING. Herbert Read. Thames and Hudson, London.

A CONCISE HISTORY OF WATERCOLORS. Graham Reynolds. Thames and Hudson, London.

THE CONTENT OF WATERCOLOR. Edward Reep. Van Nostrand Reinhold, New York.

CONVERSATIONS WITH PAINTERS. Noel Barber. Collins, London.

A DICTIONARY OF ABSTRACT PAINTING. M. Seuphor, Methuen & Co., London.

A DICTIONARY OF MODERN PAINTING. Carlton Lake and Robert Maillard. Tudor Publishing Company, New York.

DRAWING: SEEING AND OBSERVATION. Ian Simpson. Van Nostrand Reinhold, New York.

DRAWINGS OF THE MASTERS Part I and II. Una E. Johnson. Shorewood Publishers Inc., New York.

JAPANESE INK-PAINTING. Ryukyu Saito. Charles E. Tuttle Company Rutland, Vermont & Tokyo, Japan.

JOHN MARIN. John Marin. Edited by Cleve Gray. Holt, Rinehart and Winston, New York.

JOHN MARIN. MacKinley Helm. Pellegrini and Cudahey, Boston.

THE JOYS OF WATERCOLOR. Hilton Leech with Emily Holmes. Van Nostrand Reinhold, New York.

THE MATERIALS OF THE ARTIST. Max Doerner. Harcourt Brace & World, New York.

THE NEW LANDSCAPE IN ART AND SCIENCE. Gyorgy Kepes. Paul Theobald and Co., Chicago.

PAINTING IN OPAQUE WATERCOLOR. Rudy de Rayna. Watson-Guptill Publications, New York.

PAINTING WITH ACRYLICS. William Kortlander. Van Nostrand Reinhold, New York.

PAINTING WITH PURPOSE. Morris Davidson. Prentice-Hall Inc., New Jersey.

PAUL KLEE NOTEBOOKS, Vol. 1, THE THINKING EYE. George Wittenborn, New York.

SARGENT WATERCOLORS. Watson-Guptill Publications, New York.

STARTING TO PAINT WITH ACRYLICS. John Raynes. Studio Vista, London. Watson-Guptil Publications, New York.

SYNTHETIC MEDIA. Russell O. Woody, Jr. Van Nostrand Reinhold, New York.

J. M. W. TURNER, A CRITICAL BIOGRAPHY. JacK Lindsay. New York Graphic Society, Greenwich, Conn.

TURNER'S SKETCHES AND DRAWINGS. A. J. Finberg. Schocken Books, New York.

THE VISUAL EXPERIENCE, AN INTRODUCTION TO ART. Bates Lowry. Harry N. Abrams Inc., New York.

WATERCOLOR — A CHALLENGE. Leonard Brooks. Van Nostrand Reinhold, New York.

WATERCOLOR GOUACHE AND CASEIN PAINTING. Adolf Dehn. Studio Publications, Inc., New York.

WATERCOLOR PAINTING IN BRITAIN, 3 Vols. Martin Hardie. Barnes & Noble, Inc. New York.

THE WAY OF CHINESE PAINTING, ITS IDEAS AND TECHNIQUES WITH SELECTIONS FROM THE SEVENTEENTH CENTURY MUSTARD SEED GARDEN MANUAL OF PAINTING. Mai-mai Sze. Modern Library Paperbook, Random House, New York.

Index

Index

■ Leonard Brooks makes a personal survey of his many years' experience in the world of water and color. He examines the fundamental uses of watercolor and wash and illustrates ways of using them as a sketching medium or for finished paintings. Numerous examples of the many ways of using aqueous media are shown including a set of experimental exercises that will help the reader to find his own personal style of painting. Basic instruction in using the new acrylic pigments with demonstrations to show the numerous approaches to contemporary uses, figurative and abstract. Gouache, casein and inks are also discussed. For the painter of watercolor or acrylics this book will provide a background and coverage presented by a master of the aqueous media.

This book is unique in that it takes the student into the studio and describes to him the experiences and workings of a professional about his years of working in the many water and color techniques from traditional to the new media now available to the artist of today. Watercolor, Acrylic, Gouache and Casein, Inks and Mixed Techniques — all of these, including the important one of Collage and Combined Media are illustrated, and demonstrations of the methods and materials used are shown in photographs, drawings, paintings and text. *Water and Color* provides a practical textbook for the beginner or advanced student. The reader is in the artist's studio to join him in his working sessions from initial idea to the finished work ready for exhibition.